A Worldly Art

A Worldly Art
The Dutch Republic
1585-1718

Mariët Westermann

PERSPECTIVES

HARRY N. ABRAMS, INC., PUBLISHERS

For Annie and Lucelle, who like pictures as much as words

Acknowledgments

My view of Dutch pictorial culture has taken shape in an ongoing dialogue with Egbert Haverkamp-Begemann, always pleasant, frequently witty, never less than challenging. I thank him for his engaging interest and hope he will argue with the result. Joanna Woodall read the manuscript with rigorous insight; I thank her for her generous suggestions and encouragement. Other friends and colleagues have inflected aspects of my understanding. I want to thank especially Perry Chapman, Andrea Feeser, Zirka Filipczak, Walter Liedtke, Herman Roodenburg, Andy Shelton, Eric Jan Sluijter, Marina Warner, and Arthur Wheelock. At the Center for Advanced Study in the Visual Arts in Washington in 1994-95, Barbara Gaehtgens, Jodi Hauptman, Kathryn Smith, and Maria Gough helped me think through realism and problems of word and image.

I am most grateful to Tim Barringer for inviting me to think about this project and for his perceptive comments towards its improvement. With keen interest and good humor, Lee Ripley Greenfield guided the book from process to product. Sophie Collins prepared the way at an initial stage. Sue Bolsom-Morris was a model of ingenuity and diligence in assembling the illustration program, and Jacky Colliss Harvey managed the editorial process with sustained sensitivity. I thank them all for their creative work.

My loving thanks go to Charlie Pardoe, for his attentive reading and listening and for the sort of support the Dutch call angel's patience. To our daughters I dedicate this book.

Frontispiece GERARD HOUCKGEEST *New Church at Delft with the Tomb of Willem I,* page 71 (detail)

Series Consultant Tim Barringer (Birkbeck College, London)
Series Director, Harry N. Abrams, Inc. Eve Sinaiko
Senior Editor Jacky Colliss Harvey
Designer Karen Stafford, DQP, London
Cover Designer Miko McGinty
Picture Editor Susan Bolsom-Morris

Library of Congress Cataloging-in-Publication Data
Westermann, Mariët.
 A worldly art : the Dutch Republic, 1585–1718 / Mariët Westermann.
 p. cm. — (Perspectives)
 Includes bibliographical references and index.
 ISBN 0-8109-2741-1
 1. Genre painting, Dutch. 2. Genre Painting — 17th century — Netherlands.
 I. Title. II. Series : Perspectives (Harry N. Abrams, Inc.)
ND1425.N43W48 1996
754'.09492'09032 — dc20 95–24695

Copyright © 1996 Calmann and King, Ltd.

Published in 1996 by Harry N. Abrams, Incorporated, New York
A Times Mirror Company

This book was produced by Calmann and King, Ltd., London

Printed and bound in Singapore

Contents

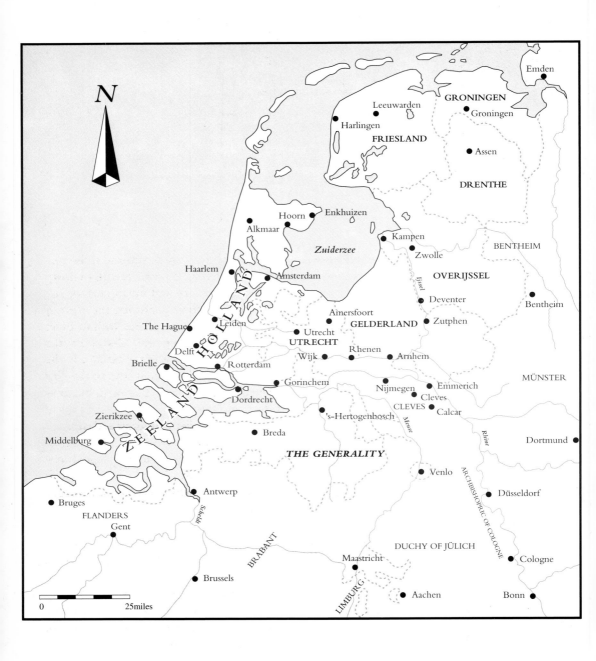

N

Emden

GRONINGEN
Leeuwarden Groningen
Harlingen
FRIESLAND Assen

DRENTHE

Hoorn Enkhuizen
Alkmaar Kampen BENTHEIM
 Zuiderzee Zwolle
Haarlem OVERIJSSEL
 Amsterdam Bentheim
 Deventer
H O L L A N D Amersfoort Zutphen
The Hague Leiden GELDERLAND
 Delft Utrecht Rhenen Arnhem MÜNSTER
Brielle UTRECHT Wijk
 Rotterdam Nijmegen Emmerich
Z E E L A N D Gorinchem Cleves Dortmund
 Dordrecht 's-Hertogenbosch CLEVES Calcar
Zierikzee Rhine
Middelburg Breda THE GENERALITY

 Venlo Düsseldorf
 Antwerp
Bruges ARCHBISHOPRIC OF COLOGNE
FLANDERS Scheldt
 Gent BRABANT DUCHY OF JÜLICH
 Maastricht Cologne
 Meuse
0 25miles Brussels LIMBURG Aachen Bonn

An Invitation to Look

1. The Dutch Republic from 1629. The provinces are named in bold type. The area labeled "The Generality" belonged to the Spanish-held province of Brabant until the Dutch captured it in 1629; it did not receive full provincial status. Present use of the name "Holland" for all the Netherlands may stem from that province's preeminence in the seventeenth-century Republic.

V isitors to Dutch museums often express surprise at the correspondence between the look of seventeenth-century paintings and the actual scenery and inhabitants of the Netherlands today. After more than three centuries, the *View of Delft* by Johannes Vermeer (1632-75) still impresses with its quiet lifelikeness (FIG. 2). The red-brick buildings and tiled roofs, the sunlit New Church, the wrinkled reflections of the skyline in the water, and the dramatic cloud formations seem true to the city of Delft as it still stands. The men and women chatting in the foreground, some watching the scene as we do, guarantee the human measure, the habitability of this plain yet extraordinary city.

This book attempts to show how Vermeer and other Dutch artists portrayed their land and society with an unprecedented concern for a "reality effect." It examines the technical means by which they attained such lifelikeness and asks why contemporaries might have enjoyed such realism, as it is now called. But it also demonstrates that paintings, drawings, and prints are never direct transcriptions of the world, and that artists and buyers of art preferred certain themes to others. Analysis of these choices shows that Dutch pictures tell particular stories about the Dutch Republic, about the people who lived in it, and about its past – narratives that say as much about the "Golden Age," as the period came to be called in the eighteenth century, as economic and political facts do. The book also considers pictures that may to modern eyes look less "Dutch" than Vermeer's *View of Delft*, but that were avidly bought by the most distinguished seventeenth-century collectors. Many works made in the Dutch Republic represented classical myths, Italian landscapes, international tales of romance, and Dutch people in fanciful guises. While painters and printmakers fashioned

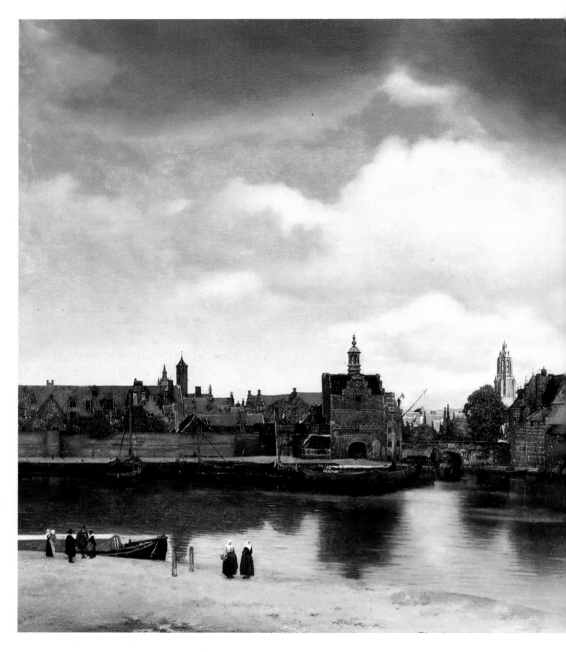

2. JOHANNES VERMEER
View of Delft, c. 1661. Oil on canvas, 38 x 46" (96.5 x 117 cm). Mauritshuis, The Hague.

Modern critics have long admired Vermeer's painting for its acute observation of houses, light, and atmosphere. Yet Vermeer did not record one moment or point of view: he adjusted the buildings and reflections in the water to create a harmonious image of Delft. Vermeer's composition follows a tradition of Netherlandish city profiles, but its closer view and broad expanses of water and sky transform the formula to monumental effect.

these pictorial stories, engineers and architects were creating the Dutch landscape and cityscape as we know it. Their buildings and landscaping projects, too, inform us about the structures and values of Dutch seventeenth-century society.

Because the pictorial and architectural material is so diverse, the chapters of this book are organized thematically rather than chronologically, although historic developments are indicated throughout and summarized in the timeline at the end. In the past few decades, historians of art and literature have called for new readings of images and texts, for interpretations that do not make the conscious intentions of artists their only goal. Studies characteristic of these approaches ask how works of art by their styles and themes articulate the concerns of the cultures in which they were made, read, and seen. The thematic arrangement of this book allows an exploration of the variety of interpretive strategies that have recently been brought to bear on paintings and prints in the Northern Netherlands. Each of these approaches offers partial readings of the pictorial and historical data, and brought together they facilitate an imaginative understanding of the myriad ways in which pictures functioned in Dutch society.

The first chapter sketches the political and economic history of the Dutch Republic, and asks how artists made and sold their works. It suggests how such market conditions may have affected the themes and styles of the pictures produced. Chapter two introduces the complex relationships between words and images in the Republic, a constellation as central to this book as it was to seventeenth-century Dutch culture. Texts provided narratives for pictures, words appeared in pictures, and writing itself could become a pictorial exercise. Less directly, seventeenth-century writings enable historians to reconstruct the resonance of particular themes. Chapter three studies the different ways in which painters made their pictures look "virtually real," and considers the functions of such realism. With their specifically local look, Dutch paintings registered and forged aspects of early national identity in the Northern Netherlands, but, as is explained in chapter four, other, apparently less lifelike images also contributed to this process. That chapter analyzes the political uses of some history paintings as well as the less obvious ideological functions of seemingly plain landscapes and pictures of social and familial life. Seventeenth-century Dutch people lived and worked in small and overlapping social units, such as families, professional groups, neighborhoods, and cities. Chapter five considers portraiture and architecture as means of articulating allegiance to such entities and asks how such representations related to notions of personal

and collective identity. Artists, too, formed professional groups, and many Dutch painters and architects were self-conscious about the status and tasks of art. The last chapter reviews their written and pictorial statements about their work, and thereby suggests how the study of artistic intention can still be meaningful.

A brief explanation of dates and terms. This book covers the "long" seventeenth century, a distinct period of more than a strict one hundred years, and deals with the Dutch Republic, also known as the Northern Netherlands or the United Provinces (see FIG. 1), an area roughly the same as the present-day Netherlands. (The modern country is often referred to as Holland, but as Holland was merely the most influential province in the Republic that name is not used here to stand for the whole.) My account begins in 1585, when the Catholic Spanish army captured the city of Antwerp in the Southern or Spanish Netherlands, a territory approximately equivalent to modern Belgium. The conquest of Antwerp caused Protestant intellectuals and artists to leave the Southern Netherlands for the Dutch Republic, where they provided innovative stimulus to the production and discussion of art. The Southern Netherlands encompassed numerous distinct provinces, among which Flanders was one of the most powerful. Traditionally, the inhabitants and art produced in the whole Southern Netherlands are referred to as Flemish, after that one province, and that convention is followed in this book to distinguish the Southern Netherlandish from the Dutch.

The book discusses works produced up to 1718, the year in which the Dutch artist Arnold Houbraken (1660-1719) published his first volume of biographies of Dutch and Flemish artists. His publication constitutes the founding moment of the history of seventeenth-century Dutch art; without it, subsequent accounts of Dutch art and artists would have been different and vastly impoverished. Houbraken's book initiated a retrospective assessment of the artistic production of the past century, and thereby marked its end.

3. JAN STEEN
In Luxury, Look Out, 1663.
Oil on canvas, 3'3" x 4'9"
(1 x 1.4 m).
Kunsthistorisches Museum,
Vienna.

Interpretive Possibilities: In Luxury, Look Out

We will enter Dutch pictorial culture through a close look at one of its finest products, *In Luxury, Look Out* by Jan Steen (1626-79; FIG. 3). This painting of 1663 prompts many of the kinds of readings pursued in this book.

Picture the scene: four adults, an adolescent, three children, a baby, a pig, a monkey, and a dog have set a plain room in turmoil. A young woman smiles at the viewer as she places a glass

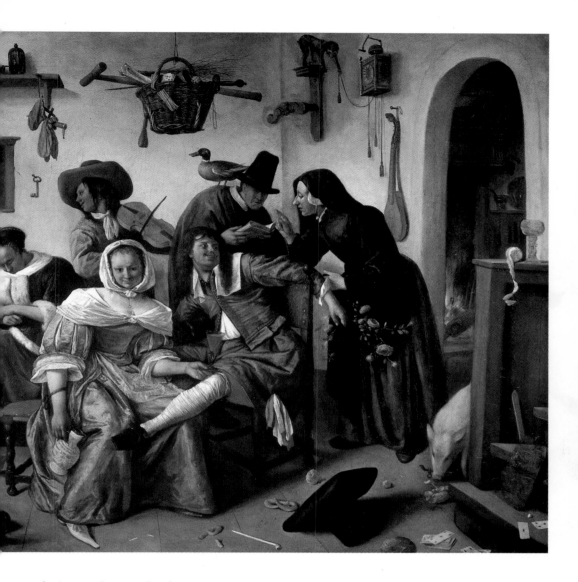

of wine in the crotch of a young man, who rests his leg on her knee. He is distracted by an older man and woman behind him, who recite from a book. A duck on the man's shoulder looks towards a youth, who plays his violin and eyes a young girl. She filches a coin from a purse. Next to her a boy draws on a pipe, perhaps to blow smoke at a dozing woman who is oblivious to the dog gobbling up a meat pie. Not even the bowl crashing onto the floor arouses her. The baby responsible for this noise turns around, far enough to see wine spilling from the barrel. A pig which has taken the tap from the barrel across the room nuzzles a rose, which must have fallen from the branch held by the young

An Invitation to Look

4. JAN MIENSE MOLENAER
Family Making Music, 1630s.
Oil on canvas, 25 x 32"
(63.5 x 81 cm). Rijksdienst
Beeldende Kunst, The
Hague, on loan to the Frans
Halsmuseum, Haarlem.

To suggest the continuity of
this family through the ages,
Molenaer included framed
portraits of deceased
ancestors, thereby commen-
ting also on the ability of
painting to preserve the
memory of persons. The
clock and the short-lived
bubbles blown by the
youngest boy, although
plausible elements in a
family portrait, allude to
the passing of time and life
as well.

man. His pipe and hat, a wine jug, pretzels, and cards litter the
floor, and a monkey stops the clock above. This is a family party
gone wild.

A popular Dutch proverb still describes messy homes as "house-
holds of Jan Steen," but did seventeenth-century homes really look
this way? Much about the picture appears lifelike. Steen care-
fully distinguished the different textures of things – shiny silk, soft
felt, glazed earthenware, polished pewter, succulent meat in a
crusty pie. A lot is going on at once, and everyone pays atten-
tion to something else, as is often true in life. It is as if the monkey
stopped time just long enough for the painter to record this mess
in progress: the bowl is forever falling, the violin keeps playing,
and the wine never stops pouring. Yet this is no momentary
snapshot. To make a picture this large – some five feet (1.5 m)
across – and to paint it this carefully, Steen must have taken at least
several days and probably weeks or months.

Moreover, some elements of the scene would have been unusu-
al in a seventeenth-century household. Few families would have
had ducks, pigs, and monkeys for pets. Most middle-class citizens
would have found the blackish clothes of the older people too

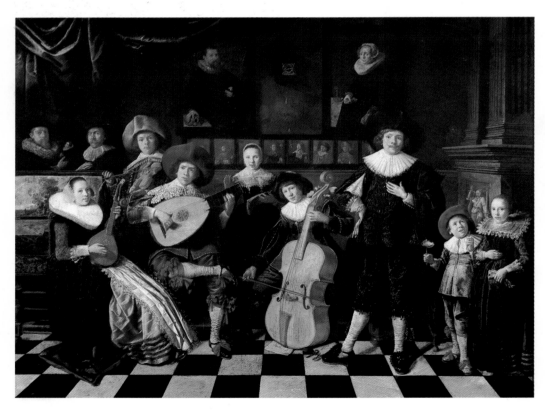

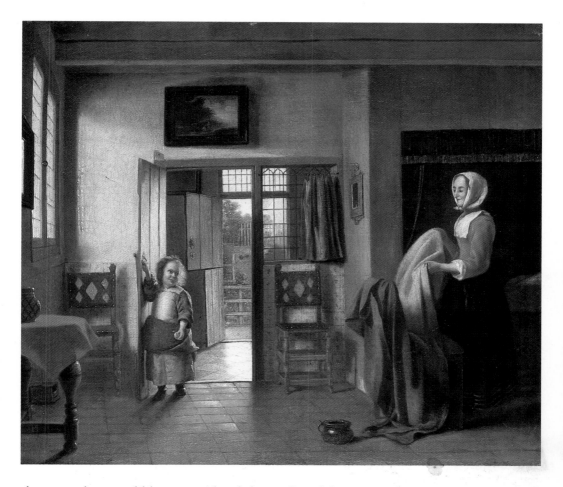

dour, yet they would have considered the outfits of the young couple too ostentatious, compared with the costumes in which respectable people had themselves portrayed. In a family portrait (FIG. 4) painted in the 1630s by Jan Miense Molenaer (c. 1610–68) the guitarist wears a suit comparable to that of Steen's young man, but it is securely buttoned and demurely colored. The low neckline of Steen's central woman would have been more customary for a barmaid or prostitute, and the playing cards, pipes, and drink would have been at home in a tavern or brothel. Yet Steen's painting does not represent a whorehouse: the children, the kitchen seen at right, and the household purse above the violinist suggest a domestic interior. But something has gone very wrong.

The flat purse quite literally gives one key to the puzzle – a key below it pointing to the dozing woman. Her respectable dress indicates that she should be in charge of this household and of its key, as women were meant to be according to contemporary

5. PIETER DE HOOCH
The Bedroom, c. 1658-60.
Oil on canvas, 20 x 24″
(50.8 x 61 cm). Staatliche
Kunsthalle, Karlsruhe.

ideas of proper family life. But her sleep, probably the result of excessive drink, marks the household's dissolution. Because this home is not watched as it should be, its funds are depleted. Without supervision, the young lovers can flirt in front of the children, who themselves have learnt to steal and smoke. The dog eating the pie underscores not only the negligence of the adults but especially the ill example they set for the kids, as moralists traditionally likened dogs licking pots to poorly reared children.

Other Dutch paintings present more orderly households. *The Bedroom* (FIG. 5) of c. 1658-60 by Pieter de Hooch (1629-84) is a clean space for a woman's domestic work, performed before a quiet child and without interference from men – or animals. Steen added the pig, monkey, and duck to enact proverbs about folly. Seventeenth-century Dutch people used proverbs readily, as witty summaries of shared beliefs. "The pig runs off with the tap," for example, meant "the party is drinking with abandon." "Throwing roses before the swine" stood for wastefulness. By stopping the clock, the monkey reminds the viewer that "In folly, time is forgotten." A duck's "quacking" was a standard phrase for nonsensical banter. Even though the dour, hunched man and woman take no part in the disorder, the duck on the man's shoulder characterizes their conversation as futile, presumably because in their bookishness they ignore the mess around them.

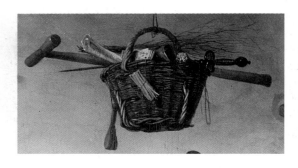

6. JAN STEEN
In Luxury, Look Out, 1663 (detail of FIG. 3). Oil on canvas, 3'3" x 4'9" (1 x 1.4 m). Kunsthistorisches Museum, Vienna.

On the blackboard in the right foreground Steen wrote another proverb: "In luxury, look out." Like many writers of his day, he warned viewers to watch out when living in riches, since fortunes can change, particularly if no one is looking. He shows what this household has hanging over its head (FIG. 6): a basket full of the marks of poverty and disease, with crutches, a leper's rattle, and switches (the lashes with which petty crimes were punished). Steen painted the clues to this message especially for the beholder to observe. The figures in the painting do not see the signs of their folly and financial ruin – the unattended key, the wasteful pig, the quacking duck, the clever monkey, the gluttonous dog, the proverbial inscription, and the fateful basket. In the seventeenth century, however, "luxury" encompassed more than the modern definition of an abundance of coveted goods: it meant illicit sexual desire as well, and drink and tobacco were thought to strengthen it. To signal this connotation, Steen placed the amorous couple at the hub of the abuse of luxury. In the Nether-

lands, artists had traditionally personified luxury as a woman seductively dressed in silks. Not accidentally, it is such an immodestly dressed woman who invites the viewer to look at luxury and to beware of it.

For whom did Steen intend all these ominous references? This large, carefully executed painting would have been an expensive piece of decoration, a real luxury, affordable only to a wealthy buyer. Although its moral might be appropriate to rich viewers, it is unlikely that they would buy a precious painting just to warn themselves. The Church and the publishing industry offered cheaper sermons for that purpose. The people *in* the painting are, after all, the ones in need of moral lessons, and they are, in dress and conduct, presumably quite different from the sort of people who owned the work. By reserving his clues for educated viewers, Steen offered them a scene they could enjoy because they knew just what to think of it. They might take up the infectious laughter of the protagonists, but to laugh at, not with them.

Any viewers who knew the art of Steen's time might have found additional pleasure in the painting because it refers recognizably to other types of painting. Steen gave the room the clean white walls typical of the proper interiors of De Hooch (see FIG. 5), but he staged disorder between them. He also included the several generations that are found in contemporary family portraits. In Molenaer's portrait, family members play music to signify their harmonious relationships. Steen's imaginary family also has musical instruments, but it sounds a different tune. An informed viewer would immediately realize that this painting does not portray an actual family. All the characters except one ignore the viewer, a rarity in portraits, and no respectable family would wish to present itself in this state of moral blindness.

So if Steen's picture, which seems so "real," comically distorts the Dutch household, is De Hooch's version more true to Dutch life? Although foreign visitors noticed the cleanliness of Dutch homes, many households were busier and dustier than those depicted by De Hooch. His painting depicts a positive ideal of the household, an ideal that Steen turned upside down for the viewer's amusement and edification. Many Dutch pictures offered meaningful delight precisely because they oscillate between a faithful reconstruction of reality and a positive or negative articulation of social ideals.

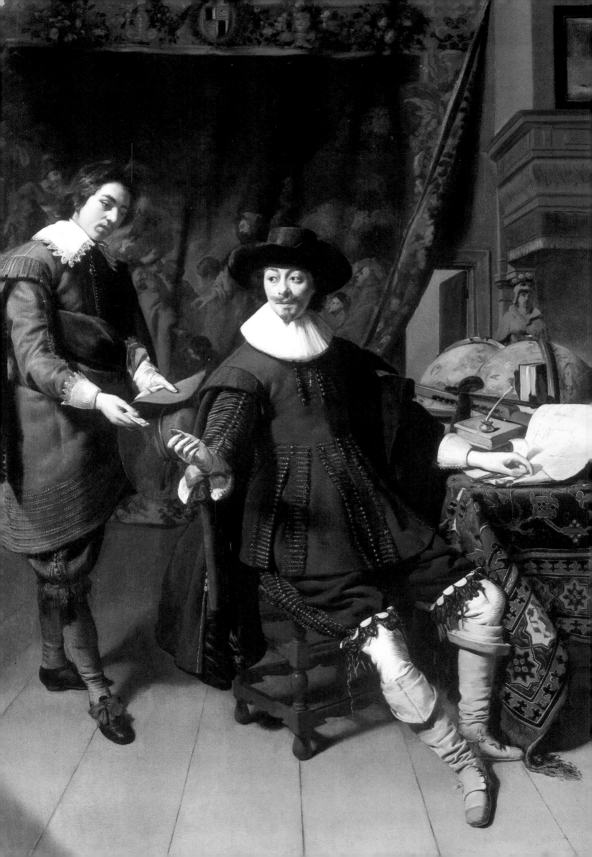

ONE

Making and Marketing Pictures in the Dutch Republic

7. THOMAS DE KEYSER
Constantijn Huygens and His Clerk, 1627. Oil on panel, 36³/₈ x 27¹/₄" (92.4 x 69.3 cm). National Gallery, London.

Huygens served as secretary to three Stadhouders of the Republic, and was a discerning connoisseur of art and literature.

For most of the seventeenth century, the provinces of the Dutch Republic occupied the same territory as the present Kingdom of the Netherlands, with the exception of south-eastern parts of the modern country. From 1481 until 1579, these provinces had been governed by members of the Austrian Habsburg family. In 1579 the provinces joined reluctantly to declare their independence from the Habsburg King of Spain, Philip II (1527-98), brother of the Habsburg Holy Roman Emperor Ferdinand I (1503-64). Philip II held title to all of the Netherlands and ruled them through a governor in Brussels. Motivated by local economic interests and encouraged by the many Netherlandish Protestants who wished to leave the Catholic Kingdom of Spain, noble provincial leaders had been rebelling since 1568. Philip II and the Spanish governors of the Southern Netherlands resisted this secession, and did not officially recognize the United Provinces until 1648, when the "Eighty Years War" ended with the Peace of Münster. The Dutch Republic had actually enjoyed some measure of recognition since 1609, when it had concluded the "Twelve Years Truce" with the Spanish at Antwerp. By agreeing to the Truce on Northern Netherlandish terms, Philip II acknowledged the reality of the Republic, which was led primarily by Protestant Dutch leaders of the aristocratic and upper middle classes.

Although the United Provinces did not secede solely for religious reasons, Netherlandish Protestant religion did provide popular impetus to the revolt. The Protestant Reformation of the sixteenth century, spearheaded by Martin Luther (1483-1546) and Jean

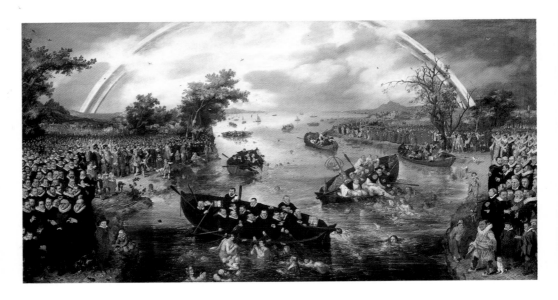

8. Adriaen van de Venne
Fishing for Souls, 1614.
Oil on panel, 38½″ x 6′2½″
(98 x 189 cm).
Rijksmuseum, Amsterdam.

Many faces in the middle
ground of the banks are
portraits of political leaders,
including the Stadhouder
Maurits and his successor
Frederik Hendrik. Van de
Venne included himself in
the front row of Protestant
dignitaries on the left,
exuding confidence with his
hand on his hip.

Calvin (1509-64), had reached the Northern Netherlands in the
third quarter of the century via France and the Southern Nether-
lands. The first Protestant Churches in the Netherlands were called
Reformed, and they followed Calvin's doctrines of a church found-
ed on close readings of the original biblical text and of salva-
tion through personal faith, rather than through mediation of the
clergy and the sacraments. The Reformed or Calvinist Church
maintained the sacraments of baptism and communion, but it made
them less central to belief and did not envelop them in the visu-
al splendor associated with the Catholic mass. It did away alto-
gether with sacraments wholly dependent on the clergy, such as
confession. This less hierarchical religion held strong appeal in
lands far removed from Rome, and it provided a rallying ideo-
logy for local aristocratic leaders at odds with their Habsburg over-
lords, who had taken on the defence of the Catholic cause in
Europe.

During the Truce, the painter Adriaen van de Venne (1589-
1662) represented the moral superiority claimed by Dutch lead-
ers in his *Fishing for Souls* (FIG. 8). The painting visualizes Christ's
words to his disciples, "I will make you fishers of men," as a
contemporary contest for souls between two Reformed boats at
left and two Catholic vessels at right. The orderly Dutch Protes-
tants are more successful, catching people with the Bible and with
the Christian virtues Hope, Faith, and Charity inscribed in the net.
The near-capsizing Catholic monks use incense and music for lures.
On the left bank, Dutch leaders are neatly aligned, opposite the
less numerous Flemish dignitaries on the other side. Although the

Southern Netherlandish camp is painted respectfully, their background is literally constituted by a withered tree and a Pope borne by adulatory monks.

Although the Northern Netherlanders enjoyed their independence, they did not immediately think of their country as separate from the Southern Netherlands in the way the Netherlands today is distinct from Belgium. Even after the Truce, some Southern and Northern leaders hoped for reunification on Catholic or Calvinist terms. A map produced by Claes Jansz Visscher (1587-1652) during the Truce registers the gradual change in the relationship between North and South (FIG. 9). Visscher represented all seventeen Netherlandish provinces in the traditional heraldic shape of "Leo Belgicus," the Netherlandish lion. Yet the vignettes of important cities along the borders separate the Northern ones, at left, from their Southern counterparts at right.

The revolt of the Seven United Provinces marked not only a religious conflict, but arose also from deeply rooted political,

9. CLAES JANSZ VISSCHER AND WORKSHOP
Leo Belgicus, 1609-21. Engraving and etching, 18$\frac{1}{2}$ x 22$\frac{1}{2}$" (46.8 x 56.9 cm). Bibliothèque Royale Albert Ier, Brussels.

In later maps, the heraldic lion served for the Dutch Republic or even for the province of Holland alone. At lower left sit personifications of "the Free Netherlands" and the Southern Netherlands, on top of a figure for "The Old Quarrel." On the horizon, a profile of Amsterdam is marked "Prosperity of the Land."

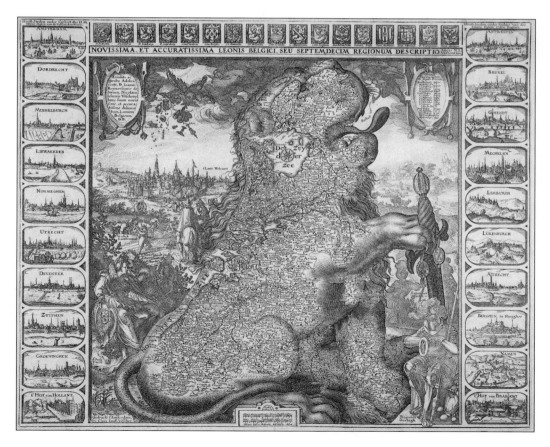

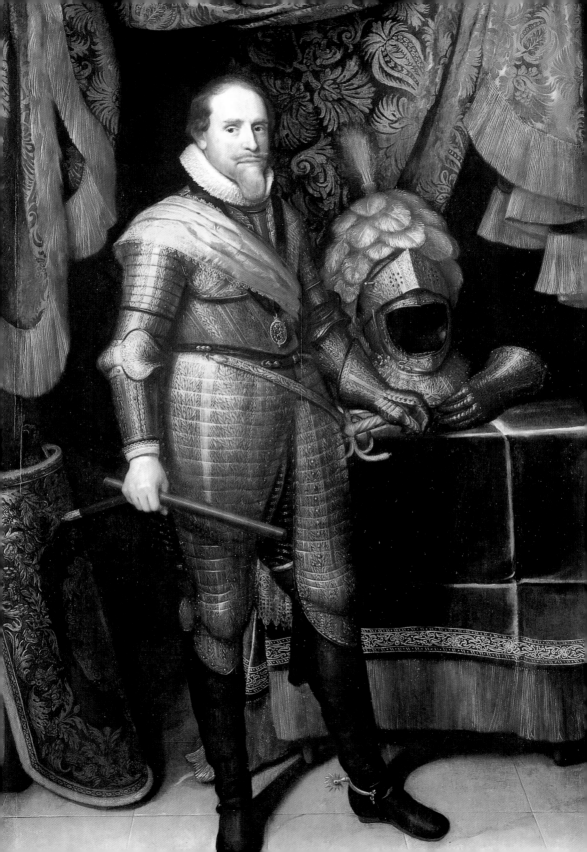

economic, and social differences. Whereas the Spanish Kingdom and its territories were ruled by an increasingly centralized court, usually resident in Madrid, the government structure of the Netherlandish provinces had remained localized in the cities that formed their economic backbone, governed by a middle-class elite of so-called regents. Whereas socio-economic power in Spain was primarily based on land-ownership and on precious metal mining in the New World, in the Northern Netherlands it derived from industry and trade.

From its inception, the Republic precariously balanced the interests of the individual provinces, their cities, and their regents. Each province elected its own *Stadhouder* ("city holder"), the highest military official, and its own States (delegates) to the States-General, an assembly that met in The Hague to set and execute the Republic's military, diplomatic, and economic policies. Within the States-General, the representatives from the province of Holland, and especially those from Amsterdam, its flagship city, wielded most power, as Holland was the most populous and prosperous of the provinces. The States-General appointed a general Stadhouder as well, traditionally an aristocratic descendant of Willem I, Prince of Orange (1533-84). Willem I, "father of the fatherland," had been the reluctant but effective leader of the Dutch revolt; the first nobleman to convince the Northern provinces to appoint him Stadhouder at large. His family held hereditary title to the Netherlands through their descent from the local Counts of Nassau, and in the seventeenth century Willem's sons Maurits (1567-1625; FIG. 10) and Frederik Hendrik (1584-1647) built up a fine Stadhouder's court in The Hague. Although its splendor made claims for the Oranges as natural rulers of the Dutch Republic, the Stadhouders were always dependent on the finances and political designs of the States-General, controlled primarily by the upper-middle-class regents from the cities rather than land-based nobles. Therefore, despite its centralizing political and military institutions, the Republic was strikingly local in its economic and political organization. The towns frequently resented the taxation of the States, and many regent factions resisted the military primacy and political influence of the Stadhouder. It was mostly in military crises that the Republic's constituents transcended their differences for the common interest, occasionally embodied in the Stadhouder.

The Republic was indeed at war for much of the seventeenth century. After the Truce ended in 1621 hostilities resumed. Frederik Hendrik's victories on land and several naval exploits, such as the capture of Spanish ships carrying bullion from America,

10. MICHIEL VAN MIEREVELD *Prince Maurits, Stadhouder*, c. 1625. Oil on panel, 7'2" x 4'6" (2.2 x 1.4 m). Rijksmuseum, Amsterdam.

Maurits is represented in the gilded suit of armor the States-General had given him for his military victory at Nieuwpoort in 1600. The portrait thus makes claims for the Stadhouder's indispensability to the States-General and the Republic. Van Miereveld's studio produced numerous paintings of the prince.

eventually secured independence. Immediately upon the Peace of Münster of 1648, however, Amsterdam and the States-General tried to curb the powers of the new Stadhouder, Willem II (1626-50). In 1650, Willem sent his army to subdue the city, which was saved only by a providential fog. Willem's premature death from smallpox soon after the challenge allowed the States-General controlled by the regents to leave the office open, as his baby son Willem III (1650-1702) was ineligible. In the Stadhouderless period that followed, the regent Johan de Witt, highest official of the States-General, initially kept the Republic together against naval challenges from England over trade rights, and against Orangist supporters of the young Willem III. But as De Witt was forced to concentrate attention on local issues of commerce and political structure, the Republic was caught by surprise when the French army and English navy coordinated devastating attacks in 1672. De Witt was arrested for his inadequate military preparation, and he and his brother were torn apart by an angry mob. Supported by pro-Orange sentiment cutting across classes, regents opposed to De Witt were able to have Willem III elected Stadhouder. His army repelled the Anglo-French offensive, and the Stadhouder from then on enjoyed a prominent role in a stable government during a period of economic growth, although his position depended fully on the urban regent factions that had brought him to power. Willem III gained stature through his marriage to the English princess Mary, and eventually, as William III, assumed the English throne alongside her in 1689, after the Catholic king James II had fled the country.

Along with external challenges, internal religious strife disrupted the Republic. Although by the late sixteenth century most cities were under Reformed control, Calvinism was no true state religion. Moreover, Calvinism itself incorporated numerous factions. During the Truce, the two most prominent groups fought for control of the Calvinist Church, seeking support from the States-General and Stadhouder Maurits. Van de Venne's harmonious image of the Reformed camp in his *Fishing for Souls* erases these differences. In 1618-19, the Calvinist Synod at Dordrecht pitted militant advocates of an ideological fight against Catholic Spain till the bitter end, against more pragmatic leaders seeking peace. The stricter Calvinists also wished to wage religious war on dissidents inside the Republic, railing against continued opportunities for the Catholic mass as well as recreations such as fairs and theater. Maurits, whose political influence depended on his continued military leadership, strongly supported the militant faction. In keeping with the complex social structure

of the Republic, the faction patronized by the nobleman Maurits enjoyed broad support from the less wealthy but numerically strong segments of the urban middle class, while the more lenient Calvinists in favor of peace were led by prosperous patricians and upper-middle-class intellectuals.

After the Synod the peace-minded denomination lost influence in local and national government, but although the stricter Calvinists controlled the highest public offices from then on, the Republic continued to allow diversity of worship. At mid-century only

11. Interior of the Catholic sanctuary of Our Lord in the Attic, Amsterdam, 1663. Although the pews and lighting in this sanctuary are like those of Protestant churches, its decoration, especially the large painted altarpiece of the baptism of Christ with a sculpted image of God above, runs counter to Calvinist strictures against the use of images in worship and against representations of God.

a third of the population was Calvinist while more than a third was Catholic, in part because the Republic had gained Catholic territory when it captured Southern Netherlandish towns in 1629. The remainder belonged to other Protestant sects, including the Lutheran, Mennonite, and Anabaptist, and a small minority was Jewish. Catholics were not allowed to worship in public, but could do so in converted private houses, against the ineffective protests of Calvinists (FIG. 11). While professional and residential options for Jews were curtailed throughout Europe, the Republic remained open to Jews and offered them more opportunities for work than

12. EMANUEL DE WITTE
*Courtyard of the Amsterdam
Stock Exchange,* 1653. Oil
on panel, 19 x 18³/₄″ (48 x
47.5 cm). Museum Boymans-
van Beuningen, Rotterdam.

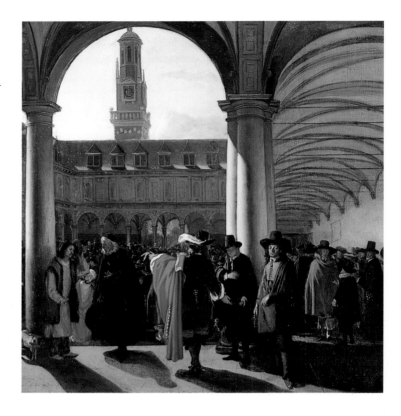

other societies did. In Amsterdam, the Jewish district was home
to respected intellectuals and businessmen.

Like the Stadhouder and the militant Calvinists, the merchants
in the trading cities, and especially Amsterdam, had an interest
in continued warfare. During the war, the Republic's navy block-
aded Antwerp's harbor, thereby paralyzing its foreign trade and
robbing the city of its sixteenth-century status as the preemi-
nent European port. Amsterdam now took over this role. The
resulting expansion of Amsterdam's trade allowed the city to devel-
op its extant banking system and commodity exchange services to
the highest levels of volume and sophistication in Europe. In its
Exchange, merchants and brokers from all over the world traded
goods, currency, rumors – and an unprecedented volume of stocks.
Contemporary reports sketch the bustle in the new Exchange build-
ing designed by Hendrick de Keyser (1565-1621), the most respect-
ed architect and sculptor of his generation. Artists such as Emanuel
de Witte (c. 1617-92) painted the busy throngs of domestic and
foreign traders (FIG. 12). At the Exchange investors bet on the
future values of goods, from basic commodities such as wheat and
herring to luxuries like pepper and nutmeg and, in a notorious

speculating frenzy of the 1630s, tulip bulbs. The Dutch Republic and Amsterdam derived their economic power primarily from foreign imports that were stockpiled, refined, or used in manufacturing, and then exported at higher prices. Although carriage of bulk goods provided a steady foundation for the economy, most surplus value was derived from trade in expensive items such as ceramics, spices, and silks from the Mediterranean, the Caribbean, and the East Indies, and refined products manufactured in the Republic.

Since the Middle Ages manufacturing and distribution had been organized in a system of guilds, fraternities of merchants, professionals, artisans, or laborers working in a particular trade. The guilds were very much brotherhoods, and although women were not explicitly excluded from membership, few belonged. Only guild members could practice a given trade and sell their products in a town. To become a master in a trade, applicants served several months or years as apprentices to a master, after which they would pass a test, often in the form of a "masterpiece." Guilds set working hours, minimum prices, and quality standards, thus offering protection from competition by outsiders. As cities and their markets grew at the end of the Middle Ages, production became ever more specialized by guilds. There were frequent disputes between guilds about rights to work a certain material, for example between joiners and carpenters. Such arguments were often arbitrated by the city government, which appointed the deans and jurors of the guilds. In the seventeenth century, however, traditional guild production could scarcely keep pace with demand. Increasingly, entrepreneurs outside the guilds provided artisans with raw materials to manufacture products, and then acted as wholesalers to shops. Many such production organizers also circumvented guild regulations by finding cheaper labor in small villages without guilds. In the course of the century, the protectionist guild system by and large contracted, to the benefit of more clearly market-driven production processes.

The development of Dutch shipbuilding to create a fleet of high-speed ships with maximum storage space was a prerequisite for the import of raw materials, ever needed in the small Republic, and the export of bulk goods and manufactured products. Dutch ship manufacturing and the resale of old ships became industries in their own right. Merchant ships benefited from the protection of efficient naval vessels, ships that had been tested and perfected in decades of naval warfare. Consortia of merchants, investors, and ship captains operated the trading ships, thus spreading the risks of loss. The largest commercial fleets, however, were

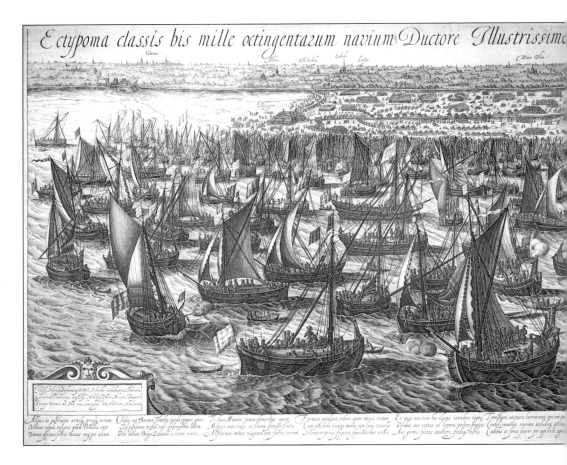

Ectypoma classis bis mille octingentarum navium Ductore Illustrissim...

13. ROBERT DE BAUDOUS
AFTER HENDRICK VROOM
The Landing at Philippine,
1600. Engraving, 15 x 24"
(38 x 61 cm). Rijksmuseum,
Amsterdam.

The States-General paid
Vroom 150 guilders for his
drawing for this engraving
of the fleet that brought
Dutch troops to Philippine,
near Nieuwpoort, where the
Stadhouder led them to
victory. The States must
have preferred an image of
the fleet to one of the battle
because the flotilla looked
so intimidatingly impressive.

commanded by trading companies with monopolies on Dutch
trade in the East and West Indies, along the African coasts, and in
Japan. In 1602, the States-General granted the East Indies Com-
pany, based in Amsterdam and five other cities, the monopoly
on trade from the Indonesian archipelago, and in 1621 the West
Indies Company gained similar privileges between Africa and South
America. Regents were conscious of the primacy of Dutch ship-
ping, frequently commissioning prints and paintings to com-
memorate ships and their feats (FIG. 13). In a large engraving com-
missioned by the States-General to celebrate a land-based victory
of 1600, Hendrick Vroom (c. 1566-1640) pictured the flotilla of
ships used to land troops near the battle site.

The Republic was new in a geological as well as a political
sense. Between 1607 and 1640, entrepreneurs and engineers drained
vast lakes in the province of Holland, thus creating acres of new
arable land. New villages sprung up in these low-lying "pold-
ers," protected only by dikes and pumps, driven by the readily

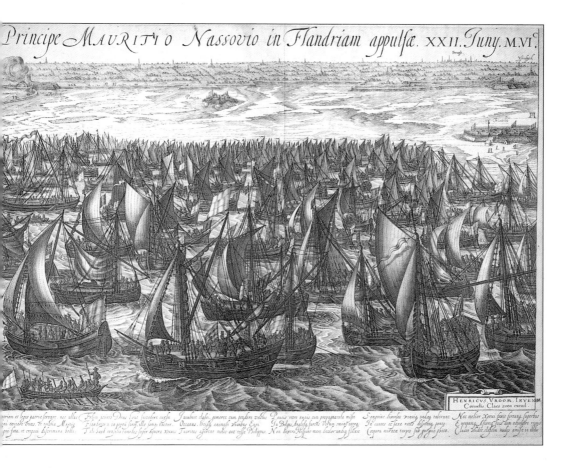

Principe MAVRITIO Nassovio in Flandriam appulsæ. XXII. *Juny.* M.VI.

HENRICVS VROOM. INVENT
Cornelis Claes zoon excud.

available wind power of the flat countryside. At the same time, entrepreneurs created an efficient system of transportation along rivers and canals, as a painting of 1622 by Esaias van de Velde (1590/91-1630) attests (FIG. 14). Horse-drawn boats connected the major cities and many smaller villages, allowing people, cattle, and goods to travel from, say, Amsterdam to The Hague in less than a day. Between 1609 and 1672, Amsterdam rebuilt itself on a plan of concentric canals (FIG. 15), allowing the city to maximize valuable water frontage for warehouses and to create a novel sewer system controlled by sluices.

The Republic's decentralization and its diversity of interests accounted for its strengths and weaknesses. The specialized nature of manufacturing, organized locally, created the basis for a securely diversified economy. Politically, decentralization allowed cities to enact locally sensible policies. Socially, tolerance of other religions and peoples was probably motivated more by business sense than by enlightened ideology, as the record of the profitable Dutch

slave trade from Africa to the Americas suggests. Even so, the pragmatic stance of the Republic's officials and merchants opened possibilities for non-Protestants. The entrepreneurs who profited from and expanded the favorable conditions for large-scale industry and shipping could be Reformed, Catholic, or Jewish. The painters Vermeer and Steen, whose works opened this book, were only two of the numerous Catholic painters who successfully sold to middle-class Protestants and Catholics alike.

Training Artists, Making Pictures

The production and marketing of images in the Republic resembled the organization of other industries, although the luxury and frequently intellectual character of the finest paintings and prints also gave the picture industry a distinctive identity. In most towns the guild of St. Luke, patron saint of artists, controlled the production and sale of paintings, prints, and sculpture. Before the seventeenth century, artists often belonged to the guilds of saddlemakers, cabinetmakers, or house painters. Probably aware of developments in Renaissance Italy, where painters and sculptors had managed to obtain their own guilds of artists, separate from craftsmen of lower intellectual status, Dutch artists gradually sought

14. ESAIAS VAN DE VELDE *Ferry Boat,* 1622. Oil on panel, 30 x 44¹/₂" (76 x 113 cm). Rijksmuseum, Amsterdam.

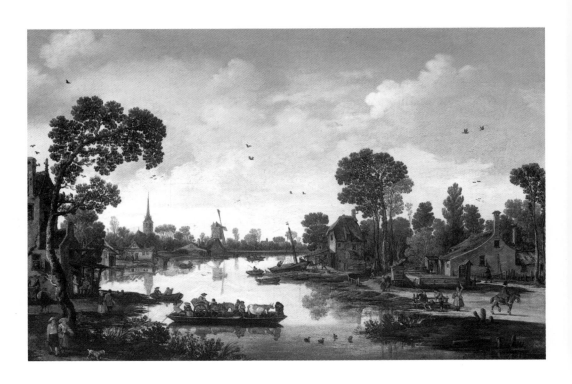

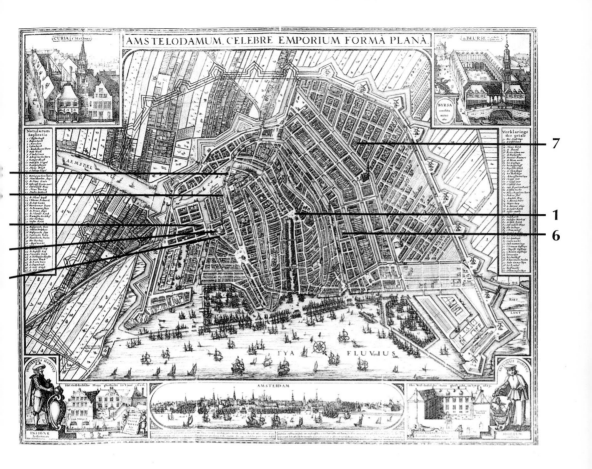

AMSTELODAMUM, CELEBRE EMPORIUM FORMA PLANA.

to establish their own guilds. This development was in keeping with the increasing specialization of production in most industries, but also registered a growing self-consciousness on the part of painters and printmakers about their craft as art.

To become a painter or printmaker, boys (rarely girls) would find masters to take them as apprentices when they were in their early teens. The child's parents would pay the master a fee for instruction, materials, and often room and board. An apprentice helped organize and clean the studio and learned to sharpen metalpoints (the precursors of pencils), to lace canvases onto a support known as a stretcher, to bind brushes, grind colored pigments and mix them with oil to produce paints, to prepare canvases or panels with a ground layer for painting, and to prepare copper plates for engraving or etching. In a painting of a studio by Adriaen van Ostade (1610–85), a pupil is depicted grinding pigments on a stone (FIG. 16). Pupils also learned to draw, first after the master's drawings, prints, and paintings, then from inanimate objects

15. Significant art-historical sites in seventeenth-century Amsterdam:

1 Location of new town hall
2 Hall for which Rembrandt painted *The Nightwatch*
3 House of Pieter Lastman
4 Rembrandt's house, 1639–58
5 House of Rembrandt's patron Jan Six
6 House of Frans Banning Cocq, captain in *The Nightwatch*
7 House of Govert Flinck
8 House of Hendrick Uylenburgh, Rembrandt's first dealer.

Making and Marketing Pictures in the Dutch Republic 29

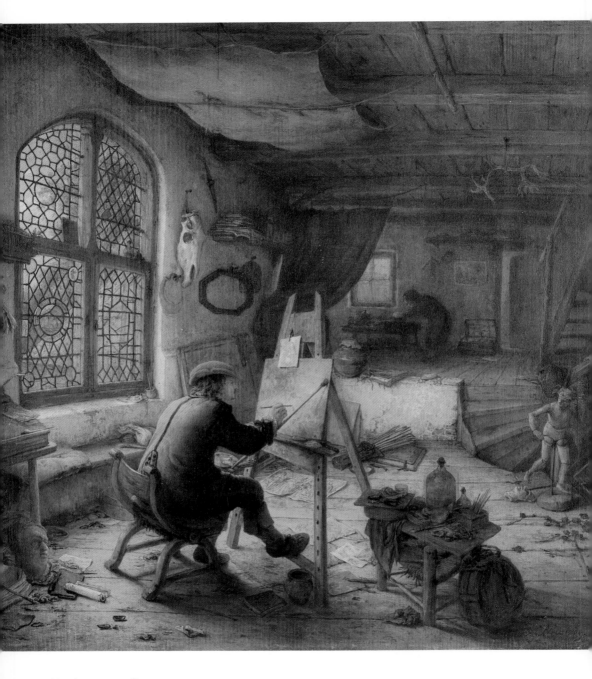

16. ADRIAEN VAN OSTADE
Painter in His Studio, 1663. Oil on
panel, 15 x 14″ (38 x 35.5 cm).
Staatliche Kunstsammlungen,
Gemäldegalerie Alte Meister, Dresden.

30 *Making and Marketing Pictures in the Dutch Republic*

such as plaster casts of antique statues, anatomical figures, and body parts. Later, they might draw after dressed mannequins, seen unclothed in Van Ostade's painting, and eventually after live animals and people.

The modern practice of drawing after the nude was rare, and it was mostly done from male models. Nude models gradually became more easily available through so-called "academies" of drawing, modeled after Italian examples of the sixteenth century. The earliest Dutch academy, founded in Haarlem in 1583, was no more than a loose association of three friends, Karel van Mander (1548-1606), Hendrick Goltzius (1558-1617), and Cornelis Cornelisz, also called Cornelis van Haarlem (1562-1638). A second informal academy appeared in Utrecht early in the seventeenth century, and similar drawing groups were later formed in Amsterdam around Rembrandt van Rijn (1606-69) and in The Hague. These academies existed alongside the guilds to offer additional opportunities for drawing, and perhaps informal discussions of theoretical issues such as perspective or subject matter.

Once pupils were able to draw and design compositions, they learned to paint with the palette and brushes, first after the master's own pictures. Soon, they would be allowed to paint the less important parts of the master's paintings, such as costumes in portraits or landscape backgrounds. Under guild regulations, masters could sell such collaborative works as their own. Michiel van Miereveld (1567-1641), the most successful portraitist of the first quarter of the century, signed paintings made in collaboration with his assistants as his own product. To make his highly sought-after paintings of the Stadhouders Maurits and Frederik Hendrik, for example, Van Miereveld might let his pupils fill in costumes and backgrounds to a face painted by him, or, more rarely, allow them to paint the entire portrait based on the master's model (see FIG. 10). In other studios, too, talented assistants were occasionally allowed to paint pictures and sell them under their own names.

After two to four years, the apprentice would pass an examination and often make a masterpiece to show the guild his mastery of requisite skills. Finished apprentices with funds to set up a studio would become masters in their own right and take on pupils, but many kept working as journeymen in a master's studio. The social status of painters therefore varied from day laborers through independent masters to well-rewarded court artists such as Van Miereveld and Gerard van Honthorst (1590-1656), who specialized in portraiture of high officials. In one such portrait, of Margareta Maria de Roodere and her parents, Van Honthorst rep-

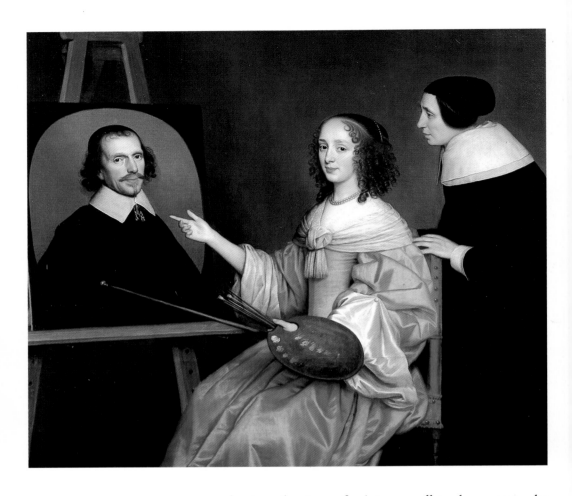

17. Gerard van Honthorst *Margareta Maria de Roodere and Her Parents*, 1652. Oil on canvas, 4′8″ x 5′6″ (1.4 x 1.7 m). Centraal Museum, Utrecht.

Portraits of upper-middle-class amateur painters such as De Roodere marked and contributed to a growing appreciation of painting and drawing as intellectual and socially respectable arts.

resented yet another type of painter: a well-to-do amateur who painted for pleasure (FIG. 17). Several women became accomplished painters in this way. Most master painters were men, but more than a dozen women are recorded as having attained master's status, most famously Judith Leyster (1609-60).

A master's workshop was usually a fairly plain "painting room" with a few windows to the north to let in even light. In the majority of Dutch paintings, this light illuminates objects, people, and even landscapes from the left. The master obtained raw materials, and he and his pupils processed them for use. As the production of art became more specialized suppliers gradually assumed these tasks, selling brushes, chalks, metalpoints, mixed paints, and prepared panels and canvases. In 1643, a dealer of painting supplies still advertised his shop as a novel venture. Besides utensils and supplies, artists also kept reference books close at hand, including treatises on painting, the Bible, and other literature.

How painters actually made pictures varied widely, but there were common practices. Many artists prepared their paintings with drawings, including a sketch of the whole composition and detailed studies of figures, objects, and body parts. The painter in Adriaen van Ostade's *Studio* sits before his easel, as painters often did, and he paints on his panel from a drawing clamped above it. Painters worked on wood panels or, increasingly, on cheaper canvas. These supports were usually prepared with a "ground" that included chalk, white or brown pigment, and a binding material such as oil or glue. On the ground, painters would sketch out preliminary designs in chalk or pencil and then "dead-color" that composition in monochrome paint. Next, they would paint the final layers, frequently working from the background of the representation to the foreground, perhaps leaving open spaces for figures and objects closer to the front of the pictorial space or adding such foreground items over painted backgrounds. Painters often changed their minds or corrected mistakes by just painting over them. As the top layer of paint has often become more transparent over time, such changes (*pentimenti*) have become visible again, laying bare the painting process. Most painters added protective varnish at the end. Invariably these varnishes darkened over time, causing paintings to look yellow until the coating is removed.

Marketing, Buying, and Collecting Art

As the Republic became more prosperous around 1600, and especially after the Truce of 1609, the market for pictures grew rapidly. This market catered for various interests and levels of income and social status. Striking in comparison with other European markets is the virtual absence of Dutch Church patronage. Calvinist theology did not allow the use of altarpieces and representations of God and Christ in worship, and it was opposed to the Catholic cult of saints, which required so many paintings and sculptures. Calvinists did allow images for didactic purposes or decoration, but such pictures of biblical stories, landscapes, buildings, or still lifes were meant to decorate secular buildings rather than churches.

Most pictures were bought by private, middle-class citizens, known as *burghers*, from modest artisans to wealthy regents. An English observer commented that in the Republic even humble abodes brimmed with pictures, but laborers and small peasants surely could not afford more than a few mediocre prints, if any at all. Solid burghers collected avidly, however. They hung their

pictures throughout their homes, the largest and probably finest in an upstairs living room (the *saal*), but others in bedrooms, halls, and even kitchens. As burghers amassed more wealth, particularly after the peace of 1648, they built increasingly large homes, which could accommodate larger paintings and more of them. The increase in production of large canvases after mid-century can in part be explained by this development. In Amsterdam and Leiden, collectors lived along prominent canals, in homes built in the latest styles (FIG. 18). After 1686, the house illustrated here belonged to the De la Courts, a family of discerning collectors. A doll's house assembled by one of its members, Petronella Oortmans-de la Court (1624–1707), replicates the frequently symmetrical display of paintings in wealthy homes (FIG. 19). The doll's house itself is a miniature collection, for which the owner commissioned 1,600 pieces of furniture and paintings and 28 fine dolls.

At the top of the collecting hierarchy, patrons ordered pictures directly from painters, specifying subject, size, and price. The

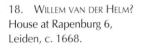

18. WILLEM VAN DER HELM?
House at Rapenburg 6,
Leiden, c. 1668.

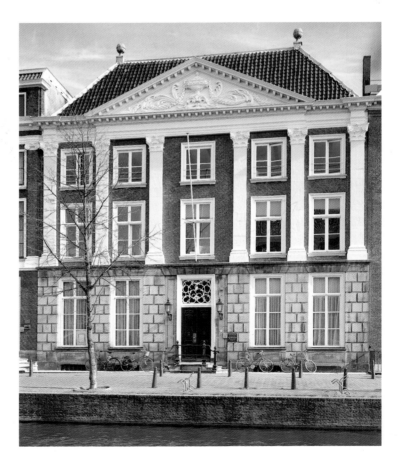

Stadhouders in The Hague patronized specific artists for portraits and history paintings. The court also commissioned gardens and buildings, some sumptuously decorated. In 1647, Amalia van Solms (1602-75), Stadhouder Frederik Hendrik's widow, had the central hall of her new palace turned into a mausoleum for her husband (FIG. 20). Constantijn Huygens (1596-1687), the influential secretary to the Stadhouder, and the court architect Jacob van Campen (1595-1657) designed a decorative scheme that operated as a pictorial biography of Frederik Hendrik, painted from floor to ceiling by the Flemish Protestant Jacob Jordaens (1593-1678) and several other Dutch and Flemish artists. Rather than describing events, these paintings employed allegories to sing the praises of the talented, virtuous, and triumphant Stadhouder. The east wall, painted by Jordaens, provides the room's focal point, with the apotheosis of Frederik Hendrik on a triumphal chariot, accompanied by his

19. View of the doll's house of Petronella Oortmans-de la Court, c. 1670-90. Wood with miniature objects, 6'9" x 5'11½" x 29" (2.1 m x 1.8 m x 74 cm). Centraal Museum, Utrecht.

The owner and her husband were significant collectors of full-size paintings as well, readily available in their home town of Amsterdam.

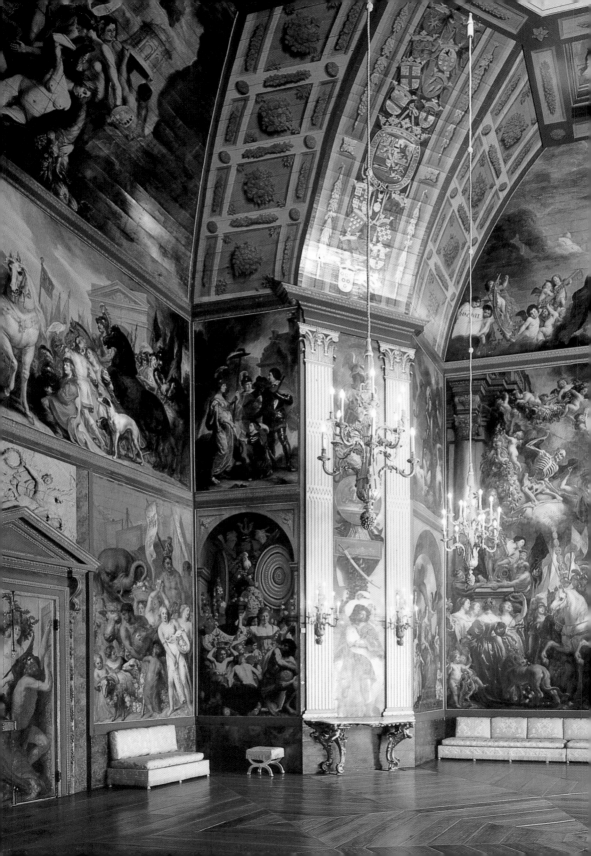

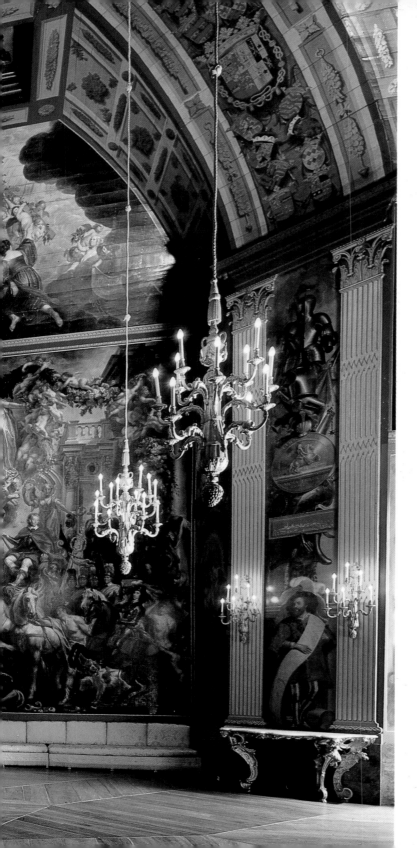

20. JACOB VAN CAMPEN, JACOB JORDAENS, AND OTHERS North and east walls of the Oranjezaal at Huis ten Bosch, The Hague, 1647-52. Oil on panel and canvas. Height of room: 62' (19 m); canvases on lower level extend upwards to a maximum of 27' (8.2 m).

The building was designed by Pieter Post, with the advice of his teacher Van Campen. The *Triumphal Procession of Frederik Hendrik* by Jordaens, oil on canvas, 24' x 24'6" (7.3 x 7.5 m) forms the focal point of the hall. The boards above represent the Stadhouder's ascension to heaven, and the canvases to the sides show various groups contributing to the procession. The court intended to reproduce the paintings in print, but plans came to nought, possibly because the States-General suspended the Stadhouder's office in this period.

21. JOHANNES VERMEER
Woman with Water Jug,
c. 1662. Oil on canvas,
18 x 16" (45.7 x 40.6 cm).
Metropolitan Museum of
Art, New York.

successor, Willem II. He is paraded as the creator and guarantor of Dutch peace and prosperity, symbolized by triumphal standards, olive branches, and cornucopias. His horses lead a procession that moves through triumphal arches painted along the lowest level of the walls in the room. Between the north and east walls, for example, figures carry the products of the East and West Indies like the spoils of war in Roman victory processions. Frederik Hendrik appears single-handedly responsible for the military triumphs and riches of the Republic. While the patron

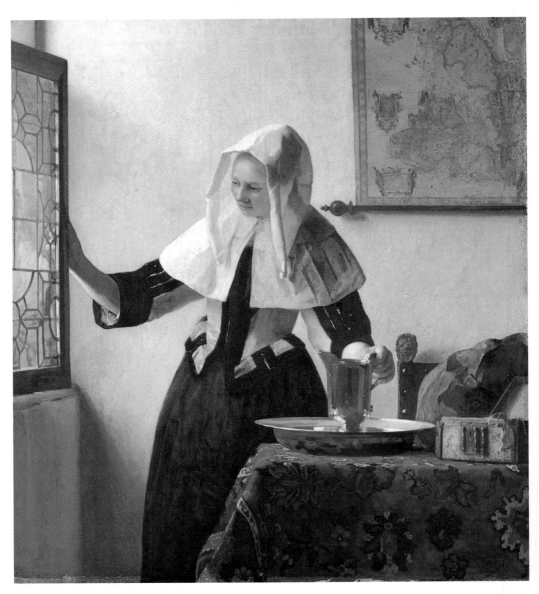

and her visitors must have delighted in deciphering the learned references, the room makes its most powerful impact through the sheer profusion of painted imagery. The creation of such an ensemble in a grand style was typical of international courts of the period, but it was unusual for the Republic, where the authority of the Stadhouder depended on the graces of the States-General. In its allegorical themes and exuberant style, the Oranjezaal sets out the political and cultural ambitions of the Orange court.

Outside the court, several painters enjoyed profitable relationships with collectors who might buy several paintings per year. Johannes Vermeer (FIG. 21) had an arrangement of this sort with the prominent investor Pieter van Ruijven (1624-74). Gerard Dou (1613-75) and his pupil Frans van Mieris (1635-81) received regular payments from two investors in Leiden for the first right of refusal on any painting they completed. There is no evidence that these patrons commissioned specific themes. They merely bought the right to buy any picture the master chose to make. More usually, customers went to a painter's workshop to buy a painting finished or in progress. Such works would be somewhat less expensive, as a painter would not want to make too costly a work without a guaranteed return. Painters also sold through art dealers, book and picture shops (FIG. 22), and yearly fairs. The latter offered the only occasion for anyone outside the guild to sell paintings in any town. Painters also tried to sell cheaply at public auctions and lotteries. Guilds sometimes participated in these sales but just as often fought them because they undercut prices.

22. SALOMON DE BRAY *Book and Picture Shop*, 1628. Pen and ink and wash on paper, 3 x 3" (7.6 x 7.6 cm). Rijksmuseum, Amsterdam.

As in other early modern industries, increasing demand on the open market caused further specialization of production, encouraging artists to concentrate on certain genres of pictures. Some printmakers and publishers specialized in reproductive prints after other works of art, and others might focus on landscapes, for example. In the sixteenth century such specialization had developed in Antwerp, then the Netherlandish center of pictorial production, but the proliferation of genres became more pronounced in the Republic. These genres included landscapes, cityscapes, portraits, "history paintings" based on biblical, classical or contemporary texts, animal paintings, still lifes, and paintings of everyday life. Confusingly, in the eighteenth century this last kind of painting came to be called "genre painting," even though it is only one

23. ABRAHAM BLOEMAERT
Adoration of the Magi,
c. 1623-24. Oil on canvas,
13'7" x 9'6" (4.2 x 2.9 m).
Musée de Peinture et de
Sculpture, Grenoble.

Bloemaert painted this
altarpiece, one of his
largest, for the church of
the Catholic order of the
Jesuits in Brussels, in the
Southern Netherlands.
Such commissions were
extremely rare in the Dutch
Republic. Bloemaert's
jubilant color and festive
pageantry befitted the
theme and answered the
Jesuits' need for a lively
backdrop to their main altar.

genre among many. In the seventeenth century, moreover, genre paintings were designated more precisely by themes, such as "merry company," "peasant fair," "Carnival," and "smoker." Most types of painting can be subdivided further: landscape encompasses skating scenes, Italianate views, and seascapes, and portraiture includes single portraits and groups, for example. Although these definitions are always somewhat artificial, seventeenth-century painters and owners seem to have worked in similar terms. The unwritten rules of a certain genre can help the modern viewer understand how conventional or innovative a picture was and they thereby open avenues for its interpretation.

It is difficult to associate preferences for certain pictorial genres with particular types of owners, but a few trends can be detected. All types of customers seem to have ordered portraits, from individual shopkeepers and artisans to the boards of local militias or commercial companies. In a few cases, collectors can be identified with specific themes. Large New Testament paintings were often painted for use in private Catholic churches. The Catholic painter Abraham Bloemaert (1564-1651), resident in predominantly Catholic Utrecht, painted spectacular altarpieces in a style reminiscent of sixteenth-century Italian painting (FIG. 23). Calvinist collectors were often especially interested in Old Testament paintings, as Calvin had advocated careful study of the biblical narrative. Jan Victors (1620-76?), who painted mostly Old Testament scenes, apparently made them primarily for Calvinist patrons (FIG. 24). In the 1620s and 1630s, aristocrats furthered a new vogue for particular kinds of history and portrait painting, of "pastoral" scenes involving the loves of shepherds and shepherdesses in lush, idealized landscapes. In 1635, four painters made a series of pastoral paintings for the Stadhouder's court, chronicling the popular story of Amaryllis and Mirtillo. In a scene contributed by Dirck van der Lisse (d. 1669), maidens play blind man's buff with the blindfolded shepherd Mirtillo (FIG. 25). The series ends with a kissing contest – the sort of subject that appealed to a courtly culture, in which pastoral romances were performed and recited. By mid-century, pastoral pictures had also become attractive to numerous burghers with aristocratic aspirations and interests in pastoral romance.

Collectors did not buy pictures exclusively for their decorative, artistic, or narrative merits. Several gathered objects, drawings, and prints primarily to amass knowledge about the world's geography, its flora and fauna, and its different cultures. In Amsterdam, the Catholic lawyer Laurens van der Hem (1621-78) took a grand loose-leaf atlas and had its maps hand-colored

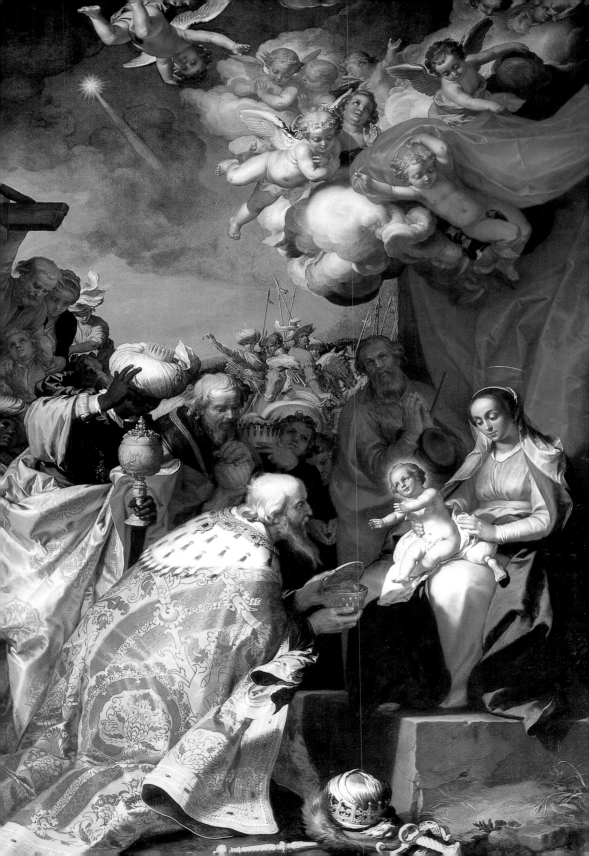

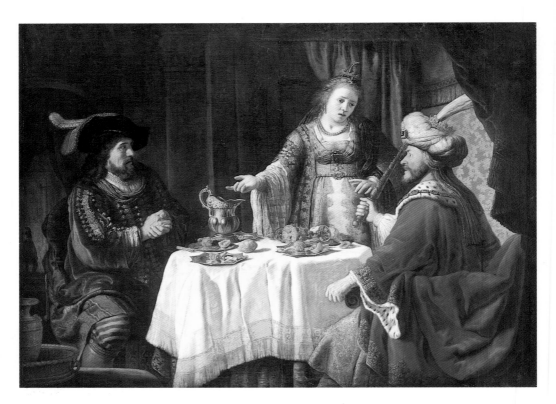

Above 24. Jan Victors *The Banquet of Esther and Ahasuerus*, 1640s. Oil on canvas, 5′6″ x 7′5″ (1.7 x 2.3 m). Staatliche Museen, Gemäldegalerie Alte Meister, Kassel.

The Jewish heroine Esther, wife of the Persian King Ahasuerus, notifies her husband of the plans of his advisor Haman, here seen at left, who has schemed to massacre the Jews in the Persian empire.

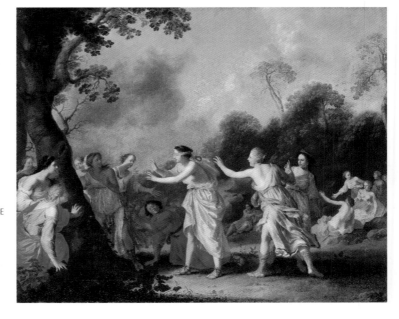

Right 25. Dirck van der Lisse *Blind Man's Buff*, 1635. Oil on canvas, 3′10″ x 4′7″ (1.2 x 1.4 m). Staatliche Schlösser und Gärten, Jagdschloss Grunewald, Berlin.

and bound (FIG. 26). Through the 1670s, he pasted in drawings and printed maps, portraits, landscapes, and historical scenes, to fill 29 volumes about the world and its history. Van der Hem enhanced this encyclopedic collection with 200 portfolios of works on paper and several thousand books. His bespoke atlas was sufficiently well known to attract distinguished international visitors. Its geographic range mirrored the reach of the Dutch trading empire around the world.

It has been suggested on good evidence that the marketing mechanisms of Dutch painters may have affected the techniques, and less directly the styles, of their works. The paintings of Vermeer, Gerard Dou, and Frans van Mieris, who had some secure income from patrons, are uncommonly elaborate and polished in technique and must have taken longer than average to paint (see FIG. 21). Their paintings fetched prices as high as several hundred guilders. Other painters, particularly landscape specialists who painted primarily for the open market, from the 1620s on developed new, simplified compositions and fluid, loose brushwork that left some of the ground showing (see FIG. 14). This style allowed them to paint more quickly and with fewer materials. Although these painters commanded lower prices than their more meticulous colleagues, perhaps averaging twenty guilders per picture, their revenues could still be substantial as their turnover might be high.

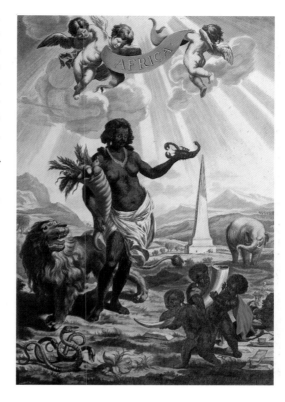

26. JEREMIAS FALCK (C. 1619-77) AFTER NICOLAES BERCHEM? *Africa*, c. 1662-77. Engraving and etching hand-colored by Dirk van Santen for the *Atlas van der Hem*, 17¹/₂ x 11¹/₄" (44.4 x 28.6 cm). Österreichische Nationalbibliothek, Vienna.

This title to the African section characterizes the continent and its people as "wild" and "natural": a scantily dressed woman, accompanied by a lion, an elephant, and snakes, presents the bounty of the African trade: gold, ivory, and produce. In unintended irony, she also represents a commercial staple: slaves bound for America.

The uncommonly successful early career of Rembrandt van Rijn (1606-69) lucidly exemplifies the many different aspects of artistic education, production, and marketing. Rembrandt attended the Latin school and, briefly, university in Leiden and then was apprenticed to a local painter. To gain special knowledge of history painting, he went to Amsterdam in 1624 for additional training with Pieter Lastman (1583-1633). Lastman had spent about four years in Italy, and after his return in 1607 had become the leading history painter in Amsterdam. Like many history painters active in Italy around the turn of the century, Lastman was concerned with clear narrative and plausible, if still imagined, historical settings and attributes. His *Paul and Barnabas at Lystra* of 1617 (FIG. 27) tells the story of the apostles who healed a lame man at Lystra.

27. PIETER LASTMAN
Paul and Barnabas at Lystra,
1617. Oil on panel, 23 x
45″ (58 x 114 cm).
Amsterdams Historisch
Museum.

The story of Paul and
Barnabas could serve as a
potent example of early
Christian resistance to
idolatry, the worship of
more than one god or of
images of God. This issue
was central to Reformed
theologians who attacked
Catholic rituals involving
images, relics, and incense
as idolatrous.

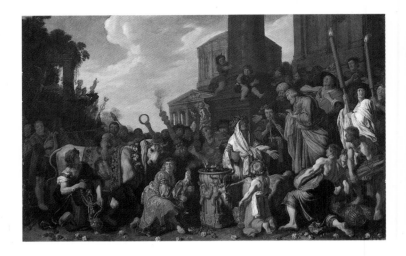

The inhabitants of the pagan town believed the foreigners to be
Jupiter and Mercury, and brought oxen to offer to them. Paul
and Barnabas ripped their clothes in fury and tried to prevent
the idolatrous sacrifice. Lastman shows Paul towards the upper
right, crossing his arms in refusal, and Barnabas just above him,
tearing his shirt. In their urgency to make the offering, the white-
robed priest and colorful throng have pushed aside the healed man
with his crutches. The temple of Jupiter in the background,
with the god's statue before it, further clarifies the story.

Rembrandt's production suggests that he learned much from
Lastman's narrative skills and recreations of historic events.
Back in Leiden as an independent master, he engaged in crea-
tive competition with Jan Lievens (1607-74), another promising
pupil of Lastman. Their earliest works are reminiscent of their
teacher's in their bright coloring and dramatic narrative. If Rem-
brandt and Lievens even shared a studio, as has been suggested,
this arrangement would have offered them financial as well as crea-
tive benefits in their difficult first years.

Soon Rembrandt met Constantijn Huygens, the Stadhouder's
secretary, who wrote knowledgeably about the arts (see FIG. 7, page
17). Huygens admired Rembrandt's history paintings and helped
him obtain commissions from the court for portraits and scenes of
Christ's suffering and crucifixion. Around 1631 Rembrandt moved
to Amsterdam, presumably because he saw opportunities in its
thriving market, which he knew from his apprenticeship with
Lastman (see FIG. 15). He must also have realized that this mar-
ket had a special appetite for his chosen specialities: portraiture
and history. Rembrandt's access to this market was initially
brokered by Hendrick Uylenburgh (1587-1661), a leading dealer

and artistic entrepreneur who lived in the heart of the city and obtained commissions for many young artists. With his help, Rembrandt took Amsterdam's portraiture market by storm, with portraits that his contemporaries described as uncannily lifelike. In the 1630s he also developed a lively, large-scale mode of history painting.

Rembrandt attracted many apprentices, who reportedly paid him as much as 100 guilders a year, and journeymen. These artists copied his works and collaborated on his paintings. He sold such works as his own and may even have allowed students to "sign" his works by imitating his signature. This practice marked paintings as products of his studio and was not forbidden, but as Rembrandt gained fame, collectors became more concerned to have works from his own hand. To cope with demand and to receive tuition income, Rembrandt may have had as many as a dozen painters working with him at a time.

Rembrandt's works, and those of his studio, had a clearly recognizable "look" in any given period. Thus, a patron commissioning a portrait in the 1640s might expect broad strokes of deep red, brown and white paint, and a quiet, balanced composition. Evidence indicates that one such sitter, the Amsterdam regent Jan Six (1618-1700), appreciated this style for its casual elegance and its visible marks of the artist's handiwork (FIG. 28). Six owned several copies of a famous sixteenth-century Italian book, *The Courtier* by Baldassare Castiglione (1478-1529), and the Dutch translation of 1662 was dedicated to him. Castiglione advocated an accomplished nonchalance of bearing, and he also described how different individuals develop distinctive styles according to their natural inclinations. Six may have liked Rembrandt's portrait style for its personal characteristics as well as its apparent facility, just as other collectors, including Constantijn Huygens, preferred the more finished look of other portrait painters.

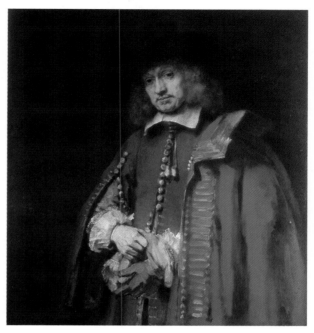

28. REMBRANDT
Jan Six, 1645. Oil on canvas, 3'8" x 3'4" (1.1 x 1 m). Private collection, Amsterdam.

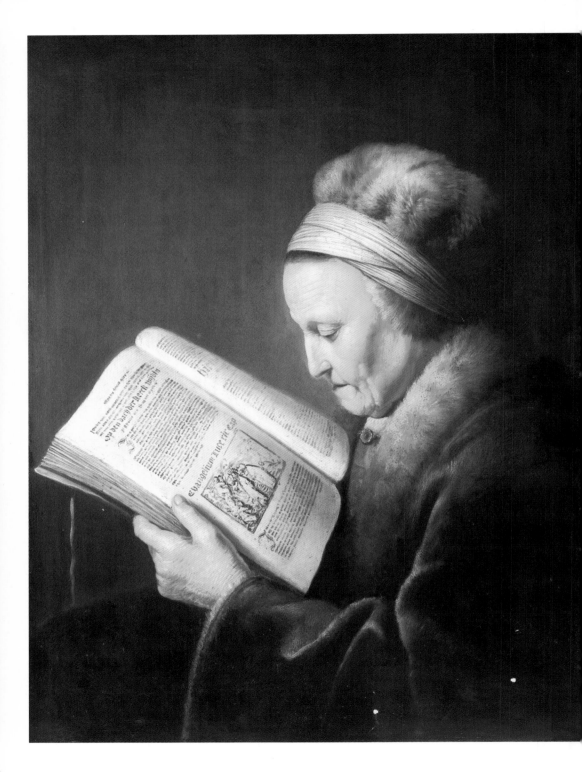

TWO

Texts and Images

G iven Calvinist distrust of the use of pictures in religious worship, the voluminous pictorial production of the Dutch Republic may seem surprising. But there are some solutions to this apparent contradiction, as Dutch texts and images produced and communicated knowledge in complementary ways that did not violate Calvinist proscriptions of an image cult.

Iconoclasm and the Privileged Word

In the sixteenth century, the Bible was a primary site of conflict between Protestant and Catholic theologians. While Luther and Calvin argued for faith based on a close understanding of scripture, made accessible to all by preachers and by vernacular printings of the Bible, Catholic leaders wished to restrict access by mediation through the priests who were among the few who could read the Latin and Greek Bible of the Catholic Church. Catholic theologians also upheld the intermediary roles of saints and the sacraments in the individual's path to salvation and actively propagated cults of the saints and the sacraments, encouraging the proliferation of their images, from cheap prints to lavish altarpieces. Calvinist preachers vehemently denounced such cults, contending that personal salvation depended on faith alone. They were particularly offended by the Catholic emphasis on a belief encouraged by visual representations of religious figures and dogma, and thus Calvinist churches rarely commissioned images for their houses of worship.

Moreover, in the sixteenth century the Protestant stance on images repeatedly occasioned waves of iconoclasm, violent and often ritualized attacks on paintings and sculpture in Catholic churches throughout northern Europe. In the Netherlands, a devastating iconoclast movement spread from town to town in 1566. As

29. GERARD DOU
Old Woman Reading, early 1630s. Oil on panel, 28 x 21¾" (71 x 55.5 cm). Rijksmuseum, Amsterdam.

The woman is reading about the entry of Jesus into Jericho, an episode from St. Luke's Gospel. The illustration shows the tax-collector Simon, who climbed into a tree to observe the event. Jesus, who is shown looking up at him, went to the man's house despite his disciples' objections to his visiting a tax collector, for the profession was considered corrupt. To Protestants, the story proved that sinners are saved by faith.

the Protestant churches organized themselves officially around the turn of the century such violence became more rare, but the image question continued to affect the production of art in the Netherlands. In 1610, the cathedral of 's-Hertogenbosch, a Catholic frontier city of the Spanish Netherlands, took advantage of the Truce to build an impressive choir loft, an architectural division between the nave and the choir (FIG. 30). Significantly, it replaced the rubble of a structure that had been damaged in the iconoclasm of 1566 and later burned down accidentally. With its profusion of sculpted saints and representations of Catholic charity, the new choir loft was a monument to the vitality of Catholicism in the city and to the legitimate role of sculpture in Catholic worship.

In the Protestant Republic, the once thriving sculpture industry contracted significantly, especially in comparison with the burgeoning production of pictures. Although iconoclasts had attacked paintings and sculpture alike, Calvinist agitators complained especially about sculpted images, and prints recording iconoclast attacks emphasize the destruction of sculptures. Apparently, opponents found statues particularly dangerous because their three-dimensionality enhanced the impression that the religious figures might be real. As many sixteenth-century statues were painted or executed in colorful stone, their effect could have been as startling as that of modern wax figures, particularly in dark churches lit through stained-glass windows and by candlelight.

Acknowledging the absence of significant Church patronage in the Northern Netherlands, several painters, most innovatively Pieter Saenredam (1597-1665), created a new genre of church painting that celebrates the clean walls of Protestant churches, virtually devoid of decoration (FIG. 31). In Calvinist churches the most important piece of furniture was the pulpit, from which preachers read and preached to the congregation. In Saenredam's *Interior of the Church of St. Bavo in Haarlem*, the pulpit leans against a distant pillar. This church interior belongs to one of the "neutral" genres of painting that Calvin had authorized for use in decoration and teaching rather than in religious ritual.

Rembrandt and his followers specialized in biblical scenes that cast great events in terms of recognizable human emotion, thereby enhancing their didactic value to contemporaries. One of his finest etchings, traditionally called *The Hundred Guilder Print,* presumably after the high price a dealer paid for it, thematizes Protestant approaches to religious representation (FIG. 32). Rembrandt showed Christ as if preaching, and the responses of his audience to his words, from intent listening and contemplation to argument and action. While *The Hundred Guilder Print* thus seems didactic,

Below and right 30. CoENRAET VAN NoRENBORCH AND OTHERS Roodloft from the Cathedral of St. John in 's-Hertogenbosch, sculpture and architecture, 1610-13. Victoria and Albert Museum, London.

The photograph was taken about 1866 by A.G. Schull, when the roodloft was still in the cathedral. The following year it was brought to the South Kensington Museum (now the Victoria and Albert Museum) in London. The statue of St. John the Evangelist (see right), patron saint of the cathedral, was sculpted by Hendrick de Keyser of Amsterdam. The Reformed Church to which he belonged ordered him to stop the work.

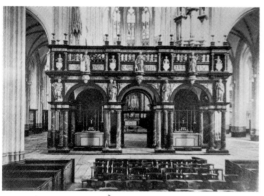

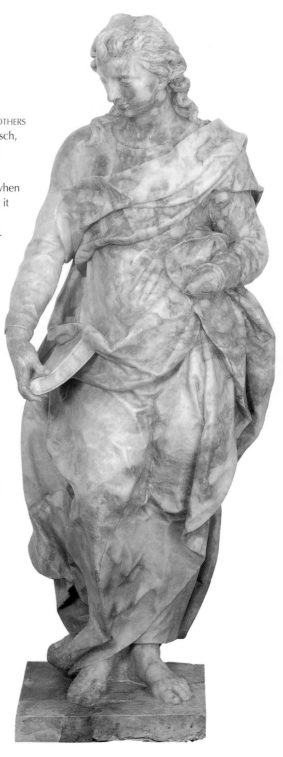

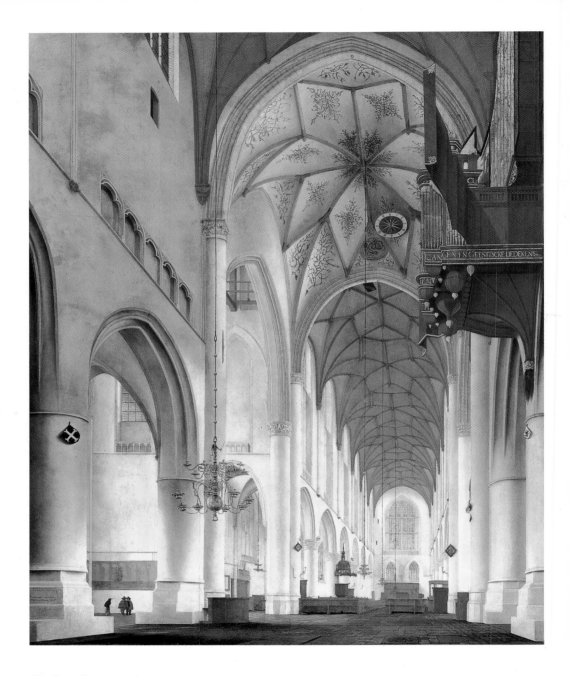

31. PIETER SAENREDAM
Interior of the Church of St. Bavo in Haarlem, 1648. Oil on panel, 6′7″ x 4′7″ (2 x 1.4 m). National Gallery of Scotland, Edinburgh.

The prominent organ displays biblical fragments exhorting worshipers to use music and songs to praise God and to teach Christian values. These references contribute, probably deliberately, to the Calvinist debate on organ music in services. While strict theologians considered music too frivolous, most churches continued to use organs.

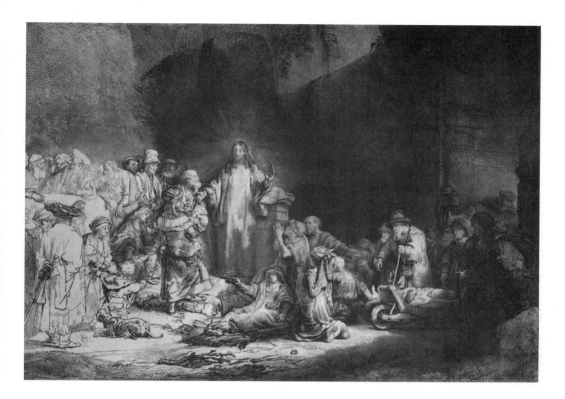

it also attests Rembrandt's ability to create original themes from traditional texts, using a highly personal print technique, varying from light, quirky line to deep, blurred shade, that calls attention to his hand. By conflating separate biblical events, Rembrandt also demonstrated an advantage of pictures: in one scene they can visualize what must be said sequentially in words. In this sense pictures often do speak a thousand words. The legendary price for the etching indicates that collectors may have appreciated this print as much for its artistry as for its messages, which could be heard without charge in churches.

Calvinists and the States-General jointly encouraged people to read the Bible and explanatory texts for themselves. At the request of the Synod of Dordrecht, the States-General financed one of the finest Dutch literary efforts: a new Dutch translation of the Bible, based on original readings of the Greek and Hebrew texts. The "States Bible" took two decades to produce and was published in 1637. In keeping with Calvinist arguments for reading the Bible and books on proper Christian behavior, painters frequently represented people holding or reading the Bible. In the early 1630s, Gerard Dou, one of Rembrandt's first pupils, painted an old woman reading a lectionary, a selection of biblical

32. REMBRANDT
The Hundred Guilder Print,
c. 1642-49. Etching,
drypoint, and engraving,
10½ x 15" (27 x 38 cm).
British Museum, London.

Evidence suggests that Rembrandt initially made this print as a gift, rather than for sale, perhaps to present to friends. His technique and interpretation of the theme are so distinctive that the work amounts to a summary demonstration of his art. Rembrandt conflated several statements by Christ from the Gospel of St. Matthew, grouping them around Christ's healing of the sick and his admonition "Suffer the little children to come unto me."

33. GERARD TERBORCH
Woman Reading a Letter,
early 1660s. Oil on canvas,
31 x 26³/₄" (79 x 68 cm).
Her Majesty Queen
Elizabeth II, London.

Terborch frequently
represented elegantly
dressed men and women
writing or reading letters,
often, as here, in the
company of servants, family
members, or friends quietly
awaiting the reader's
reactions. Well-to-do
burghers relished the
aristocratic social ritual of
the love letter.

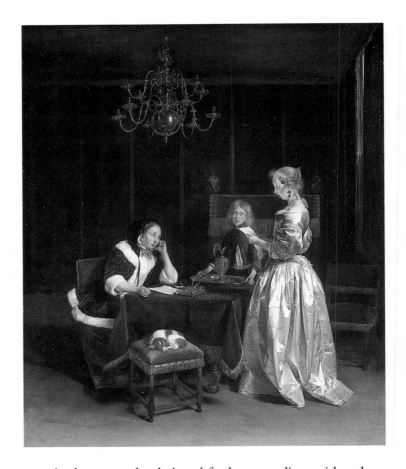

texts in the vernacular designed for home reading, with a clearly visible illustration to clarify the lessons (see FIG. 29, page 47). Although the Catholic Church had begun to issue these books in the sixteenth century, partly responding to similar Protestant efforts, the Calvinist Church, too, considered them suitable for domestic use. Dou represented the woman in profile, absorbed in the text and unaware of the viewer. Like Rembrandt in his etching, Dou paradoxically emphasized the primacy of the word and the visual powers of art at the same time, by showing an illustrated page and by painting so meticulously that he seems to have caught every wrinkle of skin and each hair of the fur coat.

Dou worked in Leiden, site of Holland's first university, and it is not surprising that many paintings made there show books or people reading. Although literacy levels are difficult to measure, contemporary comments and analysis of written records suggest that the Dutch community as a whole was relatively more literate than other European populations, though reading was probably

more prevalent than the ability to write. Many paintings show people reading or singing from books or writing and reading letters, spawning a subgenre of titillating love-letter paintings practiced in fine variations by Gerard Terborch (1617-81; FIG. 33). Dutch towns had vigorous publishing industries. In this respect, too, Amsterdam, Haarlem, and Leiden took over Antwerp's previous role. The most popular books had editions into the thousands of copies, very large given that the Dutch Republic had about 1.5 million inhabitants, and that books were shared in families and schools.

Words into Pictures

The integration of printed text and illustration in the lectionary represented by Dou is typical of many books made and read in the Republic. Numerous publications enlivened text with pictures, from single-leaf broadsheets with the latest news or jokes to histories of the Netherlands and scientific dissertations. Although printed illustrations could be made in a variety of techniques, including woodcut and etching, publishers favored engraving with the burin for its durability and sharp look (FIG. 34). To make an

34. HANS COLLAERT AFTER JAN VAN DER STRAET, ALSO CALLED STRADANUS
The Art of Copper Engraving, c. 1600. Engraving, 8 x 10½" (20.3 x 27.3 cm).

At right, a master engraver cuts a design into the copper plate. Assistants warm and smooth plates close to the center, and at left plates and paper are pulled through a press. After printing, the moist sheets are hung to dry.

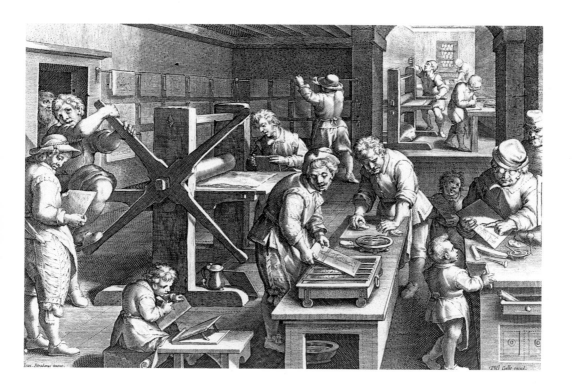

35. WILLEM VAN SWANENBURG AND CHRISTOFFEL VAN SICHEM I AFTER JACQUES DE GHEYN II *Sailing Cars*, 1603. Engraving, woodcut, and letterpress; engraved plates, 21¼ x 49½" (54 x 125.5 cm). Rijksmuseum, Amsterdam.

The large size of the print required that it be made from three different plates, labeled *a*, *b*, and *c* at lower right. The smaller sailing car to the right was used in a test drive. Simon Stevin, the car's designer, was also famous for his constructions of fortifications.

engraving, an artist uses a burin, a sharply pointed tool, to dig a design out of a copper plate, rubbing away the metal removed. This hard labor requires expert control, with the result that lines are sharply defined. The plate is inked and wiped clean, leaving the engraved lines full of ink and the rest of the plate bare. It is then rolled through the press with a piece of paper on top, so that the ink from the incised design is squeezed onto the paper to make an "impression" of the plate. The sharp lines can look particularly objective, and partly for this reason were favored for news prints, scientific illustrations, and reproductions of works of art. Publishers also printed illustrations in woodcut, a technique offering clear diagrammatic qualities. The woodcutter carves away the background of a woodcut design, creating the image in raised ridges on the woodblock. When the inked woodblock is rolled through a press, the design is transferred from the inked ridges onto the paper. The pressure on the raised design can easily cause damage, however, limiting the life of a woodblock to only several hundred copies, against a potential of thousands for the engraved plate. Copper plates can also be more easily recut when damage appears.

The most ambitious broadsheets often combined several print techniques, executed by one or more artists who might publish the print themselves or work for a publisher. A huge engraving of *Sailing Cars* is an illuminating example of a broadsheet (FIG. 35). The Stadhouder Maurits commissioned it from his friend Jacques de Gheyn II (1565-1629) to commemorate his two-hour ride along the coast in the wind-powered contraption, invented by his court engineer Simon Stevin (1548-1620). Willem van Swanenburg

(1581/82-1612) engraved the main image, and Christof-fel van Sichem I (1546-1624), who acted as publisher, added a woodcut diagram at the bottom. But despite the neutral look of the engraved image and the explana-tory function of the woodcut the print is no mere objec-tive report. A long poem not only records the car's miraculous engineering and speed, but also sings the praises of the windswept Dutch countryside and its lib-erator Maurits. The huge size of the print is unusual for a broadsheet, but it did not prevent it from being frequently republished. The States-General were so taken with the work that they paid De Gheyn 70 guilders for some colored impressions of it, and several pub-lishers reissued the print in subsequent decades. Clear-ly, the combined resources of picture and text con-veyed information, but they also made a powerful statement about Dutch ingenuity and military might.

De Gheyn was one of many painters who designed prints for the flourishing Dutch publishing industry. Some even wrote illustrated books. Adriaen van de Venne produced several book-length poems illustrated with his own engravings. His long descrip-tion of a fair in The Hague is equally lively in its texts and pic-tures, as the author himself boasted (FIG. 36). The title, *Scene of the Laughable World*, announces the book's pictorial character. Throughout the book, Van de Venne's comic texts and illustra-tions work together to ridicule socially undesirable situations, such as women dominating house husbands.

While most texts used illustrations sparingly, others required readers to study text and illustration together for full comprehen-sion. Emblem books in particular relied on such combined atten-tion. This genre of literature, which had been developed in Renais-sance Italy, attained exceptional currency in the Netherlands. The principle of the emblem book is simple: each of the emblems in a book consists of a motto (a pithy statement) and an engraving, linked by a poem that clarifies their relationship and comments on their relevance for a virtuous life (FIG. 37). In an emblem com-posed by Johan de Brune (1588-1658) and illustrated by Adriaen van de Venne, a woman wipes a baby's bottom under the motto "This body, what is it, but stink and dung?" An elaborate poem by the strict Calvinist De Brune instructs that human bodies, how-ever beautiful, are conceived in a base union of male and female flesh and are no more than such flesh, given to rotting and smelling. The implication of this human condition, which Dutch books hammered out again and again, is that earthly pursuits such as

36. ANONYMOUS (AFTER ADRIAEN VAN DE VENNE) *"John the Washer."* Engraving and letterpress from his *Tafereel van de Belacchende Werelt* (*Scene of the Laughable World*), 1635. Engraving, 3³/₄ x 5" (9.5 x 13 cm). Private collection.

Van de Venne's text ridicules the distinction between a man's public dignity and his private inability to dominate his wife. By bending over to execute his wife's orders, this man assumes a "feminine" role, according to seventeenth-century treatises on domestic management. The scolding and undecorous pose of the woman would have been understood as too aggressively "masculine," under the same code.

37. Willem de Passe
(1598-c. 1637) after
Adriaen van de Venne
*This Body, What Is It, But
Stink and Dung?* Emblem III
from Johan de Brune,
Emblemata of Zinne-Werck
(*Emblems or Meaning-
Work*), 1624. Engraving, 3 x
4¹/₂" (7.6 x 11.4 cm). Private
collection.

The explanatory text of the
emblem takes up five more
pages. De Brune's work is
one of the most
meticulously produced
Dutch emblem books, but
its elevated style and ideas
made it less suitable for
wide consumption than
simpler emblem books.

human love are futile. Seen on their own, the picture and the motto appear like a riddle, and part of the pleasure for well-prepared readers would have been teasing out meanings before reading the explanation.

Emblematic pictures could include difficult allegorical references, understandable only to educated readers, but in the seventeenth century they often included plain objects or scenes from everyday life, as in De Brune's example. They thereby resemble contemporary genre paintings, and it has often been pointed out that emblem books offer an interpretive context for such paintings of "real life." Adriaen van Ostade's *Alchemist* of 1661 offers an example (FIG. 38). Hunched in front of his fire, the alchemist is trying to turn base materials into gold. In the background a woman, probably the alchemist's wife, is wiping her baby's bottom. A seventeenth-century viewer would have been aware of the thought that, in the grand scheme of creation, human endeavors were comparable in significance to the smell of a baby's bottom, as De Brune's emblem claimed. The motif is apt for the theme of the alchemist, not only because a baby's excrement might remind viewers of the base materials used by the alchemist, but also because alchemy was generally condemned as vainglorious folly, offensive to God's prerogative in the creation of matter and laughable for its disastrous financial consequences, suggested by the shabby room.

The discovery of such correspondences between pictures and emblem books or other illustrated texts has led to new insights, but it has also tended to reduce the paintings to single messages. While seventeenth-century viewers undoubtedly derived lessons from such pictures, and pleasure at being able to decipher them, they also valued paintings for qualities such as an artful look of reality, tight narrative structure, convincing emotional representation, or impressive display of classical style. Moreover, the use of emblems to interpret pictures works better for some paintings than for others. In Van Ostade's *Alchemist*, for example, the process of perusing the room and eventually discovering a significant reference in the background resembles that of deciphering the relation between emblematic image and motto. But if viewers would stop at the emblematic smell, they might miss an ironic parallel implied by Van Ostade: like the alchemist, the painter turns base materials into precious objects, including this painting.

Other paintings give too little information for fruitful emblematic investigation, or too much: many objects could refer to

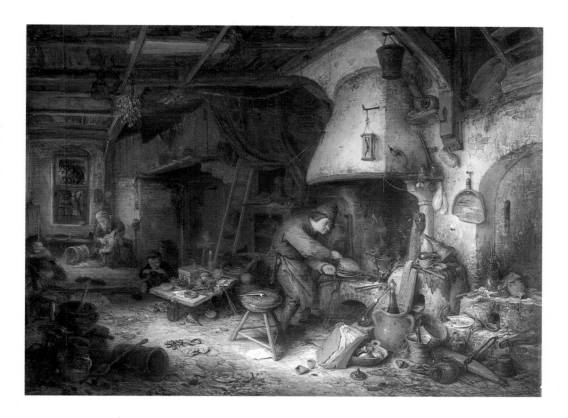

myriad, even contradictory ideas. It then becomes impossible to prove that an object "means" one thing and not another. Seventeenth-century readers recognized and relished such ambiguity. In his *Scene of the Laughable World*, Van de Venne warned readers that his book, like the world, was full of all sorts of situations and that readers should make up their own minds about it. If they did not appreciate his text, he admonished, they should look aside. This was sly advice, for to the side of his main text Van de Venne printed marginal notes that add riddles, moralizing comments, and proverbs for the reader to contemplate (see FIG. 36). The proliferation of these additional texts, not unlike the profusion of items in genre painting, does not always clarify "the" meaning of the text and even multiplies the possible readings. The structure of Van de Venne's poem and of many genre paintings suggests that if we look too hard for one, and only one, meaning, we probably misrepresent the multiple ways in which paintings and texts were seen, read, and enjoyed. Nor does a closed interpretation allow for the possibility, especially in the case of cheaper works, that viewers of different means, religion, education, and gender might have various responses to one image.

38. ADRIAEN VAN OSTADE *Alchemist*, 1661. Oil on panel, 13⅜" x 17¾" (34 x 45.2 cm). National Gallery, London.

The dilapidated state of the interior is presumably the consequence of the alchemist's foolish business venture. Such insolvency was satirized vigorously in the Republic, dependent as the state was on the financial responsibility and high productivity of a broad middle class.

39. JAN VAN DER HEYDEN
Room Corner with Curiosities, 1712. Oil on canvas, 29 x 25" (74 x 63.5 cm). Szépmüvészeti Múzeum, Budapest.

The objects assembled recall the varied contents of the *Atlas van der Hem* (see FIG. 26). As a model collection it includes cartographic objects, a Bible, an Italian history painting, natural history (the armadillo carcass and ivory and tortoiseshell in the cabinet), and exotic artifacts (Smyrna carpet, Chinese silk cloth, and Japanese ceremonial sword).

Texts appeared as frequently within images as pictures were placed with texts. Like their counterparts elsewhere, many seventeenth-century Dutch artists signed and dated their works. A few medieval sculptors or manuscript painters had signed their works, but the signing of pictures as standard practice was a recent development in the Netherlands. Although it may now seem a self-evident procedure, the introduction of signatures and dates on paintings had significant effects on viewing pictures. The inscription of the artist's name on a picture calls attention to the making of the image and thus disturbs the illusion that the painting is a simple, faithful record of reality. Perhaps aware of that effect, Pieter Saenredam often countered it by inscribing his name as if it were graffiti on a column in a church, and by recording the precise location and date as guarantee that he personally recorded the scene: "This is the Cathedral great church of Haerlem in Hollandt. Pieter Saenredam finished painting this, the 27th of February 1648" (see FIG. 31). As in legal documents, a signature also had the function of claiming the initial ownership of the work by the master. Even if he or she had not painted all of the picture, the signature was a guarantee to the customer that the work had come from a particular workshop.

Painters and printmakers also inscribed texts to convey information about the themes of their images. Portraits often give the sitters' ages and occasionally their names, thus verifying that the work records a particular person at a specific time. Such information reminds the viewer of the capacity of art to preserve life by commemoration. Like signatures on pictures, the making of portraits in the sense of records of specific people had become widespread Netherlandish practice only in the fifteenth century. Both developments indicate a new European understanding of personal identity, discussed further in chapter five.

Many other types of images included texts, especially still lifes and genre paintings. In his *Room Corner with Curiosities* of 1712, Jan van der Heyden (1637–1712) arranged books, globes, and fine objects from foreign cultures as a miniature collection, apparently in use by its owner, who has left open an atlas and a Bible at right (FIG. 39). The Bible is opened to the beginning of Ecclesiastes, one of the gravest Old Testament books, with the opening words "Vanity of vanities, all is vanity." Dutch preachers, writers, and still-life painters frequently cited this text to underscore the vanity, in the sense of futility, of earthly goods and pursuits. The text was so well known that it gave its name to a subgenre of "vanitas still lifes," filled with objects to mark the transience of life. Ironically, Van der Heyden's still-life collection uses one of

its books to relativize the vanity of collecting, but at the same time this jeweled painting epitomizes and praises that endeavor, and art's ability to make it last in extreme verisimilitude.

Of all genre painters, Jan Steen most often used texts to gloss his pictures. The title proverb of his *In Luxury, Look Out* guides the viewer, setting up a relation between text and picture that resembles that in emblems (see FIG. 3). Often represented texts comment on pictures less emblematically. Still lifes could include books by famous Dutch poets or eulogies on naval heroes, thereby celebrating their contributions to the Republic's literature and history. Like seemingly emblematic attributes in genre paintings, inscribed texts occasionally do not clarify a picture's meanings but rather destabilize them by offering numerous possibilities, as do the marginal texts in Van de Venne's *Scene of the Laughable World*.

Some writers and artists even blurred the border between picture-making and writing. Early in the century, schoolmasters and engravers turned handwriting into a pictorial genre of its own, in calligraphic exercises that indicate both learning and extreme manual control. A handwriting manual by Jan van de Velde (1569-1623) offers intricate designs that attest to the

40. SIMON FRISIUS AFTER JAN VAN DE VELDE Dedication page for *Spieghel der Schrijfkonste* (*Mirror of the Art of Writing*), 1605. Engraving, 8¼ x 12½" (21 x 32 cm). Rijksmuseum, Amsterdam.

skills of the author as well as those of the engraver Simon Frisius (c. 1580-1629), who copied his designs in copper (FIG. 40). Perhaps not accidentally, these spectacular celebrations of writing and its reproduction in print were developed in a period of European self-consciousness about literacy and printing as feats that distinguished European civilization from the cultures of Africa and the New World. These claims unconsciously enabled Europeans to justify their increasing efforts to control foreign lands and labor. Indeed, missionaries genuinely thought of their efforts to bring European writing to the "savages" as God-given tasks.

Painters and the Genres of Literature and Art

In 1604, Karel van Mander published the first Netherlandish treatise on painting and painters, simply called the *Schilder-Boeck* (*Painting-Book*). It appeared in Haarlem, a leading center of pictorial and textual production. Van Mander had come to the North from Antwerp after 1585. In Haarlem he had been one of the

founders of the first, casual Dutch academy. His elegant title-page (FIG. 41) signals his awareness of the calligraphic innovations of Jan van de Velde, for whose manual he created the title illustration. His book has three parts: a long introductory poem teaching young painters the genres and techniques of painting; prose biographies of Italian, German, and Netherlandish artists; and an explanation of one of the most famous ancient texts, Ovid's *Metamorphoses*. Van Mander's intended audience comprised "painters, lovers of art and poets, also all ranks of people." To "lovers of art" and to modern art historians the theoretical poem and the biographies have been of the greatest interest. To many painters, however, the explanation of Ovid must have been more useful. The *Metamorphoses* offered painters a treasury of romantic and adventurous stories about the classical gods and heroic mortals; indeed, most Dutch mythological paintings were based on this book and explanations of it. Ovidian themes were favored especially in Haarlem and Utrecht, in the first half of the century. The informal academic activities in both towns may have stimulated that preference.

Van Mander and his Haarlem colleagues must have been among the more erudite seventeenth-century artists, but many painters knew and consulted a wide range of texts. History painters read the Bible, and perhaps the history of the Jews by Flavius Josephus (AD 37-100?), which could clarify biblical stories. Most artists knew the most famous Renaissance compendium of allegorical imagery, the *Iconologia* by Cesare Ripa (c. 1560-c. 1623), published in Dutch translation in 1644. Ripa gave explicit instructions on the proper attributes and appearance of all manner of personifications, from fidelity and laughter to agriculture and painting herself.

41. JACOB MATHAM AFTER KAREL VAN MANDER Engraved title-page to *Het Schilder-Boeck (Painting-Book)*, 1604. 7 x 5" (18 x 13 cm). Private collection.

Some painters wrote their own poetry and plays. From the fifteenth century on, Netherlandish artists had often belonged to local literary societies, known as chambers of rhetoricians. These amateur writers, named for the basis of their craft in ancient rhetoric, produced plays and poems in three genres: allegorical-religious, amorous, and comic. Many of their products were ephemeral, meant for special occasions, but printed records of rhetoricians' festivals show a high level of literary sophistication. In the course of the seventeenth century, however, literary and theatrical production gradually became the preserve of professional authors and actors, and the chambers of rhetoricians declined.

42. JAN STEEN
Doctor's Visit, c. 1658-62. Oil on panel, 19¼ x 16½" (49 x 42 cm). Apsley House, London.

The melodramatic ailment of the patient is mocked as much as the pretentious demeanor of the doctor, who pontificates but may be missing the true problem. Steen made the point, a common motif of comedies, by giving the doctor an outmoded, perhaps theatrical costume, by letting the boy Cupid smile knowingly at the viewer, and by inserting a famous comic painting, Frans Hals's *Jester Pickle-Herring,* at top right. Contemporary jokes also ridiculed doctors for their inability to diagnose pregnancy, a condition here indicated by the mythic pregnancy test of a ribbon dipped in urine, smoldering in the brazier.

Although many painters still belonged, particularly in Haarlem, some made fun of the rhetoricians in paintings, just as poets ridiculed them in texts. Such representations of rhetoricians as outmoded suggest that painters kept abreast of literary developments. Moreover, painters who wrote about art, such as Van Mander and Van de Venne, frequently compared painting to poetry, in a comparison inherited from antique literature and Italian art theory. Leading poets, such as Joost van den Vondel (1587-1679) and Jan Vos (c. 1620-67), supported the analogy, calling painting speaking poetry and poetry mute painting.

While genre paintings can resemble emblematic texts in structure and motifs, other literary genres bear meaningful comparison with types of painting as well. Genre paintings also share characteristics with domestic conduct books, the most popular of which were written by Jacob Cats (1577-1660) and illustrated by Adriaen van de Venne. More straightforward than emblem books, Cats' long texts in simple verse prescribe proper ways of Christian courtship, marriage, child rearing, and household management. To make his points, he drew on biblical texts, classical history, mythology, and examples from daily life, including his own experiences. This accessible use of literary and theological sources was a common strategy of genre painting. Jan Steen, for example, embellished such a familiar event as a doctor's visit to a young maiden with classical references to the nature of the patient's discomfort (FIG. 42). Directly above the swooning patient hangs an Italianate painting of Venus and Adonis, while in the left foreground a boy strings his toy bow. A viewer with the barest classical education would have recognized the lad as Cupid, the notorious son of Venus who wounds men and women with his arrows, thereby making them lovesick for a frequently unattainable love. These clever references not only let Steen tell an entertaining joke about doctors and lovesick women but also let him display his ingenuity in a meticulously executed work.

Netherlandish literary theorists in the Renaissance had created a ranking of literature following classical poetic theory. At the top they placed poems and tragedies based on historical events, taken from mythology or the Bible. Tragic literature represented people as better and larger than life, speaking with uncommon eloquence and experiencing the deepest emotions. Comedy, representing people as they are and speak, in all their follies and foibles, was considered a lesser task. Farce, which caricatured people and was less tightly structured than comedy, was ranked even lower. During the Renaissance new genres evolved, including pastoral poems on the rustic loves of shepherds and shepherdesses.

43. CORNELIS CORNELISZ, ALSO CALLED CORNELIS VAN HAARLEM *Wedding of Peleus and Thetis*, 1593. Oil on canvas, 7'8" x 13'7" (2.4 x 4.2 m). Frans Halsmuseum, Haarlem.

The Haarlem government commissioned this painting to decorate a guesthouse for the Orange family and other dignitaries. The painting's reference to the beginnings of the Trojan War presented an impressive reminder that even trivial discord causes devastating wars. This was a topical message in Haarlem, which had suffered debilitating defeat in a Spanish siege of 1573. The work also showcased Haarlem's patronage of sophisticated international history painting.

In 1678, Rembrandt's pupil Samuel van Hoogstraten (1627-78) tried to codify a similar hierarchy of the genres in pictures in his treatise on painting. He reserved the "third and highest rank" for history paintings that "show the noblest actions and intentions of rational beings." The second tier of painters specialized in "cabinet pieces," smaller works on themes from pastoral romance to comic scenes, thus encompassing what are now called landscape and genre paintings. On the lowest rung were the still-life painters, the "foot soldiers in the army of art." Portraiture, which Van Mander had considered an ill-paid, lowly trade, could straddle the categories. On the one hand it imitated life too plainly, not forcing artists to exercise their imagination in the way history paintings did. On the other, portraits, like history paintings, represented human figures that could serve exemplary functions. Ironically, some of

the "lower" types of painting, such as portraiture and finely paint-
ed genre and still life, were profitable and made artists famous.
Rembrandt, for example, willingly made highly paid portraits
throughout his career.

 Although most artists may not have been concerned about the
ranking of their genres, analysis of literary genres can help mod-
ern viewers understand related pictorial ones. Associated with the
literary genres were modes of speech or rhetoric. Tragic literature
typically used an elevated rhetorical mode and rather idealized
characters to represent grand events. History painting had pic-
torial equivalents for such themes and rhetoric. For example,
history paintings are on average (though certainly not always) larg-
er than paintings of other types. In the *Wedding of Peleus and Thetis*
of 1593, depicting events leading up to the Trojan War, Cornelis

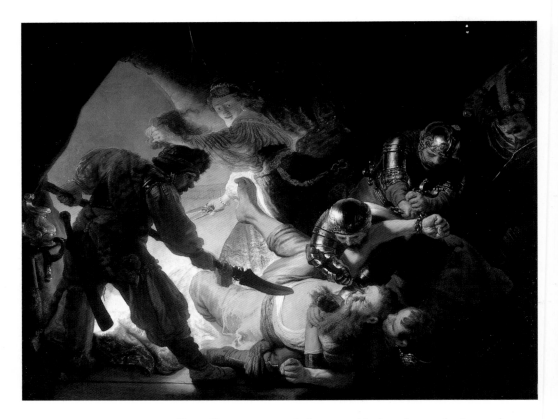

44. REMBRANDT
The Blinding of Samson,
1636. Oil on canvas, 6'5"
x 8'8" (1.9 x 2.6 m).
Städelsches Kunstinstitut,
Frankfurt-am-Main.

In 1639, Rembrandt offered
Constantijn Huygens a large
painting, to thank him for
arranging a commission
from the Stadhouder and to
apologize for his tardiness
in completing it. The
Samson may have been this
gift. Although gruesome, it
would have allowed
Rembrandt to advertise his
talents as an expressive,
large-scale history painter.

Cornelisz represented the assembled gods as naked muscle-men and soft-skinned women, in endlessly varied poses (FIG. 43). Their idealized, heroic bodies befit their immortality and the ominous event they witness. These figures were clearly based on drawings after the nude which Cornelisz could have made in the small academy in Haarlem. His grand style would have reminded knowledgeable viewers of the history painting of the Italian Renaissance, specifically of Michelangelo (1475-1564) and his followers, and of the praise for idealized nudity and difficult poses in sophisticated art theory. These elements would obviously be out of place in genre painting or most portraiture.

History paintings by Rembrandt and his students did not privilege the idealized, heroic nude in the same manner, but they often represented dramatic turning-points in the narrative, much like seventeenth-century tragedies. Rembrandt's *The Blinding of Samson,* painted in 1636, depicts the gruesome moment of blinding, the drops of blood leaping from the eye of the screaming, contorted man (FIG. 44). Rushing out of the cavernous room, Delilah carries off the hair she has cut off, which was the source of Samson's strength. This reference to several events within one

painting resembles another technique of tragedy, by which protagonists recall seminal events in dramatic dialogues.

In contrast, genre scenes are often more ambiguous, as they depict general situations rather than specific moments. Although comic plays had a narrative sequence, they allowed humorous scenes less directly related to the plot to sketch characters and occasions. Comic poems often gave rambling descriptions of crowds of peasants or burghers at markets or feasts, in "low" dialect and with minimal concern for plot. These texts, of which Adriaen van de Venne's *Scene of the Laughable World* is a fine example, evoke popular genre themes such as the *Peasant Fair* popularized especially by David Vinckboons (1576-1632?), a Flemish émigré to Amsterdam (FIG. 45). In Vinckboons's painting, peasants carouse in a village. The viewer may linger on the individual vignettes of drinking, laughing, and dancing without looking for the central narrative that tends to structure history paintings.

Like pastoral poems and plays, pastoral paintings are often set in an idyllic, not specifically defined landscape, grown with lusher vegetation and bathed in a more splendid light than that seen in the Netherlands (see FIG. 25). As in other history paintings, the faces of pastoral protagonists are idealized, and their dress is imaginary. Theorists explicitly distinguished between *antijckse* and *moderne* modes of costume and props, the antique being proper to all history painting and the modern for genre. Portraits usually represented sitters in clothes of their own time, but aristocratic and affluent customers occasionally chose pastoral guises.

It is more difficult to relate landscape paintings to Dutch literature, although both Van Mander and Van de Venne tried to evoke the Dutch scene in their writings, and Constantijn Huygens wrote a paean to his Dutch country house. Such texts were indebted to Italian and classical models, however, and did not really describe the landscape with the apparent exactitude of Dutch paintings. It is in landscapes, city views, and church interiors that Dutch pictures most obviously convey information and moods for which no literary equivalents exist (see FIG. 46). For reasons not entirely understood, Dutch culture spoke of its local scene with greater originality through pictures than in words.

The sophisticated relations between Dutch texts and pictures imply considerable learning on the part of artists and viewers. The high level of education available to middle-class citizens allows postulation of such a community of artists and beholders. The vigorous circulation of pictures in the Republic suggests that many of these viewers were visually literate as well, attuned to the special pleasures of pictorial representation.

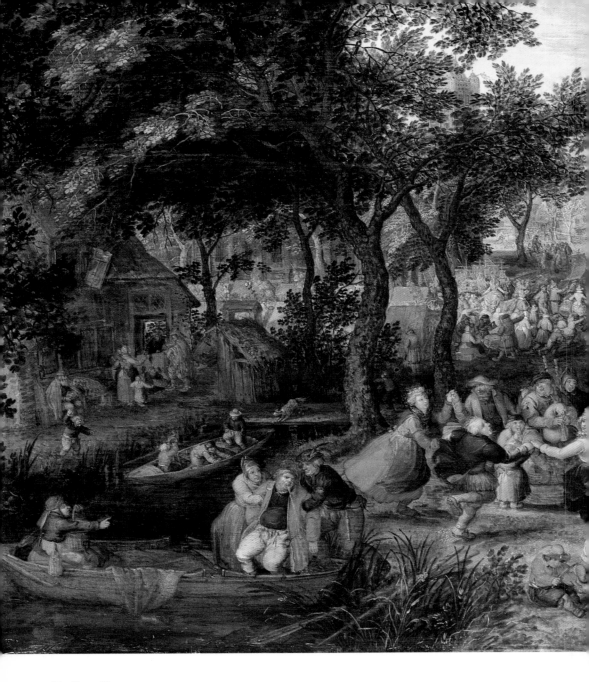

45. DAVID VINCKBOONS

Peasant Fair, c. 1601-10. Oil on panel, 20 x 36" (51 x 91.5 cm). Staatliche Kunstsammlungen, Gemäldegalerie Alte Meister, Dresden.

Vinckboons's swirling composition, with its wealth of descriptive detail, and bulging, neckless peasant bodies, constitutes a "low" rhetorical mode appropriate to the comic peasant genre. The peasants dancing, guzzling, and vomiting offered unproblematic viewing pleasure to urban collectors, as they form a harmless image of communal village pleasures, seen from above.

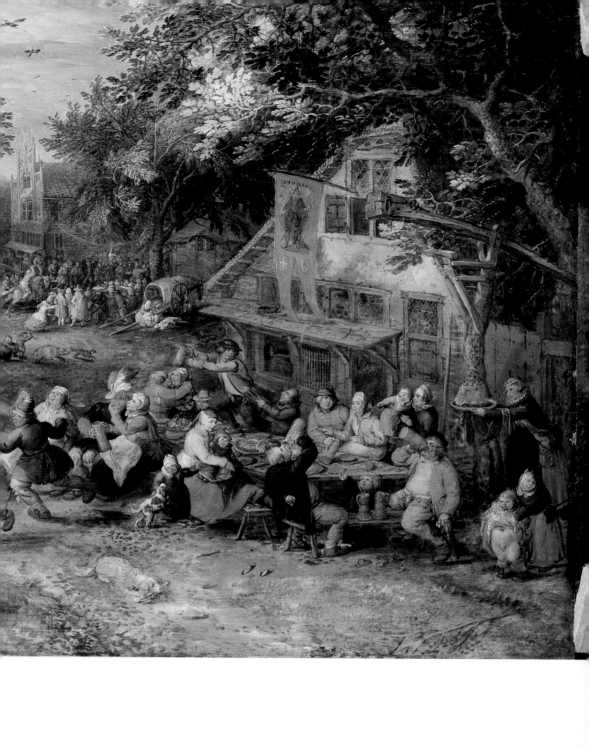

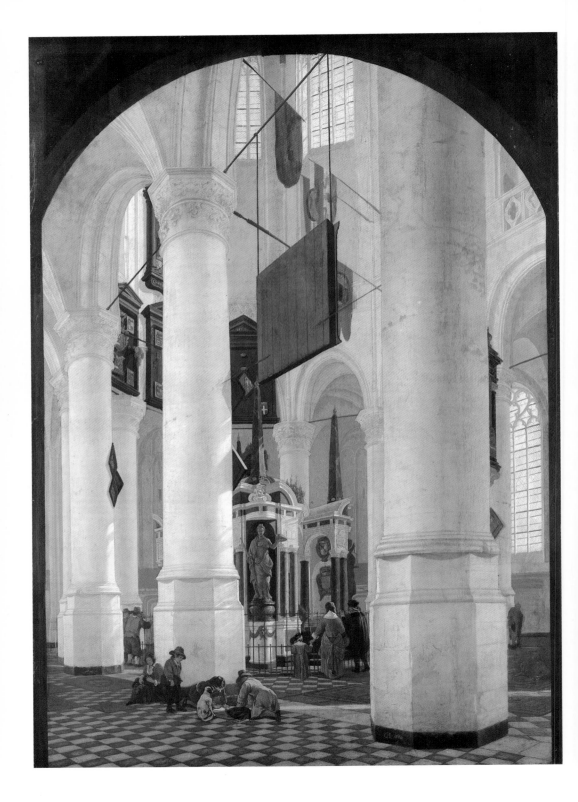

THREE

Virtual Realities

Observers have always noted the uncannily real effect of many seventeenth-century Dutch paintings. Because of their verisimilitude, these pictures have often been considered uncommonly truthful and honest depictions of Dutch life. This chapter addresses the status of "realism" for seventeenth-century artists and viewers, by examining the pictorial means that suggest reality and the themes represented with them.

Realist Strategies

For all its photographic effect, Vermeer's *View of Delft* is no instant image of the city. This point applies to all seventeenth-century landscape paintings. Painters did not paint outside as Impressionists were to do in the nineteenth century. The painting process in the studio required hours, days, even months and years. How, then, did Dutch painters forge their apparent transcriptions of the local scene?

Central to all pictorial production was drawing *naer het leven*, from life. In his *Schilder-Boeck*, Karel van Mander exhorted landscape painters to seize the day and wander out to sketch. Many Dutch landscapists did draw extensively, occasionally going on journeys for this purpose along the coast and the great rivers or to Germany, Switzerland, and Italy. More than a thousand surviving drawings by the prolific painter Jan van Goyen (1596-1656) range from the slightest chalk sketches, many preserved in sketchbooks, to elaborate scenes with added watercolor. While most of them were preparatory to paintings, their high survival rate indicates that collectors must also have appreciated them as independent works. In 1646, Van Goyen made numerous drawings of Scheveningen, a fishing town on the North Sea coast, which he then used for paintings (FIGS 47 and 48). His lively beach painting still offers the impression of spontaneous transcription, but he

46. GERARD HOUCKGEEST
New Church at Delft with the Tomb of Willem I, 1650. Oil on panel, 49 x 35″ (125 x 89 cm). Hamburger Kunsthalle.

Above 47. JAN VAN GOYEN
Beach at Scheveningen,
1646. Oil on canvas, 36¼
x 42½" (92.1 x 108 cm).
Collection Thyssen-
Bornemisza, Madrid.

More emphatically than in
his drawings, Van Goyen
stressed the productive
bustle of the successful
fishing port.

Right 48. JAN VAN GOYEN
Beach at Scheveningen,
1646. Black chalk and gray
wash on paper, 7 x 11"
(17.5 x 27.5 cm). Musée du
Louvre, Paris.

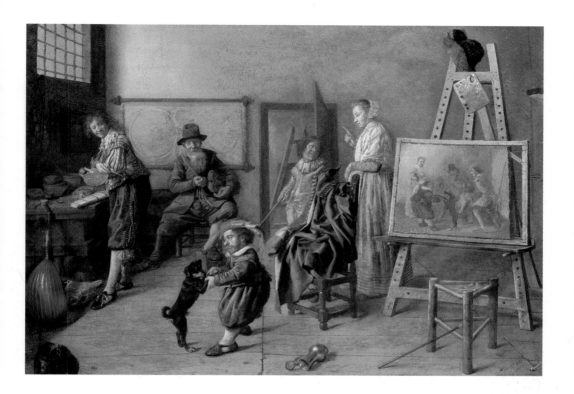

dramatized his drawings by raising the dunes and accentuating the cloud pattern. Most astounding is the apparent veracity of light filtered through packed clouds. Van Goyen's rather monochrome drawings could only approximate such a lifelike atmosphere, and he must have created it in the studio from a remembered, mental image. Such painting *uyt den gheest*, from the mind, was considered at least as important as drawing from life.

Both imitative processes, *naer het leven* and *uyt den gheest*, worked together in other genres as well. Portrait painters might sketch sitters in their homes, working out costume, setting, and other details later, in the studio. A genre painter would draw after models, usually in the studio, and compose a painting on the basis of his studies and by reference to paintings or prints of similar themes. Jan Miense Molenaer wittily thematized the process of painting such works, in a picture (FIG. 49) of a painter painting a picture of people around a jolly musician, a genre of painting that became popular in Haarlem in the 1620s. By representing the colorful characters as if taking a break while the painter prepares another palette, Molenaer emphasized the artificiality of the musical company genre, a kind of painting that can seem especially lifelike in its exuberance.

49. JAN MIENSE MOLENAER *A Painter in His Studio, Painting a Musical Company*, 1631. Oil on canvas, 34 x 50" (86 x 127 cm). Staatliche Museen, Bodemuseum, Berlin.

Molenaer seems to comment on his own pictorial practice, as he frequently represented musical companies. The comic character of that genre and of this picture is signalled by the dwarf and the monkey, stock figures of comedy. Many self-portraits and paintings of studios featured musical instruments, as allusions to the inspiring qualities of music.

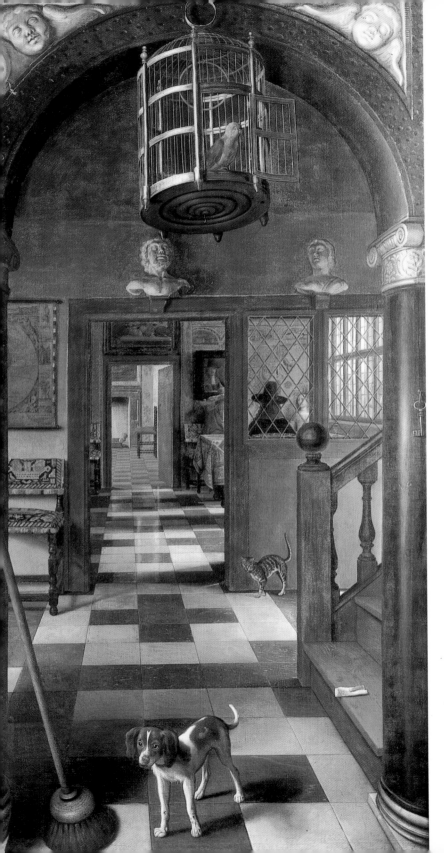

50. SAMUEL VAN
HOOGSTRATEN
View of a Corridor,
1662. Oil on canvas,
8'6" x 4'5" (2.6 x 1.4 m).
National Trust, Dyrham
Park.

Imaginary lines drawn
along the pavement
tiles receding to the
background seem to
meet on the inside of
the fireplace, at top
right. This one-point
perspective construction
creates a convincing
sequence of rooms.

Painters of church and house interiors engaged in similar practices, though more directly informed by geometrical studies that allowed them to create lucidly constructed spaces. Some painters used "classic" one-point perspective, recommended by Karel van Mander, in which all lines leading from the picture surface into the space seem to converge in one point, as in Samuel van Hoogstraten's *View of a Corridor* (FIG. 50). After he left Rembrandt's studio, Van Hoogstraten perfected and recorded his knowledge of perspective, which he called *zichtkunst*, "sight art," in his paintings and in his treatise of 1678. As theorists noted, one-point perspective can make a picture surface resemble a window or door through which the world is seen in deceptive depth. The pictorial space of such painting belies the two-dimensionality of the surface on which it is painted. Dutch artists frequently used a variant of this system, a two-point perspective structure in which the receding lines seem to converge in two points at the left and the right of the picture. In 1650, Gerard Houckgeest (c. 1600–61) used such a system of perspective to make the interior of the New Church at Delft recede dramatically to left and right (see FIG. 46, page 71). This construction serves to focuses the viewer's eyes on the central tomb of the Stadhouder Willem I and makes it loom especially tall.

A few decades earlier in Haarlem, Pieter Saenredam had devised a complicated variation on conventional perspective, which allowed him to represent more in one scene than would normally be visible from a single position (FIG. 51). Rather than constructing pictorial space as if seen by one fixed eye outside the picture's "window," Saenredam's perspective positions the beholder's eye inside that space, with the result that viewing his church interiors can resemble a viewing experience in life, where one's looking is more accidental, having more options than one-point perspective encourages. Saenredam's interior of the church of St. Bavo may still strike the modern viewer as a window onto a pictorial world, but it is less insistent than, say, Van Hoogstraten's *View of a Corridor* in privileging one view. Although Saenredam's elaborate signatures undermine the reality effect, by calling attention to the picture's maker and to its status as two-dimensional object, they also enhance it by guar-

51. PIETER SAENREDAM *Crossing, Nave, and West Window of the Church of St. Bavo in Haarlem, Seen from the Choir*, 1635. Pen and ink, black chalk, and white and yellow heightening on blue paper, 21 x 15″ (53.3 x 38.1 cm). Gemeentearchief, Haarlem.

Saenredam signed and dated the drawing on the capital of the tall column at right.

anteeing the artist's presence on the scene. And yet a comparison of his painting of 1648 (see FIG. 31) with the preparatory drawing he made for it 13 years before reveals significant adjustments of "reality" as recorded in that drawing. The painting shows more of the church's interior, by taking a view a few steps back to accommodate the organ and by widening the side arches. The painting's narrower vaulted ceiling creates dramatic spatial recession towards the back wall. The view is more perfectly framed, with two columns at lower left and right, almost as if to give Saenredam space for his meticulous inscription.

Where Molenaer and Houckgeest more or less assumed a specific viewing position outside the pictorial space, and Saenredam's perspective suggests looking from within it, many landscape painters positioned the beholder in undefined or even impossibly high positions. Philips Koninck (1619-88) often suggested such a bird's-eye view in his sweeping panoramas of Dutch fields and rivers beneath imposing skies (FIG. 52). The absence of one fixed viewpoint implies that the viewer is seeing an objective record of a city or landscape, recorded without human intervention.

52. PHILIPS KONINCK
Panorama View of Dunes and a River, 1664. Oil on canvas, 37 x 47" (94 x 120 cm). Museum Boymans-van Beuningen, Rotterdam.

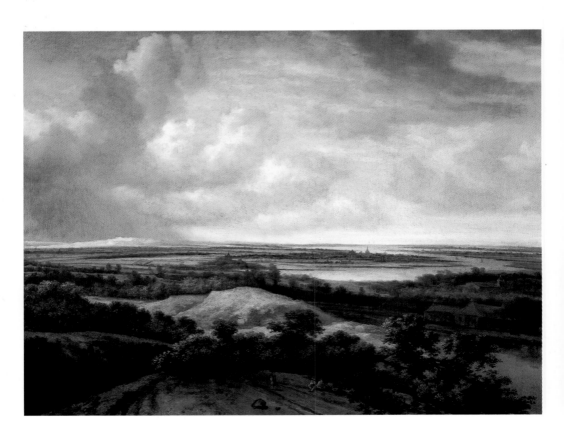

It has been suggested that, by positing such a freely surveying eye, these landscapes resemble the exquisite maps produced in great variety and quantity in the Dutch Republic. The maps depicted in genre scenes, hung on walls like paintings (see FIG. 49), indeed indicate that seventeenth-century viewers did not make the modern distinction between paintings as "art" and maps as "knowledge." Maps are never neutral knowledge either, given that they select what is worth knowing and represent it in a shorthand that is conventional for a given culture. Laurens van der Hem unproblematically combined maps, thematic prints, and "artistic" drawings in his giant atlas. The *Leo Belgicus* map by Claes Jansz Visscher not only impresses with its information but also delights with its city vignettes (FIG. 53) and with its pictorial design, which cleverly imposes the lion onto the 17 provinces. That said, maps served functions other than those of panorama paintings, even if both might decorate walls. No one would consult Koninck's painting for information about the run of rivers or the position of towns in the eastern Dutch region it probably represents, but they might well use Visscher's map for that purpose. A bird's-eye painting of Amsterdam would give a sense of its innovative system of canals, but for a real-estate transaction viewers would surely refer to more detailed plans, seen fully from above rather than from the oblique angle assumed by panoramic paintings.

53. CLAES JANSZ VISSCHER AND WORKSHOP
Leo Belgicus, 1609-21 (detail of FIG. 9, page 19). Engraving and etching, 18½ x 22½" (46.8 x 56.9 cm). Bibliothèque Royale Albert Ier, Brussels.

The city of Zutphen. Profile views had become standard features of maps in the sixteenth century.

Other paintings may assume a fairly specific position for the beholder but distance him or her through the use of figures within the pictorial space. An interior painted c. 1658 by Pieter de Hooch, perhaps a home but more likely an inn, attains a look of incidental actuality, with its one-point perspectival space and the casual conversation of the men and women (FIG. 54). The woman in the foreground who turns her back makes the viewer into an unnoticed witness of the scene. This exclusionary figure creates an intimacy absent from panoramic landscapes or from more theatrical genre paintings. Gerard Dou's *Old Woman Reading* (see FIG. 29) obtains a similar effect by placing the viewer close to the woman seen at half-length and by presenting her in profile, with her eyes focused on her lectionary.

Dou, De Hooch, and the majority of painters represented in this book share one of the uncanniest realist strategies: a fine, meticulous handling of oil paint that makes the individual strokes of paint difficult or impossible to discern. This smooth technique, combined with a keen regard for the reflections and refractions of

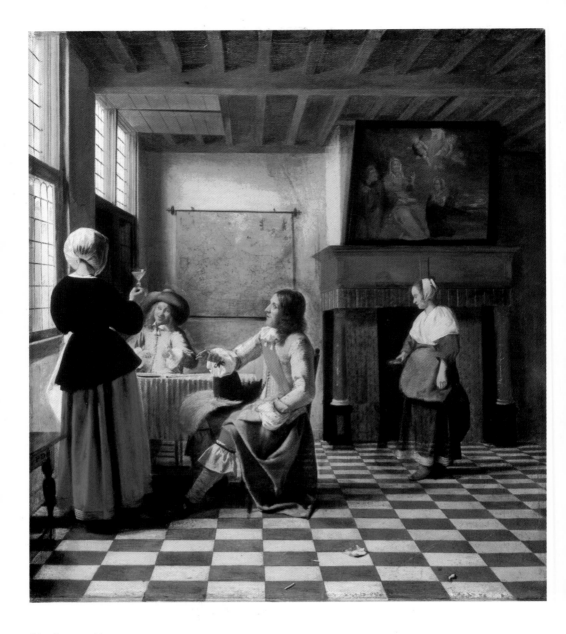

54. PIETER DE HOOCH
A Woman Drinking with Two Men, and a Serving Woman, c. 1658.
Oil on canvas, 29 x 25½" (73.7 x 64.6 cm). National Gallery, London.

Investigation has shown that De Hooch first drew the one-point
perspective scheme and then added the figures. At an early stage, a
man appeared to the left of the female servant. De Hooch later painted
him out, but his outline has become visible as the upper paint layers
have become more transparent over time.

light and the appearance of different colors and textures under various illuminations, creates the widely acknowledged photographic quality of Dutch paintings. Indeed, seen in real life rather than in photographs, these paintings can seem to outdo the most sensitive of photographs in capturing textures revealed by light. This look of truth depends on the viewer's perception that no one had a hand in the representation: the meticulous, smooth technique erases all evidence of handiwork. The effect is paradoxical, as the artist's ostensible self-effacement in technique almost immediately calls attention to its very brilliance. But for the moment of the beholder's initial marveling, the effect of the real is real indeed.

This veristic technique pervaded all Dutch centers of the art industry, and the well-traveled Gerard Terborch became one of its most accomplished exponents (see FIG. 33). But it also became the special preserve of genre painters in Leiden, particularly of Gerard Dou and his student Frans van Mieris, who developed an uncommon ability to differentiate textures (FIG. 55). They became famous during their lives for this technique, which contemporary critics described as *net*, neat. The double meaning of this word, referring to meticulous painting as well as cleanliness, spawned early legends about Dou's neatness and phobia of dust, recorded first by Joachim von Sandrart (1606-88), a German artist and writer who lived in the Republic between 1637 and 1645. Although his comments on Dou's ritualistic protection of his paintings may be taken with a grain of salt, they evoke the spotfree quality of Dou's glazed surfaces. Whereas Dou always let his tiny individual strokes remain just visible, Van Mieris developed an even smoother technique, quite possibly in a conscious effort to surpass his master. Such creative competition with artists of the past and present, usually referred to as emulation, was considered an honorable spur to pictorial innovation.

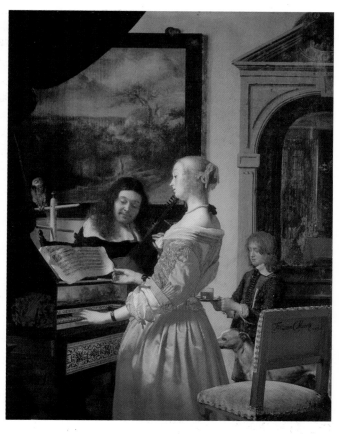

55. FRANS VAN MIERIS *Duet*, 1658. Oil on panel, 12$\frac{1}{2}$ x 9$\frac{3}{4}$" (31.7 x 24.7 cm). Staatliches Museum, Schwerin.

The curtain drawn aside lets the viewer spy on the elegant, mildly titillating musical partnership.

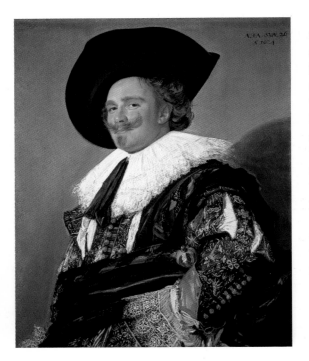

56. FRANS HALS
The Laughing Cavalier,
1624. Oil on canvas, 34 x
27″ (86 x 69 cm). Wallace
Collection, London.

With their *nette* or *gladde* (smooth) techniques, Dou and Van Mieris received some of the highest prices paid for paintings in the seventeenth century. Paradoxically, they shared this financial honor with Dou's teacher, Rembrandt, who began painting in a moderately smooth manner but in the 1640s developed a "loose" or "rough" manner. Contemporaries remarked on this stylistic distinction. The visible brush strokes in "rough" paintings by Rembrandt and Frans Hals (1582/83-1666), quite different from each other in execution, call attention to the virtuosity of their makers, but such dashing brushwork also works as a realist ploy (see FIG. 28 and FIG. 56). In Hals's portraits, the quick and decisive look of each stroke suggests spontaneity, the recording of one specific instant in the life of the sitter. Moreover, with these techniques Rembrandt and Hals edited out many descriptive specifics, creating a composite image that is greater than the sum of its parts. This strategy makes the viewing experience of their portraits resemble lifelike encounters with the sitters, in which we tend to focus on a few aspects of a person rather than on every hair, wrinkle, button, and earring, as do the pictures of Terborch, Dou and Van Mieris. Rembrandt further simulated an actual meeting by casting less important parts of his portraits in shadow and by highlighting faces, hands, and significant attributes.

Most portraits enhanced the lifelike effect by letting the sitter look at the beholder. Such a direct address is also frequent in genre painting, where it seems to contradict the realistic strategy of representing people as if they were unaware of the artist's presence (see FIG. 3). Yet such immediate looks also guarantee actuality, as they engage the viewer in the scene represented and seem to claim that they actually happened. These pictorial interactions are analogous to the asides of comic theater, and it is not accidental that they are especially typical of comic paintings. Contemporary theater critics looked askance at direct audience address in serious tragedy, which should represent a closed narrative as if viewed from outside, but they allowed it for more loosely structured comedies, in which the asides pierce the imaginary window between stage and spectators.

As the examples given thus far demonstrate, Dutch realism was a matter not merely of imitative techniques but also of everyday themes: people and objects, houses and streets that might be found in the Republic. Comic paintings seem especially deliberate in their concern with thematic as well as pictorial realism. Like comedies, comic images in theory should depict people as they are, or even as worse than they are. Painters fulfilled this requirement in paintings of down-to-earth, lowly themes, of peasants and burghers guzzling, drinking, laughing, dancing, and groping. In theme, these paintings recall comic texts and plays that linger on similar scenes and motifs rather than presenting a tight narrative. A painting of boors fighting by Adriaen Brouwer (1605/6-38) may seem uncommonly lifelike (FIG. 57), with its violent action, gruff faces, poorly dressed peasants or urban dissolutes, and disheveled tavern interior. A survey of traditional literature on and pictures of peasants and low-lifes quickly indicates, however, that there were a few standard, endlessly repeated images of these social groups. On the one hand, peasants always seem to drink, vomit, make crude remarks, and fight; on the other, from an urban middle-class point of view, peasants in their noble simplicity and pub-dwellers in their idleness live an enviably carefree life. Neither of these conventional images allows for the complexity of concerns and behavior actually present in such populations, but they rang true for a burgher public socially situated above the classes represented for their delight.

Comic painters attained verisimilitude not just by lowly thematic choices but also with some pictorial means additional to those already outlined. The comic scenes of Brouwer and Jan Steen appear real in part as a result of the plethora of activities going

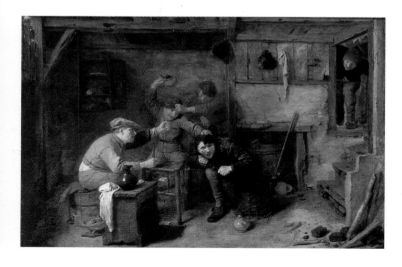

57. ADRIAEN BROUWER *Peasants Fighting*, c. 1631-35. Oil on panel, 13 x 19¼" (33 x 49 cm). Alte Pinakothek, Munich.

on at the same time and because of the dispersed attention of people within the paintings. As is often the case in life, participants look in different directions, at various people and interactions. Comic paintings are also marked by the deliberate disorder of items within the pictorial space – tables and chairs turned at angles, pipes and tankards littering the floor – and of the compositional structure. When seen as surface patterns, Steen's and Brouwer's paintings seem at pains to emphasize crisscross diagonal lines and sharp or obtuse angles, rather than the parallel lines or straight angles of more restful genre paintings (see FIG. 21). Their interiors are more loosely structured than the lucid perspectives of Saenredam and Van Hoogstraten, which establish calm and quiet (see FIGS 31 and 50). Steen made his visual noise still louder with color juxtapositions that may even seem unlifelike. Brouwer mimicked dusty interiors and scruffy characters with a brownish palette and carefully directed but rough brushwork.

Art, Science, and Illusionism

All artistic means to represent a room and posit a viewer, to paint the look of reflected light on silk or to paint living organisms require some understanding of what might be considered scientific issues: the measurement of space and its representation in two dimensions, the effects of light and shade on perception, the taxonomic description of species. In part because of its openness to immigrants, Dutch society hosted a cosmopolitan scientific culture that developed analytic techniques relevant to these problems. At Leiden University, instruction in anatomy, zoology, botany, and optics was based on observation and registration of results in pictures and texts. The practice of recorded looking, fostered even in basic schools, must have furthered the interest of painters and their customers in pictures that look like products of that habit. Although most painters received scientific knowledge at second hand, from their masters or books, several Dutch artists engaged in scientific experiments, registered in their pictures.

The sophisticated perspectival constructions of Gerard Houckgeest and Samuel van Hoogstraten are typical of the optical researches of artists from about mid-century on, especially in Delft and Dordrecht. Vermeer may occasionally have viewed the world through a *camera obscura*, a box with a pinhole in one side that lets in light reflected from the scene in front of it. With the aid of lenses, the reflected light can be focused onto a white surface, on which the image can be viewed or traced. Although, given Vermeer's elaborate painting processes, it is highly unlikely that his

59. CAREL FABRITIUS *View of Delft, with Salesman of Musical Instruments*, 1652. Oil on canvas laid down on panel, 6 x 12¹/₂″ (15.4 x 31.6 cm). National Gallery, London.

As in many seventeenth-century paintings of artists, the lute and violin, presumably offered for sale by the seated man, may allude to the inspiration and work of the painter. The artist's prominent signature in the shadow of the lute reinforces the association.

paintings trace actual camera obscura images, the experience of looking through such an instrument may have suggested some of his striking pictorial effects. In the *View of Delft* (see FIG. 2), the small dots of paint that seem peculiarly emphatic for the reflections they denote represent a visual characteristic of camera obscura images. Another feature of the camera obscura is its reduction of complex things to generalized outlines. Knowledge of this effect may have encouraged Vermeer to smooth and simplify the limbs of the *Woman with Water Jug* (see FIG. 21). Curiously, these scientifically obtained results in one sense reduce the reality effect as they represent phenomena not normally seen. But they also enhance it, in part by their plain presence, which signals the scientific character of Vermeer's observations. Moreover, the simplification of visual information mirrors the viewer's selective looking in life.

Carel Fabritius (1622-54), who left Rembrandt's studio about 1650 to move to Delft, shared Vermeer's interest in optical instruments. His small surviving output includes a wide-angle view in Delft that looks as if it was structured with a lens system (FIG. 59). The odd format and strong distortions suggest that it was meant for viewing through a lens, perhaps in a peep-box with one

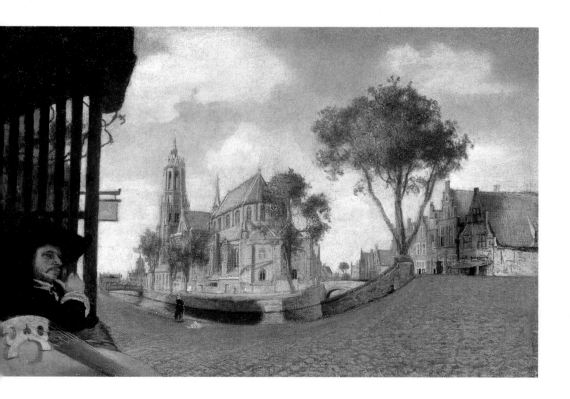

or more sight holes to fix the viewer's eye. The canvas painting could have been mounted on a curve to produce a convincing image of a canal and bridge in Delft. Northern European art had a strong tradition of such optical trickery, aimed at creating deceptive substitutions for "reality." At its most deliberately realistic, Dutch seventeenth-century painting frequently perpetrated such eye-foolery, now referred to as illusionism or *trompe-l'oeil*, literally "deceive the eye." Most illusionistic pictures involved perspectival skills, and many were called *perspectieven*.

Like Fabritius, Samuel van Hoogstraten specialized in perspectives after he left Rembrandt's studio in the late 1640s. Soon afterwards he lived in Rome and Vienna, both centers of pictorial and scientific production, and from 1662 to 1667 he worked in London. There he was in contact with members of the Royal Society for the Advancement of Natural Knowledge, who were equally concerned with optical experiment. For several of them he painted perspectives such as the *View of a Corridor* (see FIG. 50). Thomas Povey (c. 1633-85), the politically influential owner of this painting, had it installed in his grand London home, in a very small room behind a door. Whenever Povey opened the door for his visitors, the painting would reveal an airy progression of several rooms where none existed. The contrast between the roomy pictorial space and the confined actual room must have been striking. The border between real and represented space is called into question by the bird cage and the top of the broom handle, which protrude into the viewer's space. Van Hoogstraten enhanced the theatricality of the game by making the dog and cat confront the intruders as if startled by their presence. Van Hoogstraten choreographed a similarly illusionistic viewing experience in his *perspectyfkas*, a perspective box with two sight holes that give a view of several rooms in a domestic interior (FIG. 60). The box is lit through the open side, which affords a view of the jumble of distorted scenes painted on the inside. The images cohere only when seen through the apertures.

While some artists and scientists used the camera obscura and illusionistic techniques to view and depict the world at large, others looked through magnifying glasses and microscopes to see miniature worlds. Anthony van Leeuwenhoek (1632-1723), if not the single inventor of the microscope as often claimed, certainly pioneered its systematic use, applying it to all manner of objects and substances. Van Leeuwenhoek – who tellingly was made executor of Vermeer's estate – hired draftsmen to record his observations, which included bacteria, and had his findings published in illustrated books. More directly relevant to pictorial production

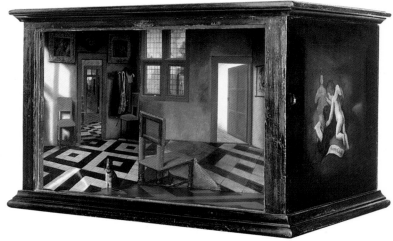

Right 60. SAMUEL VAN
HOOGSTRATEN
*Perspective box with Dutch
Interior,* late 1650s. Panel,
overall dimensions 22⁷/₈
x 35³/₈ x 25″ (58 x 88 x
63.5 cm). National
Gallery, London.

Left 61. JACQUES DE GHEYN II
Three Butterflies and a Stag Beetle, 1604. Watercolor on parchment,
9 x 7″ (22.8 x 17.6 cm). Fondation Custodia, Institut Néerlandais, Paris.

This sheet is one of 22 in an album made between 1600 and 1604. The
first owner, the Holy Roman Emperor Rudolf II (1552-1612), patronized
Netherlandish and German artists who specialized in watercolors of
small animals and plants. The German artist Albrecht Dürer (1471-
1528), whose work the Emperor collected, had developed this genre at
the end of the fifteenth century. De Gheyn's stag beetle may be a
partial homage to Dürer's famous watercolor of the insect.

Right 62. MARIA SIBYLLA MERIAN
*Cassava Plant with Caterpillar and
Butterflies.* Handcolored engraving
from the *Metamorphosis Insectorum
Surinamensium,* 1705, 17³/₄ x 13″
(45 x 33.5 cm). Private collection.

Although the book detailed the
transformations of caterpillars,
Merian was as careful in her
depiction of the indigenous plants
that sustained them. Thus, while
viewers could read holes in leaves as
references to the fragility of life, in
this case they also indicate the status
of the leaves as insect food.

63. OTTO MARSEUS VAN SCHRIECK. *Still Life with Plants and Reptiles*, 1667. Oil on canvas, 23 x 18″ (58 x 45.5 cm). Kunstsammlung der Universität Göttingen.

was the magnifying glass, a tool of the most meticulous painters since the fifteenth century. Jacques de Gheyn II must have used one to produce his exquisite drawings of insects and flowers.

De Gheyn's delicate study of butterflies and a stag beetle made in 1604 (FIG. 61) belongs to a collector's album meant for private study and delectation, but Dutch artists were more typically involved in projects for publication. Numerous institutions, from the botanical gardens at Leiden and Amsterdam to the East and West Indies Companies, published books, many illustrated by talented artists. Maria Sibylla Merian (1647-1717), who moved from Frankfurt to the Republic in 1685, presented her keen researches into plants and insects in handsome publications, the finest her *Metamorphosis Insectorum Surinamensium*, published in Amsterdam in 1705 (FIG. 62). Her impressive plates were based on painstaking observations conducted in Suriname, many of them with a magnifying glass. She published them with detailed descriptions, written with help from the director of the Amsterdam botanical garden that had been founded in 1682, in emulation of its famous predecessor at the University of Leiden, by then almost a century old.

The still-life painter Otto Marseus van Schrieck (1619-78) developed a subgenre of reptile-insect-and-plant paintings. According to his widow, as reported by Arnold Houbraken in 1718, he kept snakes, lizards, and insects behind his house, to serve as models for his paintings. In a painting that combines animals and plants typical for August (FIG. 63), he made an impression of butterfly wings into the paint, to achieve lifelike texture, and implanted at least one leg of a fly. Van Schrieck may have developed these interests in the lively scientific culture of Rome, where he met Samuel van Hoogstraten in 1652.

Carel Fabritius left a striking product of bird observation. Although hardly an ornithological study, his *Goldfinch* (FIG. 64) strikes the viewer as uncommonly true to life, perched on a feeder in unassuming simplicity. Yet the bird's placement against a chalky white wall evokes the representational conventions of

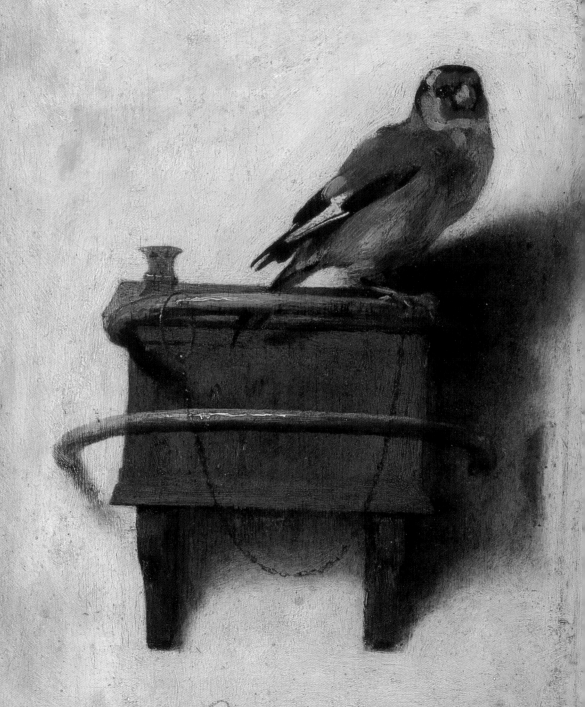

C FABRITIVS 1654

64. CAREL FABRITIUS
Goldfinch, 1654. Oil on
panel, 13 x 9" (33.5 x 22.8
cm). Mauritshuis, The
Hague.

It has been suggested that
this painting, rather than
fitting in a cabinet or
interior window, may have
served as a house sign for a
family in The Hague whose
name, De Putter, is Dutch
for goldfinch. If it were
placed in a plastered wall,
the effect would have been
strikingly illusionistic.

insect studies such as De Gheyn's, in which insects throw shadows
onto creamy parchment. Fabritius may well have embedded the
small panel in a fake window, cabinet opening, or wall to cre-
ate a *trompe-l'oeil* effect.

Meanings of Verisimilitude

The many different, even contradictory ways in which artists cre-
ated pictorial reality suggest that "realism" is always a relative term,
its meanings conditioned by the culture and genre that con-
struct it. In pursuing such a wide variety of realist strategies, how-
ever, Dutch artists seem to have been more concerned with verisimil-
itude than their colleagues in almost any other Western culture.
Several pictorial means signifying "the real" clearly depend on
exquisite skill. The educational requirements and quality control
institutionalized by the Dutch guilds account for the large volume
of technically accomplished Dutch paintings, but they did not man-
date realist strategies. Two aspects of realism were rooted in at least
two centuries of Netherlandish tradition: conspicuous textural
imitation and a penchant for ordinary and exaggeratedly comic
scenes. Around 1430, Jan van Eyck and his patrons already val-
ued the finest differentiation of textures through a meticulous hand-
ling of paint that leaves no trace of the painter's hand. This decep-
tive capacity was inconceivable without the fifteenth-century
invention of oil paint. The association of Van Eyck with the
perfect manipulation of oil paint was so well known that Italian
and Netherlandish writers alike credited him with its invention.
Painters and customers in the new Dutch Republic may have
thought of verisimilitude in Van Eyck's tradition as a particular-
ly Netherlandish achievement and they may have valued it partly
for that reason.

Similar interests in traditionally Netherlandish genres could
have stimulated the prodigious representation of "realist" themes
– Dutch landscapes, city views, animal paintings, group portraits,
and raucous comic scenes, all of which had origins in earlier Nether-
landish Renaissance pictures. The finest of these works had pre-
viously been produced in what had become, through the Dutch
secession, Southern Netherlandish territory, but in the seventeenth
century Dutch painters expanded realist genres and techniques
more insistently than their Flemish counterparts, thus participat-
ing in the development of a specifically Dutch culture. Such efforts
were pursued more explicitly in Dutch language and literature.

A specific art theoretical prescription would seem to have pro-
vided a strong impetus for verisimilitude. According to Italian

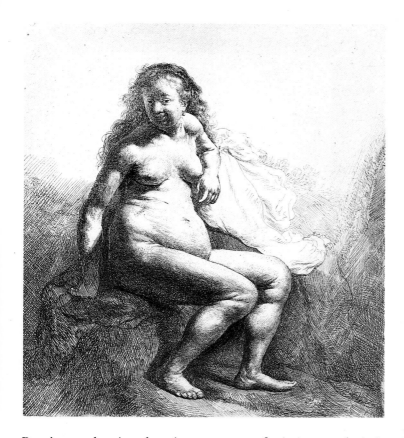

65. REMBRANDT
Seated Female Nude,
c. 1631. Etching, 7 x 6¼″
(17.7 x 16 cm). British
Museum, London.

In 1681, the theater critic
Andries Pels (1631-81)
denounced Rembrandt's
representations of nude
women, claiming that the
painter took for his models
"no Greek Venus; but
sooner a washerwoman or
a peat treader from a barn,
calling his error imitation of
Nature, all else vain
ornament. Weak breasts,
disfigured hands, even the
marks of the laces of the
corset on the stomach, of
the garter on the leg, all
must be copied for nature
to be satisfied."

Renaissance theorists, the primary purpose of painting was the imitation of nature, that is, reality in all its aspects. Most theoreticians immediately modified this requirement, however, by claiming that art should present a selective image of nature at its best. "Nature," in this view, is an ideal state of things, as opposed to "life," with its accidental deformities. Instead of copying one woman, for example, the painter should select from life the most ideal aspects of numerous women, to produce a perfected image of woman through combined mental and manual effort. This process implied that artists might learn as much from successful images by other artists as from life studies. Van Mander advocated this view in the Netherlands, and artists such as Cornelis Cornelisz seem to have heeded it in many respects (see FIG. 43).

The apparent veracity of so many Dutch images seems to redefine the old injunction to copy nature, by flouting the requirement of idealization. By representing every wrinkle and stocking mark on grotesquely unideal women, Rembrandt may have turned this approach into a specialty (FIG. 65). If Dutch pictures look unidealized, they are as bound by genre conventions as the

less realistic paintings produced in the Republic. Although the numerous themes of Dutch painting seem to cover every aspect of the local scene and social life, the ways in which a particular landscape or interaction were represented conform to patterns. Most landscape paintings from the 1630s on, for example, give some two-thirds of the painting over to sky. Most of them are horizontal in format, and rectangular in shape. These conventions are now so familiar that they do not strike us as unusual, but there is no objective reason why they should apply, as exceptions to the rules show. Moreover, some pictorial conventions may contradict seventeenth-century actuality to make specific points.

A painting of a *Vase of Flowers* by Ambrosius Bosschaert (1573-1621) strikingly articulates the oscillation between realist and deliberately artificial strategies in Dutch painting (FIG. 66). Although Bosschaert meticulously represented numerous species of tulips and other flowers, all of them available in the Republic, his bouquet could not have existed in life: these particular flowers would never have been in bloom during the same season. The stone arch window that frames the arrangement so perfectly was unusual at best in Dutch domestic architecture, and the mountainous view behind hardly suggests local landscape.

These deviations from verisimilitude suggest how contemporaries would have regarded this and other still lifes. Bosschaert's arch frame and symmetrical composition evoke a long tradition of devotional images, in which an isolated Madonna and Child or saint would invite viewers to meditation. Such imagery was no longer viable in Protestant cultures, but this particular mode of looking may well have survived. Indeed, seventeenth-century letters and poems about flower still lifes refer to them as objects for contemplation. Such thoughtful looking could occasion a wide variety of responses. Quite typical was a joint admiration for the Creator's ability to forge such a marvelous variety of natural objects and for the artist's capacity to imitate it so convincingly. In this view, the artist almost rivals God's creative powers, particularly as Bosschaert arranged flowers in non-natural combinations. That thought would be modified, however, by the common realization that what the viewer sees, in life and art, is only *schijn*, appearance, rather than the essence of nature or existence. Paradoxically, a distrust of the *schijn* Dutch painters had perfected informed most Dutch theological treatises and emblem books of the period. Painters and viewers of still life neutralized these negative connotations by considering the paintings microcosms, little images that stand for and include the elements of the macrocosm made by God. Bosschaert generated macrocosmic thoughts

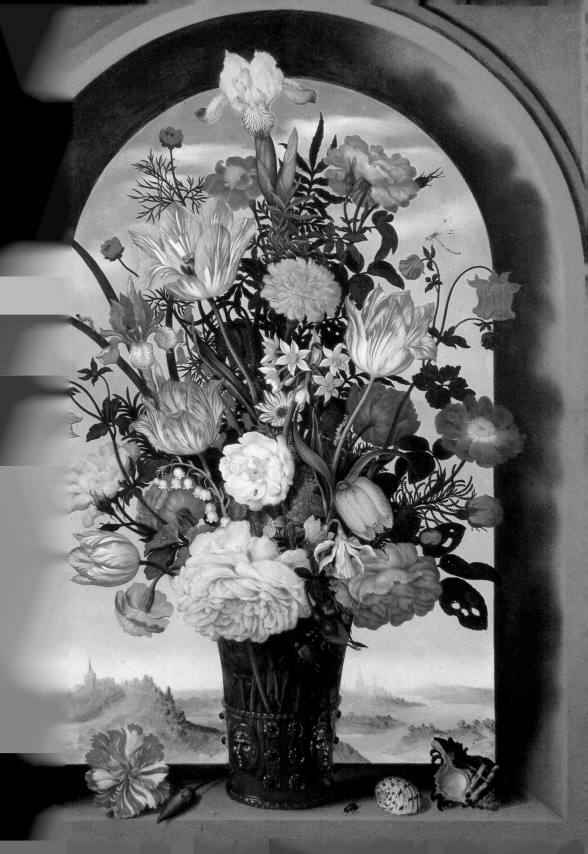

by placing his bouquet before an infinite landscape that intimates the expanse of all creation.

Like most flower painters, Bosschaert also acknowledged the vanity of life and the futility of his imitation of God's work, by showing flowers wilting and leaves withering and by including short-lived insects and dew drops. These allusions, however, also underscore the power of art in preserving the most ephemeral dying objects. Indeed, collectors bought flower still lifes in part as substitutes for real specimens out of season, especially in winter. They also had a keen interest in unusual or recently developed, expensive species. Bosschaert's vase holds some 30 flowers; as always, rare tulips are prominent. His high-priced paintings in one sense offered investors a secure replacement for the actual bulbs that were becoming the object of a speculative, ultimately disastrous trade in tulip futures.

The fame reaped by Bosschaert and the fabled prices he realized seem at odds with the lowly theoretical position assigned to still life. The contrast is a reminder that most collectors and painters in practice were not limited by theoretical rankings. If self-conscious about their art, most artists spoke of it through their works rather than in written theory. Moreover, even Van Mander praised a flower painter who may have been Bosschaert for his patience, neatness, and naturalism.

Like Bosschaert's still lifes, most Dutch realist pictures responded to demands for new knowledge, for images inviting contemplation, and for samples of eye-fooling skill. Although the insistent reality effect of Dutch pictures registers a desire to know the world and everything in it, such knowledge was not secular in the modern sense. Artists and viewers did not find scientific representation incompatible with religious understanding. Even Maria Sibylla Merian, whose work seems uncommonly "objective," lived among devout Pietists in the Republic and made standard references to the relationship between small creatures and the macrocosm. However conventional those comments may be, their tenaciousness signifies their truth for contemporary viewers.

The initial, marveling response to lifelike painting may seem self-evident, but it had important implications for painters. Not coincidentally, awareness of the special requirements and rewards of illusionistic representation appears keenest in the writings of Samuel van Hoogstraten and in Leiden, Gerard Dou's home town. Van Hoogstraten defined "a perfect painting" as "a mirror of Nature, which makes the things that do not exist, appear to exist, and which deceives in an allowed, amusing and praiseworthy manner." In 1641, the painter Philips Angel (c. 1618-45?) had made

the same point in an address to his Leiden colleagues that was published the following year. In his *Praise of Painting*, Angel stressed the prestige and financial award of the closest painterly approximation to life, as practiced by Dou and his followers. This emphasis differentiates Angel's informal presentation from Van Mander's learned tome, with its emphasis on history painting and idealization. Like other writers about Leiden painters, Angel recounted the famous antique story of an artistic rivalry between Zeuxis and Parrhasios. Zeuxis painted such convincing grapes that birds pecked at them. Determined to outdo his colleague, Parrhasios invited Zeuxis to look at one of his paintings, covered with a cloth. When Zeuxis failed to remove the cloth, he realized it was a perfect illusion. Contemporaries praised Dou as "the Dutch Parrhasios," in a joint reference to his uncanny ability to imitate life and his application of this skill to Dutch themes. Angel indicated that Dou's specialty, the textural differentiation of different metals and fabrics, was essential to such verisimilitude. As important to Angel was neat brushwork that erased evidence of the artist's hand: with their blended strokes and smooth surfaces, the paintings of Dou and Frans van Mieris indeed resemble mirrors.

Angel's remark that this type of painting was well rewarded by wealthy and noble customers is borne out by the careers of Dou and Van Mieris, who received salaries from patrons and high prices for their works. Van Hoogstraten, too, remarked that monarchs favored illlusionistic skills. He developed his optical tricks at the imperial court in Vienna, where Emperor Ferdinand III (1608-57) awarded him a medal for a deceptive still life. Indeed, although illusionistic painting seems the most Dutch of genres, it was actively patronized outside the Republic, for example in London and at the Danish court.

Alternatives to Realist Representation

Despite the fascination of Dutch realism for viewers past and present, it should not be overemphasized at the expense of non-realist modes. As already indicated, Van Mander and others valued the modification of observation through imaginative mental activity. Numerous paintings, produced particularly in Haarlem, Utrecht, and Amsterdam, look as if they were painted *uyt den gheest* rather than *naer het leven*, even if most use some realist means. Moreover, for Dutch artists and collectors alike, Italian Renaissance art remained a central model for emulation, as did the refined works produced by artists at the international courts of Prague, Vienna, and France in the sixteenth century.

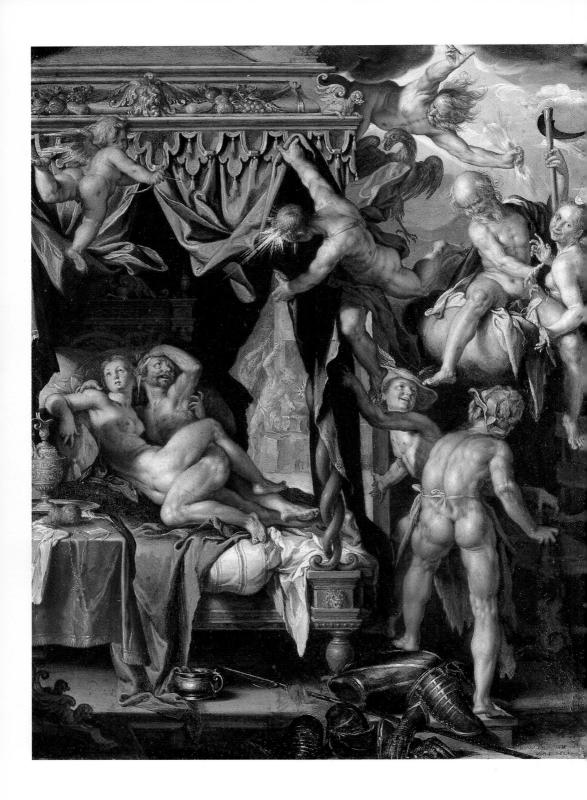

Virtual Realities

Many painters traveled to Italy to see its monuments and land-scapes and to learn from Italian colleagues. Rembrandt's teacher, Pieter Lastman, was sufficiently proud of his formative years there to sign his paintings "Pietro Lastman" well after his return to Amsterdam (see FIG. 27). Other history painters, who shared Lastman's interest in imaginative archeological settings for grand historic events, spent time in Italy in the first decades of the century. With their emphasis on narrative and emotional clarity, these painters implicitly critiqued the then prevalent taste for a highly idealized, refined mode of history painting that privileged virtuoso representations of the contorted human body, smooth finish, and the use of dashing, deliberately unrealist color. Many artists chose to use this sophisticated style to represent the doings of the classical gods, as described by Ovid and others. Various manifestations of this "Mannerist" style (as it is called for historical and largely pejorative reasons) had been patronized at the highest social levels in Italy, France, and central Europe since the middle of the sixteenth century. The Habsburg Emperor Rudolf II (1552-1612) supported it with particular vigor at his court in Prague around 1600. Through his patronage of several Netherlandish artists, what has justly been dubbed "the stylish style" was introduced to the Dutch Republic, and particularly to Haarlem and Utrecht, in the last decades of the sixteenth century. In Haarlem Cornelis Cornelisz painted ambitiously sized mythological representations in this manner for local patrons, including the municipal government (see FIG. 43), and several printmakers publicized this elegant style in accomplished engravings.

In Utrecht, Joachim Wtewael (1566-1638), who had travelled for several years in Italy and France, painted in a similar pictorial language throughout his career, not only in the largest formats but also at the opposite end of the scale, on tiny copper panels (FIG. 67). The smooth surface of the copper allowed him to work up his difficult, dense compositions to the highest finish, creating the refined type of collector's object traditionally associated with the international courts. In the Republic, a newly prosperous, middle-class audience sought these works just as eagerly, as Van Mander reported of two of Wtewael's copper panels on the theme of *Mars and Venus Discovered by the Gods*. Wtewael reinforced the desirable status of such works by their *risqué* Ovidian theme. The gods burst out in Homeric laughter as they witness Mars and Venus trapped stark naked by Vulcan, Venus's cuckolded husband (in the right foreground). His forge is glimpsed behind. Hovering in mid-air, Cupid and Apollo lift the bed curtain to afford the gods, and us, a peek at the adulterous couple.

67. JOACHIM WTEWAEL
*Mars and Venus
Discovered by the Gods,*
c. 1603-04. Oil on copper,
8 x 6⅛" (20.2 x 15.5 cm).
The J. Paul Getty Museum
of Art, Malibu.

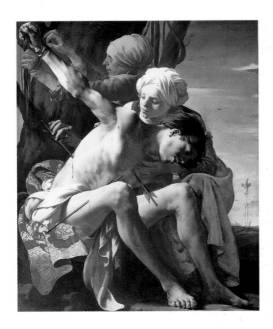

68. HENDRICK TER BRUGGHEN *St. Sebastian Attended by St. Irene*, 1625. Oil on canvas, 5′ x 3′9″ (1.5 x 1.2 m). Allen Memorial Art Museum, Oberlin College, Oberlin, Ohio.

As St. Sebastian was often patron saint of militia companies, Ter Brugghen may have made this painting for such an organization. Its original format – about 4¾″ (12 cm) taller and 2¾″ (7 cm) wider – and its contemplative composition suggest that it was an altarpiece, but Catholic militias often ordered such devotional works.

The Mannerist mode was not only about such stylish wit, however. The story of Mars and Venus, however hilariously rendered, offered an embarrassing example of the disastrous consequences of adultery. And the Catholic painter Abraham Bloemaert, who like Wtewael worked in Utrecht, effectively used some hallmarks of the Mannerist style, including delicately unreal color, figure types, and space, to visualize miraculous religious events (see FIG. 23).

With its large Catholic population, Utrecht maintained close contacts with Rome. After training with Bloemaert, Hendrick ter Brugghen (1588–1629) spent ten years in Rome, returning in 1614 with a new style that presented simplified human figures in close-up, in shallow, dramatically lit spaces. When compared with the graceful figures of Bloemaert and Wtewael, his look deliberately realist, even coarse. Ter Brugghen had developed his confrontational yet idealizing style from the example of the Italian painter Caravaggio and several of his followers in Italy and Utrecht. Like Lastman's brand of history painting, this "Caravaggist" style seems to depart deliberately from the fashionable Mannerist mode. But where Lastman's style was well suited to telling biblical stories, the Caravaggist manner was more apt for devotional representations of only a few figures, meant to stimulate the viewer to contemplation and empathy (FIG. 68). Almost too close for comfort, Ter Brugghen's eerily lit St. Sebastian, pierced with arrows, forces our attention on the martyr's plight and the selfless charity of St. Irene and her maid. The image of an individual suffering for his belief must have been potent for Catholic viewers in the Republic. The Caravaggist style proved highly successful, particularly for religious and genre painting in Utrecht, where numerous painters designed original Caravaggist compositions and often copied extant pictorial schemes.

Other painters brought back Italianate modes of landscape painting that had considerable appeal in the damp northern climate. Bartholomeus Breenbergh (1598–1657), who returned to Amsterdam by 1633, crafted meticulous Italianate settings for biblical themes such as *Joseph Selling Wheat to the People* (FIG. 69). Breenbergh marked the city as Egyptian by his inclusion of an obelisk, but the church at upper right, in front of which Joseph authorizes the sale, faithfully copies a Roman church. As in many seventeenth-century paintings, a vaguely classical town basking in

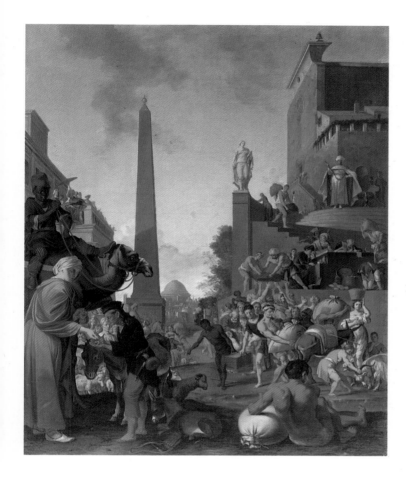

rosy light sufficed to evoke a Mediterranean, biblical past. Pastoral painters, too, effectively used sunny light, pastel colors, and generalized landscape features to evoke an Italianate never-never land for their romantic themes (see FIG. 25).

Dutch painters developed yet other modes of history painting without direct engagement with Italian art. Indebted both to Lastman's narratives and to Caravaggist light patterns, Rembrandt's history paintings could be graphic, even gruesome, in their emotions and actions, but the settings and costumes defined unspecific, remote locales (see FIG. 44). In the ambitious mausoleum for the Stadhouder Frederik Hendrik, international magnificence and allegorical fluency counted for more than verisimilitude. Artists drew on the full register of representational modes, from the virtually real to the lyrically pastoral, from the religiously affective to the heroically historical, to tell stories about Dutch society, its history, and its landscape; its inhabitants and their beliefs.

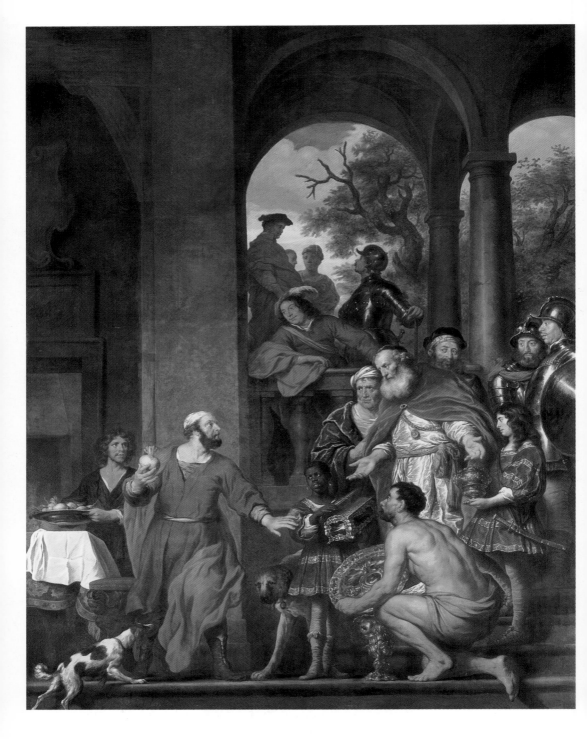

Dutch Ideologies and Nascent National Identity

Because many Dutch paintings seem so realistic, and others appear to represent time-honored historic truths, it can be difficult to discern their ideological charges. Realist strategies make depicted situations or relationships seem natural and immutable, hence true. They thereby helped to create and maintain a largely middle-class consensus about the values that structured, or should govern life in the Dutch Republic. Such a consensus could be both socially beneficial and restrictive.

70. GOVERT FLINCK
*Marcus Curius Dentatus
Preferring Turnips to Gold,*
1656. Oil on canvas, 15'8"
x 12' (4.8 x 3.7 m).
Koninklijk Paleis,
Amsterdam.

In the town hall, Vondel's poem on the painting is displayed below it: "Securely Rome may sleep in the burgomasters' care /As Marcus Curius paid the offered gold no heed /Contenting himself with simple turnip fare / Thus is the city built, by temperance and loyal deed." The twin virtues of modesty and fidelity were to govern the burgomasters in analogous ways.

Fragments of National History

Historical accounts of the revolt and independence of the Republic, most magnificently the illustrated *Nederlandsche Historien* (*Dutch Histories*) by Pieter Cornelisz Hooft (1581-1647), dedicated to the States-General in 1642, present the Dutch people as essentially different from their former overlords, as a chosen people with a common history, led to independence by divine intervention. The Republic needed such accounts for its political cohesion, as its constituent provinces and towns shared an actual history of conflict between local interests rather than one of communal purpose. The illustrations of historical events in these books used an allegorical idiom of the type seen in the Oranjezaal (see FIG. 20). Broadsheets about historical events always inflected apparent description with political aims, as in the record by Hendrick Vroom (c. 1566-1640) of *The Landing at Philippine* and in Jacques de Gheyn II's *Sailing Cars* (see FIGS 13 and 35). The large number of printed

71. REMBRANDT
The Conspiracy of Claudius Civilis, c. 1661. Oil on canvas, 6'2" x 10' (1.9 x 3 m). Nationalmuseum, Stockholm.

The city government removed the painting after a year, to replace it with a more smoothly painted, classicizing representation begun by Govert Flinck and finished by Jurriaen Ovens (1623-78). The government may have preferred their fashionable style. They may also have disliked the display of the Batavian's blind eye, which flouted decorous preferences for the representation of one-eyed people in profile. Rembrandt later cut down the original 19' x 19' (5.8 x 5.8 m) canvas.

representations of contemporary history, however allegorical, contrasts sharply with the scarcity of painted accounts.

Although many paintings addressed Dutch history, they usually did so by "typological" means. A typological representation comments on a situation by comparing it with an earlier event. In medieval and Renaissance typology, Old Testament episodes were explained as prefigurations of New Testament scenes. An analogous system governed seventeenth-century representations of Dutch history, in which ancient Netherlandish or even biblical events were represented in reference to contemporary conditions. Historians described the Dutch revolt against the Spanish as analogous to the insurrection of the Batavians, ancient inhabitants of the Netherlands, against the local Roman governor in AD 69. They glorified the heroic Batavian leader, Claudius Civilis, for his ability to defeat extortionate Roman delegates and yet restore an honorable alliance with the grand Roman Empire. Victory celebrations during the Eighty Years War frequently presented the Stadhouder as the reborn Civilis.

When Amsterdam commissioned decorations for its grand town hall, built between 1648 and 1655, it ordered a painted chronicle of the Batavian revolt for the public galleries. Rembrandt painted *The Conspiracy of Claudius Civilis* (FIG. 71) as a hushed group of men swearing allegiance to their towering leader in a dark space,

lit dramatically by hidden candlelight. As the painting was originally much taller than it is today, the momentous quiet must have been even more impressive. Rembrandt's representation of the rough-hewn Batavians conformed to the ancient history of the Germans by Tacitus, who described the Batavians as courageous but primitive people. By having Civilis represented in its town hall, Amsterdam's elite proclaimed the city's preeminence within the government of the Dutch Republic.

Corporations also commemorated their histories with representations of significant past events. In 1654, the water management board of Leiden, for example, commissioned Caesar van Everdingen (1616/17–78) to paint the granting of its charter by the Count

72. CAESAR VAN EVERDINGEN *Count Willem II of Holland Granting Privileges to the Dike Reeves of the Rhine in 1255*, 1654. Oil on canvas, 7'2" x 6'8" (2.2 x 2 m). Gemeenlandshuis, Leiden.

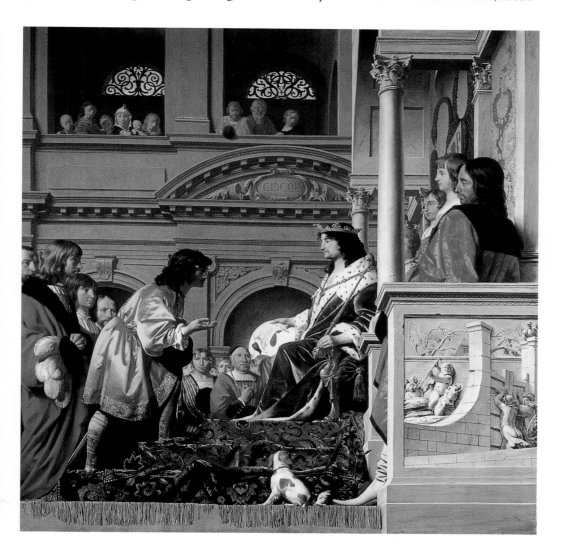

of Holland in 1255 (FIG. 72). By clothing the Count in seventeenth-century royal dress and setting the event in a classicizing space that evoked the latest style in public architecture, Van Everdingen underscored the theme's relevance to water control in his own day.

More common than episodes from Netherlandish history were paintings of biblical, Greek, and Roman themes that applied to Dutch situations. The story of Samson, for example, the Israelite hero who was defeated by female seduction, could suggest that luxury breeds loss of vigilance, a frequently heard argument for continued war with Spain. If Rembrandt indeed gave his cruel *Blinding of Samson* to the court secretary Constantijn Huygens, the gift would not have been as bizarre as it may seem (see FIG. 44). Dutch historians presented their nation as the new people of Israel, small but selected by God for moral leadership. They therefore favored legends about Jewish heroes and heroines, such as Moses and Esther, who saved God's chosen people from destruction (see FIG. 24). Paintings on such Old Testament themes must have appealed not only for their Calvinist resonance but also as prefigurations of the recent history of the Republic.

In the Amsterdam town hall several Roman themes had prescriptive relevance for the city's four burgomasters. In 1658, Govert Flinck (1615-60), who had been in Rembrandt's studio in the 1630s, painted the Roman general Marcus Curius Dentatus preferring his own, simple meal of turnips to the gold offered by Rome's enemies (see FIG. 70, page 99). Besides reminding the burgomasters of their duty to resist corruption, the painting demonstrated their awareness of this responsibility to the city at large.

Historical paintings for town halls and other civic corporations are relatively rare in the Dutch Republic. More numerous are seemingly neutral paintings and prints of historically significant Dutch sites. Aelbert Cuyp of Dordrecht (1620-91) painted several views of Nijmegen, all based on drawings he made on a trip to that city at the eastern border (FIG. 73). Cuyp's Italianate light silhouettes the buildings across the river with crystalline clarity. The fortifications topped by the tower were known as the Valkhof (falcon court), a stronghold dating back to medieval times. Historians hailed Nijmegen as the seat of Claudius Civilis and bulwark of Charlemagne and the Republic. Cuyp's quiet composition of repeated horizontals and rectangular masses registers the longevity and solidity of the city.

Painters of church interiors, too, chose views to evoke recent Dutch history. Gerard Houckgeest and other Delft painters orchestrated views in the New Church to focus on Hendrick de Keyser's tomb of Willem I, Prince of Orange, founder of the Republic (see

73. AELBERT CUYP
View of Nijmegen with the Valkhof, c. 1652-55. Oil on panel, 19¼ x 29" (48.9 x 73.7 cm). Indianapolis Museum of Art.

FIG. 46). It has been suggested that these views appealed particularly to supporters of the Stadhouder's function, which had become problematic after the death of Willem II in 1650, just when the first of these works were painted. Even if the effect of this political factor is unclear, it is likely that some of the many admirers who visited the tomb of the "father of the fatherland" would have cherished a permanent record of it.

The Dutch Scene

Landscape pictures flourished in the Dutch Republic. By mid-century, it was the most widely produced and collected category of painting and, on average, one of the most affordable. While landscape encompassed numerous modes, from the pastoral to the alle-

gorical, its least assuming theme was its most innovative: the local land. In the first two decades of the century, several printmakers in Haarlem were primarily responsible for developing this genre. In 1611, Claes Jansz Visscher issued a series of twelve etchings with the title *Pleasant Places*, representing an imaginary journey along historical landmarks and sites of industry and recreation around Haarlem. While some of the prints allude to painful recent events, such as the Spanish occupation of Haarlem after a siege of 1573, others hint at the city's newly gained freedom and prosperity, exemplified by its successful bleaching industry (FIG. 74). The apparent straightforwardness of these etchings evokes contemporary Dutch histories, which extol the plain, productive character of the people and their land.

Several other Haarlem artists soon emulated Visscher's series with their own journeys in print, which must have familiarized a wide public with these novel views of the local scene. From the 1620s on, painters such as Esaias van de Velde and Jan van Goyen began to specialize in similarly innovative paintings of Dutch coasts, streams, fields, and skies; cities, squares, and hovels. By the 1650s, the Amsterdam artist Philips Koninck was painting river panoramas on a monumental scale (see FIG. 52). More revealing than any specific motifs within these landscapes is the sheer volume of what look like unedited transcriptions of the Dutch environment. That is not to say that particular themes could not generate specific resonance, however.

Aelbert Cuyp's view of Nijmegen in the 1650s juxtaposes the venerable Valkhof with a distant, smaller windmill. The alignment not only creates spatial recession but compares the Valkhof as a specific symbol of Dutch might, independence, and cultural

74. CLAES JANSZ VISSCHER *Bleaching Fields at Den Houdt, Haarlem*, 1611. Etching, 4 x 6¼" (10.4 x 15.8 cm). Rijksmuseum, Amsterdam.

In his series of *Pleasant Places*, Visscher recombined several conventions of landscape prints, maps, and geographical descriptions. As publisher of such materials, he was well-prepared to create the new formula of a journey through a local landscape. In this etching he encourages the viewer to wander along the bleaching fields on the path through the open gate.

uniqueness with a general one: the windmill. Numerous artists represented the ubiquitous windmill to localize their landscapes, none more impressively than Jacob van Ruisdael (c. 1628/29–82?). By assuming a very low viewpoint, his *Windmill at Wijk bij Duurstede* of c. 1670 (FIG. 75) makes the mill even more imposing than Cuyp's Valkhof. The sight of windmills could induce a wide range of contemplative musings. In emblem literature and religious tracts, the wind-propelled mill referred metaphorically to the God-given power of nature and the spirit. In earlier paintings, its cruciform blades could be conflated with Christ's cross. Although Ruisdael's packed clouds may imply God's power, the painting does not obviously allude to these pictorial traditions. The formidable capability of this grain mill, as an ingenious human and Dutch tool to harness natural wind power, may have come to mind as readily. Several prints celebrated the different types of mill and their crucial industrial functions, from grinding wheat to draining and thereby reclaiming land.

75. JACOB VAN RUISDAEL *Windmill at Wijk bij Duurstede*, c. 1670. Oil on canvas, 32³/₄ x 39³/₄" (83 x 101 cm). Rijksmuseum, Amsterdam.

Although Ruisdael based his painting on drawings after the site, he isolated the windmill by removing a city wall and the "woman's gate" that should occupy the foreground, where three women mark its place.

76. HENDRICK AVERCAMP *Skating Scene outside a Village*, c. 1620. Oil on panel, 14½ x 25¾" (36.8 x 65.4 cm). Collection of Mr. and Mrs. Edward William Carter, Los Angeles.

Avercamp based his densely populated skating scenes on careful studies of individual figures, which he could use in several different paintings.

Of all Dutch landscapes, the most locally specific may be scenes of people frolicking on frozen canals (FIG. 76). Written and pictorial accounts show that contemporaries relished the expanses of frozen water and the recreational activities they allowed. Representations of skating existed before the seventeenth century, but only in the Dutch Republic did those scenes form a genre of their own, practiced most exclusively by Hendrick Avercamp (1585-1635). His scenes unite most ranks of Dutch society, from peasants through modest burghers to patricians, in harmonious outdoor activity, glossing over tensions between the classes that appear in comic texts on ice pleasures. Avercamp's panoramic view of a white world in which sky and ice merge at a distant horizon seems to delight in water's ability to metamorphose temporarily into more land for all. Dutch engineers even designed sail boats to run on ice, and poets praised the ability of the Dutch to move and work on ice.

While pictures of windmills and sailing cars, frozen canals and ice boats speak of Dutch ingenuity with water and wind, a voluminous genre of cow paintings records a primary use of Dutch land. While some precedents existed for prize-animal paintings, Dutch painters developed a true category of agricultural animal paintings only towards mid-century. Paulus Potter (1625-54) was one of the first to specialize in the genre and almost immediately painted its epitome: *The Bull* of 1647 (FIG. 77). By setting up a confrontation between life-size bull and viewer and by dwelling on the minutiae of the bull's coat and wrinkles, Potter seems to have painted a portrait of one animal, but modern anatomical studies show that he must have synthesized his bull from drawings of several animals of different ages. Viewers may have seen the bull, the cow, and the milk ewe as indices of Dutch prosperity, for the cattle-breeding and dairy industries had become sources of

national income and pride, particularly once political stability had allowed them to grow. In his map celebrating the Dutch situation during the Truce, Claes Jansz Visscher engraved cows to the right of his heraldic lion, as one of several vignettes representing Dutch use of the free land (see FIG. 9). The cow could even stand for the Republic itself. An etching by Hendrik Hondius II (1597-after 1644; FIG. 78), preceding Potter's bull by three years, ostensibly shows cows grazing and drinking; the inscription below this image, however, exhorts Dutch leaders to vigilance "so that the Dutch cow shall not be stolen from us." In an equally significant comment, the prominent cow-painter Cuyp foregrounded cattle against the heroic Valkhof of Nijmegen.

Horticulture was as potent a source of pride and livelihood as livestock. A vegetable market painted c. 1661-62 by Gabriel

77. PAULUS POTTER
The Bull, 1647. Oil on canvas, 7'5" x 11' (2.3 x 3.4 m). Mauritshuis, The Hague.

This painting was originally smaller, probably because Potter intended to represent the bull alone. Early in the painting process, he added more canvas at left, right, and top to include the farmer and the other animals. Seventeenth-century artists frequently made such adjustments of size.

78. HENDRIK HONDIUS II
Cows in a River: A Call to Vigilance, 1644. Etching, 8 x 6″ (20.3 x 15.2 cm). Rijksmuseum, Amsterdam.

The inscription reads: "Thou Gentlemen Guardians, look out attentively that the Dutch cow shall not be stolen from us." This etching featured in a series of six prints on patriotic themes.

Gby Heeren wachters wel neerstelyck toesiet, Dat Ons gerooft werd de Hollandse koe niet.

Metsu (1629-67) displays an impressive variety of cabbages and root vegetables against a backdrop of the Prinsengracht, one of Amsterdam's finest canals (FIG. 79). Metsu gave pride of place to the Horn carrot (the orange root in the cane basket) and the cauliflower, both of them expensive vegetables that Dutch growers had recently developed; they are contrasted with turnips and other humble staples of Dutch cooking. (In this light, Flinck's painting of Curius Dentatus for the Amsterdam town hall is significant beyond exemplary resistance to bribery: the general prefers turnips, plain local fare.) The canal calls attention to an enabling factor of Amsterdam's economy: its ready access to Holland's network of waterways. In setting and motifs, the painting is about Amsterdam's flourishing vegetal and economic cultures, both the subject of numerous laudatory descriptions. While such specific market pictures had some general precedents, their

79. GABRIEL METSU
Vegetable Market in Amsterdam, c. 1661-62. Oil on canvas, 38 x 32" (97 x 81.3 cm). Musée du Louvre, Paris.

combination of actual sites with the best of locally grown produce constitutes their novelty, and even their seventeenth-century Dutchness.

Metsu's painting also celebrates Amsterdam architecture, recently transformed by a building campaign to serve the ever-increasing demand for homes and warehouses. The painting contributes to the development of a new cityscape genre after mid-century. The works of Jan van der Heyden, one of the finest city-view spe-

cialists, are responsible for our general impressions of seventeenth-century Amsterdam. In paintings such as his *View of the Westerkerk* (FIG. 80) he presented a pristine, sunny image of the city in the 1670s. These cityscapes, many of which inventively recombine actual and fictional buildings, are as interesting for their omissions as for their inclusions. Both serious and comic descriptions of Amsterdam called attention to the busy traffic of people and carts, to the crying children and fighting street dwellers, to dirt and to crime, but Van der Heyden's city views edit out congestion, noise, transgression, and dust, and gloss over class distinctions, just as Avercamp's ice scenes do. They thereby present a salutary image of a unified, prosperous city, a beautifully painted fiction affordable only to its prosperous elite.

Van der Heyden's painting takes as its centerpiece the Westerkerk, a church designed in 1620 by Hendrick de Keyser, then the city's most famous architect. Although the structure owed much to earlier Netherlandish designs executed in warmly colored local brick, its details were innovative. To contemporaries the bell tower, completed in 1638, must have looked cosmopolitan with its three levels of classical columns in stone, topped by brackets that support a fanciful bulb. As the largest Protestant church built up

80. JAN VAN DER HEYDEN *View of the Westerkerk*, 1670s. Oil on panel, 16 x 23″ (41 x 59 cm). Wallace Collection, London.

Although De Keyser's church primarily served the Jordaan, a modest neighborhood, Van der Heyden represented it as seen from the stately Keizersgracht, the new Emperor's Canal.

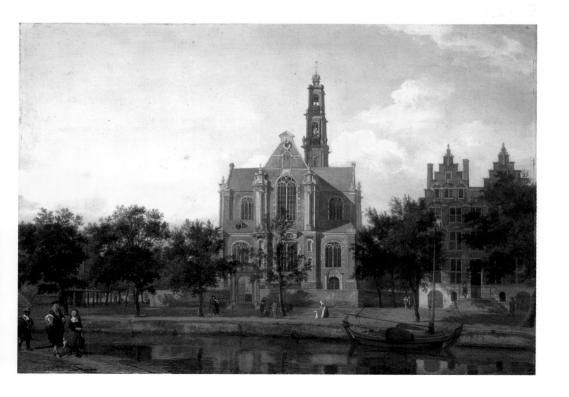

to that time, it constituted a local answer to the magnificent tradition of Catholic building. Many seventeenth-century paintings isolated such distinctive church towers puncturing the Dutch sky. Architects exploited the Republic's flatness to create a skyline of intricate spires, symbols of an exultant and ubiquitous Protestant faith. In his jubilant tower for Haarlem's New Church, built in 1613, Lieven de Key (c. 1560-1627) piled up sculptural forms of Italian origin but recombined them in a manner brought from his native Flanders (FIG. 81). Paulus Potter capitalized on the meaningful presence of lively spires on the Dutch horizon by wittily having his massive bull dwarf one (see FIG. 77). Cattle, church, field, and sky played equal roles in the pictorial construction of the Dutch scene, replete with meaning in its verisimilitude.

81. LIEVEN DE KEY
Spire of the New Church, 1613, Haarlem.

Below
82. WILLEM VAN DE VELDE II
The "Gouden Leeuw" before Amsterdam, 1686. Oil on canvas, 5'9" x 10' (1.8 x 3 m). Amsterdams Historisch Museum.

Global Dutch Economy

Seventeenth-century pictures defined the Dutch scene not only in terms of shared history but also as a site of productivity. While landscapes, city scenes, and animal paintings advertised the indigenous foundations of Dutch economic success, other genres – marine painting foremost – acknowledged its more significant basis in overseas trade and colonial ventures. Although many seascapes were available cheaply, the best marine painters were among the most highly rewarded artists. The States-General, city governments, and trading companies commissioned views of the Dutch naval and

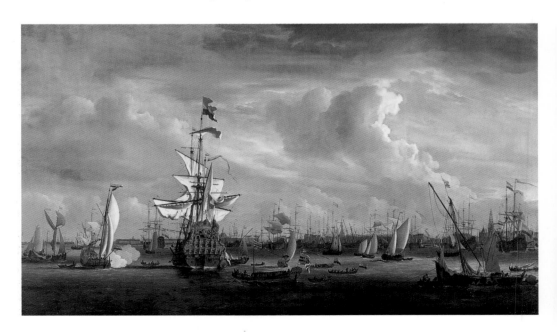

trading fleets, before a prosperous harbor, in battle, or at sea. The marine specialist Willem van de Velde II (1633–1707) painted the heroic vessel *Gouden Leeuw* in the bustle of Amsterdam harbour (FIG. 82). While Dutch primacy in merchant shipping offered high rewards, its risks were equally significant. On their long journeys to the Mediterranean, the New World, Africa, and the East, merchant vessels were perennially endangered by warfare, piracy, treacherous shores, and storms. Several painters, most dramatically Ludolf Backhuysen (1630–1708), specialized in ships adrift in tempests. He executed his largest surviving painting (FIG. 83) as if he were observing the disaster in the midst of the roiling seas, thus engaging beholders in the unfolding tragedy, encouraging them to empathize with the ships and their crews and to contemplate the powers of God, beyond full comprehension.

83. LUDOLF BACKHUYSEN *Ships Running Aground in a Storm*, 1690s. Oil on canvas, 5'5" x 11' (1.7 x 3.4 m). Musées Royaux des Beaux-Arts, Brussels.

Backhuysen detailed the progression of shipwreck through three ships. The three-master at left just manages to stay the course, wisely sailing on one mizzen. A frigate at right, with broken mast, will undergo the fate of the sinking ship nearby.

But even as such paintings acknowledge the fragility of Dutch seaborne success, their distant shafts of sunlight usually hold out hope for reversals of misfortune. A brighter future may still save Backhuysen's ship at left, its Dutch flags unfurled against lightening sky. Collectors occasionally hung a tempest painting opposite a sunny shipping scene, implying that the power of God and nature, whether terrifying or benevolent, is always magnificent.

Marine paintings often favored an elongated horizontal format, the water extending from left to right to suggest the limitless expansion of the seas. The conquest of this infinitude, through naval might and navigation, allowed Dutch trading companies to stake claims in newly accessible lands. They did so by gaining virtual trading monopolies, for spices, silks, and ceramics from

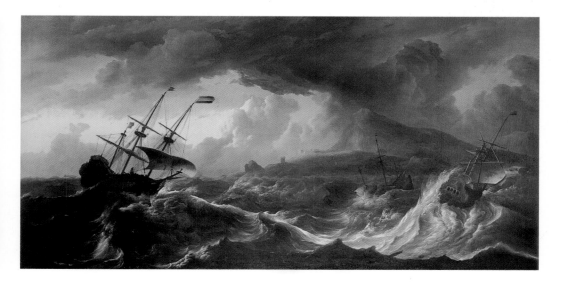

Java and Japan, for example, or ivory, gold, and, quite profitably, slaves from Africa. Commerce was facilitated by Dutch trading posts. The Republic also settled overseas territories as colonies, often gained in battle with other seafaring powers. Planters on Java, in South Africa, and in Brazil developed profitable crops of sugar, nutmeg, coffee, and other luxury products.

For all their apparent truthfulness, Dutch pictures show little of colonial working life, concentrating rather on colonial benefits to trade, art, and science. The most impressive colonial artistic project was the transcription in texts, maps, and pictures of the sites, peoples, fauna, and flora of eastern Brazil, under Dutch control from 1630 to 1654. It was sponsored by the military commander Johan Maurits of Nassau (1604-79), a relative of the Stadhouders

who was Governor-General of Brazil from 1637 to 1644. Scientists trained in medicine, biology, and cartography, and artists including Frans Post (1612–80) and Albert Eckhout (c. 1610–65) gathered material for the *Historia Naturalis Brasiliae*, a large natural and ethnographic study of Brazil, illustrated with 533 woodcuts of exotic discoveries from swordfish to chiefs of indigenous tribes (FIGS 84 and 85). In several copies of the *Historia*, sensitive hand-coloring enhanced the scientific and artistic value of the woodcuts.

Post's records of Brazilian rivers, roads, and fields fit well-established schemes of Dutch landscape painting. But for its inclusion of workers of African origin and the exotic tree, his *Ox Cart* of 1638 (FIG. 86) resembles near-contemporary Dutch pictures, such as the earlier works of his brother, Pieter Post (1608–69). Although not intended perniciously, such paintings of Dutch Brazil mark the indigenous scene as Dutch indeed, easily and rightfully accessible to Dutch cultivation. Analogously, by naming and presenting Brazilian plants, animals, and peoples in a European scientific manner, Dutch science took possession of local nature and culture as securely as military leaders did of the terrain itself. Dutch portrayal of the indigenous peoples was structured as much by received opinion as by observation. Eckhout painted a Tapuya woman with a severed human leg in her basket and a half-devoured arm in her hand (FIG. 87). The cannibalism of non-Europeans was a persistent myth for all colonial powers, although ritual cannibalism was actually rare. By ascribing inhumane acts to "primitive" peoples, more "civilized" colonizers unconsciously justified their exploitation of the indigenous populations of desired territories. The *Historia Naturalis Brasiliae*, Post's landscapes, and Eckhout's figures made the Dutch presence in Brazil look natural, to the governors and to rival powers. Many paintings and tapestries based on the Brazil project indeed served as powerful diplomatic gifts in the second half of the century.

87. ALBERT ECKHOUT
Tapuya Woman, 1641.
Oil on canvas, 8'5" x 5'3"
(2.6 x 1.6 m).
Nationalmuseet, Etnografisk Samling, Copenhagen.

With its casual, not particularly gory inclusion of half-eaten limbs, Eckhout's painting conveys an impression of portrayed truth, even though it conforms closely to other representations of Tapuya woman as type, always carrying her human food.

Although unsurpassed in scale, the encyclopedic study of Brazil is comparable with Dutch investigations of other colonies, which similarly furthered scientific as well as political interests. Botanists utilized the global reach of Dutch trade to gain information and novel specimens of horticultural and medicinal value. Maria Sibylla Merian recorded some of her finest entomological discoveries during two arduous years in Suriname, the Dutch sugar colony that was to become notorious for its unparalleled abuse of slaves. Although these scientists were motivated by a sincere and creative interest in knowledge and what it might reveal of God's designs, with hindsight it is clear that their marvelous achievements depended on Dutch economic enterprises that entailed the systematic exploitation of other peoples and the lands they inhabited. This practice, however mitigated individually by benevolent planters or isolated missionaries, was implicitly justified by a belief in the superiority of white Christians − a myth so self-evident at the time that it was articulated only obliquely.

Moral Economies at Home

Still-life painting occasionally registers the pride that contemporaries took in global trade and colonial endeavor. Like the botanical gardens and finest collections, still lifes gathered disparate objects from all reaches of Dutch trade, and brought them home, re-presenting them in European terms of science and collecting, without specific concern about their origins. In one of his paintings of fine household items, Willem Kalf (1619-93) effortlessly combined Venetian and Dutch glassware, a recently made Chinese jar for luxury ginger, a Dutch silver dish, a Mediterranean peach, and a half-peeled lemon, the object of the citrus trade and of medicinal treatises (FIG. 88). He displayed them on an Indian floral carpet, in a dramatic spotlight that invites contemplation and admiration, for the fine wares as well as the artist's recrafting of them. Kalf's jeweled technique evokes their value and unifies them in an arrangement that, however lifelike for each individual object, is clearly pictorial. Kalf used these objects in other paintings as well; the assembly is imaginary, rather than the property of one owner. At the center of the painting, the glass is supported by a gilt *putto* with a horn of plenty, an elegant summation of the picture's riches. A watch provides the obligatory vanitas reference, but it, too, is a finely crafted specimen. The evocation of time also signals the still life's capacity to outlast its objects by memorializing them in paint. The watch may even keep Kalf's time: the time it took to make this exquisite painting, labor time that

88. WILLEM KALF
Still Life with a Late Ming Ginger Jar, 1669. Oil on canvas, 30 x 25³/₄″ (77 x 65.5 cm). Indianapolis Museum of Art.

The jar was a very recent import from China, as it was made in the Transitional period (1644-62) between the Ming and Kangxi periods.

guarantees the preciosity of this new object. Like many still lifes, Kalf's manifests its interest in transience also in its pictorial structure. The goods are placed precariously, visibly touched by human hand. Yet this is not an interrupted meal: no cook would serve an acidic feast of lemon, peach, and wines, and even if they had, they would not have balanced it so tenuously on a crumpled carpet. While this disorder suggests reality, it also reinforces the unease introduced by the watch.

It has recently been suggested that Kalf's type of compromise, between cornucopia and vanitas motif, is paradigmatic for the Dutch mentality of the seventeenth century, which reveled in prosperity yet was anxious about the moral consequences of wealth; a constellation of beliefs that celebrated Dutch enterprise but obsessively acknowledged its dependence on God's benevolence. While this view ignores Dutch distinctions of class, locality, religion, and gender, it rightly centralizes the concerns of seventeenth-century burghers and aristocrats with the resource management of the Republic and of the domestic household, which writers considered a microcosm of the larger polity.

89. WILLEM BUYTEWECH *Merry Company*, c. 1622-24. Oil on canvas, 24 x 32″ (61 x 81 cm). Staatliche Museen, Bodemuseum, Berlin.

This company originally alluded more blatantly to illicit pleasure, as the man at left held a chamber pot, a fixture of brothel scenes. The offensive item was painted out early in the twentieth century, when the man's hand was repainted as resting on the chair.

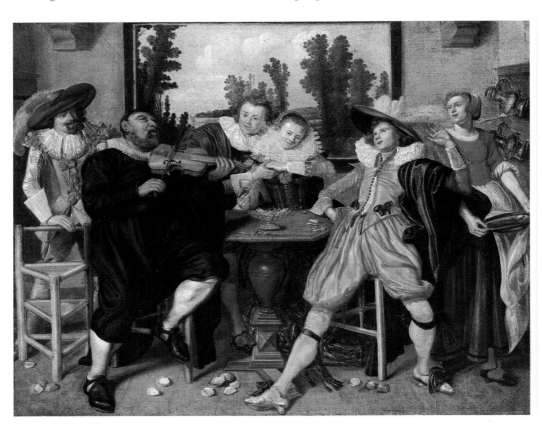

Some of the earliest paintings and prints to articulate these issues in genre scenes were made in Haarlem, although Amsterdam artists, stimulated by the presence of David Vinckboons (see FIG. 45), also contributed to the development of pictures of family and social life. In the late 1610s Willem Buytewech (1591-1624) began to paint scenes of fancily attired youths drinking, making music, and courting (FIG. 89). In a characteristic work painted in the early 1620s, after the artist's return from Haarlem to his native Rotterdam, a brightly colored group of four men and two women fully occupies a shallow interior, pressing on us their enjoyment of music, wine, and those notorious aphrodisiacs, oysters. But rather than communicating an obvious narrative, the figures are posed in attitudes of merriment, swagger, and romance. Prints after these types of scenes occasionally carry mildly moralizing or ironic inscriptions about the lazy, newly rich children of a harder-working generation, squandering the parental earnings, but it is not clear that these festive paintings would have generated the same censorious response in all viewers. Paintings of such merry companies also allowed artists to represent the latest fashions and modes of conversation and courtship, and they forced viewers to assess the propriety of each scene for themselves. In Buytewech's painting, the modernity of the group is underscored by the inclusion of a large landscape painting, which resembles the works of Buytewech's innovative colleagues in Haarlem. The irony of Buytewech's companies is suggested by his early nickname, "witty Willem," an appellation which indicates the humorous and clever efficacy of his works.

The majority of Dutch genre paintings produced in and after Buytewech's time helped construct and critique ideals of courtship, marriage, family, and home. These positive, negative, and ambiguous models are best understood in the context of a voluminous literature on domestic conduct. The most prolific and widely read writer on marriage and family was Jacob Cats (1577-1660), who moved in high social circles in Middelburg and The Hague. His long books in simple verse, most of them illustrated with engravings designed by Adriaen van de Venne, went through many editions in his lifetime and remained stock reading material into the nineteenth century. His *Houwelick* (*Marriage*), first published in 1625, was the most popular, undoubtedly because it clearly stated beliefs and values shared by the majority of the Dutch reading and listening public. A contemporary publisher estimated that by mid-century 50,000 copies of it had been sold, a number that would make it an unequalled bestseller in its time. The title-page of the first edition, designed by

90. PIETER DE JODE AFTER
ADRIAEN VAN DE VENNE
Stages of Life. Engraved
title-page to Jacob Cats's
Houwelick (Marriage),
1625. 7½ x 6¾" (19 x
17 cm). Private collection.

Van de Venne, announces the book's structure (FIG. 90). Around the title cartouche, vignettes indicate its division into six parts, each dedicated to a stage in a woman's life, from "Maiden," instructed by an older woman at lower left, through "Sweetheart" and "Bride" to "Housewife," with husband, and "Mother" with three children, and eventually to "Widow." The groups are arranged on a hill, depicting life as a stairway up to marriage, life's apogee, and down unto death. As the structure implies, Cats addressed himself explicitly to women, although his ideals of femininity for any given stage had implications for men and proper masculinity as well. The title acknowledges that the treatise "encompasses also the masculine counter-duties."

As in most cultures, a woman's main charge was to give birth to and raise children. Most parents greeted the birth of a child with happiness and pride, for emotional and, particularly in the case of sons, economic reasons. A son frequently took over a father's business or trade and would inherit the family's possessions and perpetuate its name. The economic and social benefits of marriage made monogamy imperative. Cuckoldry and illegitimate children caused shame – or mirth, if they befell others.

A painting by Steen of revelers in a lying-in room, dated 1664, suggests elation by its busy conversation, laughter, and drinking, as well as its bright color scheme (FIG. 91). Most of the visitors are women: men, including the father, were considered out of place at these events, useful only for money to sustain the celebration. The aging father in Steen's painting awkwardly holds the child as he reaches into his purse for more funds. He has good reason to be uncomfortable, as a younger man mocks him with two fingers behind his head, marking him a cuckold who may not know that his child is not his. The joke is in keeping with comic accounts of birth celebrations as gatherings of crones and maidens gossiping about sex. Midwives and nurses were consid-

ered primary perpetrators of such transgressive talk. Their unclear status, always moving between households, made them mythic purveyors of bawdy chatter. As elsewhere, loquaciousness was generally found more appropriate for men than for women. Although Steen's interior is up-to-date for a middle-class family of the 1660s, his nursery celebration seems old-fashioned for that period, exaggerated to comic effect.

Steen's chaotic composition inverts proper images of visits to the lying-in room by artists such as Matthijs Naiveu (1647-1726). In his spotless, restfully structured room, a modishly attired father converses with an elegant female visitor, who receives the child from the mother in the bed (FIG. 92). The child's paternity is not in doubt. In the milieu that could afford fine paintings such as Steen's and Naiveu's, actual nursery visits should be more like the latter's; by turning the formula upside down, Steen's raucous event has more in common with comic descriptions than with actual celebrations. Like those comic texts, Steen marks the topsy-turvy situation as laughable and thereby reinforces the ideal.

91. JAN STEEN
Celebrating the Birth, 1664. Oil on canvas, 35 x 43" (89 x 109 cm). Wallace Collection, London.

In 1852 this painting was called "the Gossiping," a traditional term for such celebrations that evokes their function as events for the exchange of rumors, presumably among women.

92. MATTHIJS NAIVEU
Visit to the Nursery,
c. 1700. Oil on canvas,
27³/₄ x 34" (70.5 x 86.3 cm).
Stedelijk Museum De
Lakenhal, Leiden.

Most Dutch themes of love, family, and home are represented in serious as well as comic modes. Serious versions usually present positive ideals that may (but need not) be closer to the experience of their middle-class viewers, and comic images offer negative versions of proper social situations. By doing so, they support the ideal but also offer some temporary pictorial relief from any stresses conformity might generate.

Parents were responsible for the Christian upbringing of their children. In Calvinist prescriptions, such education involved communal readings from the Bible and from explanatory texts on the scriptural lessons; it also entailed prayer, especially in thankfulness for each meal, concrete evidence of God's continued benevolence. Adriaen van Ostade's etching of peasants joined in prayer (FIG. 93) emphasizes the parents' good example for the two children, and the family's gratitude for a simple dish. The peasant family forms an exemplary nuclear unit. Small and quiet, it contrasts with the jumble of generations and large cast of characters crowding Steen's dissolute, middle-class households (see FIG. 3).

Moralists urged family heads to control their households and not to admit unstable outside elements, especially young men and questionable servants. Van Ostade's peasants hold up an ideal of closed family unity, tightly grouped around the table and sheltered by the etching's edges. This vision of the admirable peasant seems to contradict comic images of coarse rustics drinking, vomiting and fighting (see FIG. 57), and the difference in part marks a shift in the appreciation of peasants in the course of the seventeenth century. By mid-century, texts on peasants that extolled their simple virtue had become as numerous as comic accounts ridiculing their base pleasures. To busy city dwellers, the country bumpkin offered an image of unburdened life lived to fulfill plain physical needs. In that respect, the virtuous peasant figure is as restrictive as the comic one: it merely represents the humble opposite of the brawling boor. Benign peasant images also maintained traditional divisions between city and country and between different socio-economic layers.

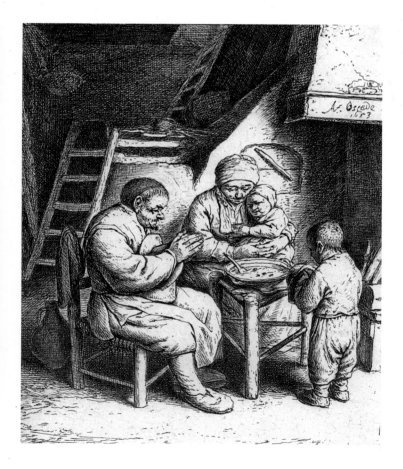

93. ADRIAEN VAN OSTADE *Prayer before the Meal*, 1653. Etching, 6 x 5" (15.2 x 12.7 cm). British Museum, London.

Genre pictures more usually situated good housekeeping in middle-class urban dwellings rather than rustic abodes. The stilled interiors of Pieter de Hooch and Johannes Vermeer define the home as a clean space for women and children (see FIGS 5 and 21). These painters tend to focus on one or two figures engaged in housework, cast in a clear light that saturates harmonious primary colors; and they structure their compositions along horizontal and vertical lines and straightforward angles. By these pictorial and thematic means, their paintings invite contemplation of domestic virtue, of the quiet and harmonious household prescribed by Cats and others. Comic images upended this ideal with more raucous motifs, unruly angles and diagonals, wild color juxtapositions, or loose brushwork.

Domestic treatises exhorted the housewife to ensure that servants carried out orders and lived a wholesome moral life. Servants frequently lived in, and this circumstance yielded rich gossip about their laziness, thieving, and sexual license. Similar to midwives in their unclear position in the family, servants, too, became mythic – and actual – destabilizers of family. In several paintings Nicolaes Maes (1634-93) explored the relationships between household, mistress, and servant, representing the housewife catching the maid asleep or, more mischievously, the maid eavesdropping on the family. In a witty picture of 1655 (FIG. 94), a maid

quietly smiles at us as she points to the room upstairs, making us complicitous in overhearing a scolding mistress. Maes generated ambiguity by hiding the object of the woman's wrath with the illusionistic curtain. To the left, utensils have tumbled over, lying idle. By opening the curtain, the painter literally reveals a badly managed household: the maid spends more time listening than working, and the mistress does not create domestic harmony.

Spinning, sewing, and lacemaking were advocated as essential domestic skills for the housewife and maiden, but in the Republic many women also used their skills to supplement the family income, selling yarn, cloth, or lace that they made at home. Occasionally, women even formed their own guilds of textile workers, exceptional within the male guild system. Maes frequently represented such industriousness in virtuous household images, but one of the most memorable of such pictures is the *Lacemaker* by Caspar Netscher (1639-84; FIG. 95). She is seen slightly from the back, in "lost profile," silhouetted in undisturbed concentration against a plain white wall. Her embroidered cap with its motif of clasped hands below a bird suggests that she is a married woman or literally has marriage on her mind. A similar marital emblem tops the title engraving to Cats's treatise (see FIG. 90). The broom is a reminder of her responsibility for a clean home.

The female gendering of the home, in pictures, texts, and life, had as its corollary the masculine definition of most public space. Although women do populate the outside, provisioning in market scenes or dallying in Italianate pastoral paintings, "serious" business beyond the home, including finance, government, shipping, preaching, and agriculture, was the pictorial and actual preserve of men. When represented in private, men still busy themselves with the outside world, with scholarship, diplomacy, account books, or sermons. Characteristically, Rembrandt represented the prominent Amsterdam regent Jan Six preparing to leave home with his coat and gloves (see FIG. 28).

The public realm was not all business and government, of course; it also encompassed more complete antitheses of home, such as taverns, gaming establishments, and especially brothels.

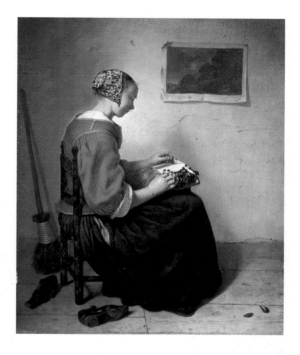

95. CASPAR NETSCHER *Lacemaker*, 1662. Oil on canvas, 13 x 9½" (33 x 24 cm). Wallace Collection, London.

The seemingly sloppy mussel shells represent the woman's special preserve, as contemporary texts frequently compared the relation between woman and home with that of the mussel to its shell: each is always in it.

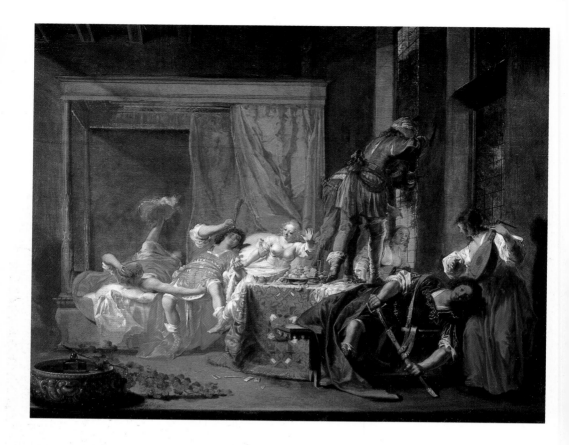

Women staffed these masculine playgrounds, but their roles there marked them as transgressive of the qualities and attributes necessary for female housekeeping, such as reticence and modest dress. Official culture censored men and women alike for excessive drinking, smoking, and prostitution. Despite the thriving whorehouse business, representation of outright bordellos seems to have been almost off limits. In the 1630s Nicolaes Knupfer (c. 1603-55) painted one such room full of swaggering men and frolicking women (FIG. 96), in a picture that seems to anticipate descriptions from *'t Amsterdams Hoerdom*, a humorous "guide" to Amsterdam's whorehouses published in 1684. The outlandish dress and behavior of the men makes them as laughable as brawling peasants in other genre paintings.

Most pictorial and written accounts of taverns were more ambiguous, however. Pieter de Hooch's gathering of a few men and women seems set in a home (see FIG. 54), yet the male attire is somewhat fanciful, with its tassels and plumes. This drinking and smoking session is surely too idle for the bright time of day.

On the other hand, the sparse glasses and intimate quiet suggest moderation, an ever-present ideal in the seventeenth century. Writers encouraged modest enjoyment of wine and other sensual delights, for they did not find moderate pleasure incommensurate with Christian life. De Hooch's painting may seek that elusive ideal of a golden mean in social interaction and appetite. As in so many Dutch paintings and texts, the responsibility for locating meaning is ultimately placed with the viewer, who is encouraged but not forced to read it in the juxtaposition between the drinkers and the painting above the fireplace. It represents the education of the Virgin, which even in the Calvinist Netherlands remained a model of moral upbringing.

The theme of De Hooch's picture within the painting is significant, as literate Dutch society believed in the necessity of religious, intellectual, and moral education for a virtuous life. Adriaen van der Werff (1659-1722) thematized this faith in a finely painted allegory on the education of children (FIG. 97). In the foreground, two fancily dressed boys and a loosely attired girl play with a cat, a caged bird, and a turtle – empty pleasures with questionable connotations in seventeenth-century thought. Their ill use of time contrasts with the diligence of the youths behind them,

98. JAN MIENSE MOLENAER
Family Visiting a School,
1634. Oil on panel, 19½ x
34" (50 x 86 cm). On loan
to Staatliche Museen,
Gemäldegalerie Alte
Meister, Kassel.

more modestly dressed in vaguely classical robes. The boy with his arm around a child summons quiet. At left, three students occupy themselves with a classical bust, and at right a young woman draws. This combination of idle and industrious children is set before a towering classical sculpture of the Greek hero Hercules, who traditionally represents Virtue, as Karel van Mander explained in his *Schilder-Boeck*. Hercules is vanquishing a personification of Envy, standard figure for all vice. Van der Werff made the elements of painterly training – the study of sculpture and drawing – stand for education as a whole, in a work that testifies to his own successful schooling in allegory as well as painting.

A school painted in 1634 by Jan Miense Molenaer makes a more general point, dispensing with Van der Werff's allegorical idiom in favor of a contrast between comic and serious modes

of painting (FIG. 98). A spacious schoolroom is enlivened by unruly boys and girls, dressed in plain clothes. The old teacher at right attempts to maintain order by corporal punishment, but, judging from the laughter of victim and bystanders, the method is not effective. At left, a well-attired man and woman are just entering, presumably to bring the children into the class or to pay a preliminary visit. Their noble bearing and different color scheme separate them from the school, however, and rather than participating in a narrative, the family provides an educated contrast to the urchins and their incompetent teacher. This painting may portray an actual family, whose proper middle-class identity is defined in distinction from that of the school group. Although such a portrait may strike the modern viewer as self-righteous, such presentational strategies were common in portraits.

FIVE

Portraiture and the Identity of Self and Community

I n the seventeenth century portraiture, in the sense of a likeness of a specific person at one moment, was of recent origin. Its rapidly increasing production in Europe since the fourteenth century was related to a growing interest on the part of literate society in personhood, in the definition of an individual self. Portraits documented, and actively contributed to, the development of notions of personal identity, as constituted by factors such as gender, marital status, class, kinship, profession, and place of origin. As this list implies, a person's identity depended to a large extent on his or her relation to groups of people. This principle held even for those who positioned themselves outside social or political bodies.

Contemporaries did not speak explicitly about the identity-forming functions of portraiture. They commissioned portraits because they made loved ones seem present while physically absent and preserved their memory after death. Portraits made on special occasions, such as weddings, could immortalize and comment on a couple's union, to themselves, their families, and visitors. Most portraits were intended for more or less public display, and they thereby allowed the sitters, whether private citizens, officials, or business leaders, to present themselves as possessing qualities suitable to their social roles. This is not to say that portraits were insincere, although by modern standards they could be, as rakes might have themselves portrayed as upstanding family men. Posed and theatrical in character, portraits helped formulate ideals of private and public personhood for sitters and viewers alike.

99. JAN DE BRAY
*The De Bray Family
Portrayed as the Banquet of
Antony and Cleopatra*,
1669. Oil on canvas, 7′8″ x
6′2″ (2.3 x 1.8 m). Currier
Gallery of Art, New
Hampshire.

Gender, Love, and Status

In the sixteenth century it was generally agreed that only those with a claim to nobility were worthy of portrayal. Nobility was primarily based on hereditary title, passed on through families thought to embody virtue quite literally. Claims to nobility could also derive from service to the state or exceptional artistic or intellectual accomplishment. Indeed, most Renaissance portraits represent monarchs, aristocrats, and famous public servants and artists. In the Dutch Republic nobility of blood and public achievement remained a primary condition for portraiture, as the numerous portraits of the Stadhouder and his entourage by the court artists Van Miereveld and Van Honthorst indicate (see FIGS 10 and 17). But the thousands of surviving Dutch likenesses suggest that portrayal had become accessible to a wider social layer. These paintings still make claims about their sitters' nobility, but in different, ostensibly privatized terms, emphasizing "interior" qualities such as intelligence, moderation, and the ability to sustain a love-based marriage.

Of the numerous individual likenesses of worthy sitters, most were intended to be seen with a "pendant," another portrait that represented the person's spouse. Pendants of married people were the bread and butter of portrait painters such as Johannes Verspronck (c. 1605/10-62). A pair of well-executed portraits of an

Below left

100. JOHANNES VERSPRONCK *Portrait of a Man*, 1641. Oil on canvas, 32 x 26" (81.3 x 66 cm). Rijksmuseum Twenthe, Enschede.

Below right

101. JOHANNES VERSPRONCK *Portrait of a Woman*, 1640. Oil on canvas, 32 x 26" (81.3 x 66 cm). Rijksmuseum Twenthe, Enschede.

unidentified couple is characteristic of the voluminous genre, which did not change significantly over the first three quarters of the century, except at the hands of innovative portraitists such as Rembrandt (FIGS. 100 and 101). Even such apparently direct presentations rely on meaningful conventions. The paintings would have faced one another, perhaps on either side of a chimneypiece. Almost invariably, the woman's portrait would hang at right, the man's at left. From the perspective of the sitters, this convention placed the woman on the man's *sinister* (left-hand) or lesser side, according to theological and social formulas which valued the *dexter* (right-hand) position more highly. This rule conformed to seventeenth-century Dutch views of marriage as a partnership based on mutual affection but steered by the man.

The sitters are posed before an indeterminate background that focuses the viewer's attention on their faces and hands, which stand out in bright contrast to the black costumes with white lace trim. Although these costumes are modestly colored, they are made of the finest materials and look up-to-date, for 1640. The bodies of the partners are turned towards each other, their mirrored triangular shapes registering the harmonious balance of their union. The woman's outline is more contained, however, as she holds a fan close to her. The man poses dynamically, his left hand holding a glove and the other bent back at his side, making his right elbow jut out towards the viewer. The contrast between the man's active stance and the woman's physical reticence would be appropriate in customary social ritual. The lighting, from the left as in most Dutch paintings, subtly enhances the expected active/passive dichotomy between the partners. Such lighting throws the man's features in relief, as his nose and eyebrows cast shadows, whereas the direct light smooths the woman's visage to placidity. The leather glove and feather fan enliven the portraits, and the sitters handle them according to social decorum: the man has pulled off the glove as if preparing to meet the viewer, and the woman holds the fan down in restrained expectation.

Through these pictorial nuances these anonymous people appear as wealthy but understated marriage partners, acting in effortless concord by conforming to their preferred roles. Their portraits present them as fine citizens who live out the ideal of accomplished moderation. The conventions that sustain this image were so standard as to seem natural, and it is that apparent self-evidence that made them effective. No seventeenth-century portrait painter willfully orchestrated them to formulate the roles of men and women, but in aggregate they unwittingly contributed to such definitions of gender and marriage.

102. FRANS HALS
Isaac Massa and Beatrix van der Laen, c. 1622. Oil on canvas, 4′6″ x 5′2″ (1.4 x 1.6 m). Rijksmuseum, Amsterdam.

While most marriage portraits are stately in Verspronck's mode, some sitters sought livelier formulas. The most innovative portrait painter, alongside Rembrandt, was Frans Hals, Verspronck's Haarlem colleague. There are no direct Dutch precedents for his double portrait thought to depict Isaac Massa and Beatrix van der Laen, probably painted for their wedding in 1622 (FIG. 102). The painting was unconventional: an outdoor setting, full-length and casual poses, public displays of affection, and smiles may be expected in modern photographs of lovers, but they were uncommon in seventeenth-century portraiture. Hals must have collaborated with the couple in formulating the portrait. Massa was a successful merchant in the Russian trade, a diplomat, and an intellectual. His cosmopolitan outlook, probably matched by that of his bride, a regent's daughter, may have predisposed him to a full-length format, garden setting, and affectionate pose, all of which were more customary in the Flemish portraits of Peter Paul Rubens (1577-1640) and his followers. Hals integrated numerous symbolic references to marriage into the portrait. Between the partners, a vine winds up the tree, metaphoric for the love and mutual fidelity on which marriage is built. The ivy to the woman's right has similar significance. Hals articulated the desirable marital relationship by having her lean on his shoulder, just as the vine depends on the tree. The same image appears next to the married couple on the title-page of Jacob Cats's marriage treatise (see FIG. 90). In keeping with the portrait's physicality, the thistle in the foreground had earthier associations. Its presumed aphrodisiac qualities related it to sexual rather than spiritual aspects of marriage, although as such it could mark monogamy.

In their natural appearance, these allusions resemble the unobtrusive references of genre painting. A knowing viewer could delight in the variety of lifelike elements and tease out their added, somewhat hackneyed significance, but it would be reductive to present this painting as a symbolic puzzle. Large and sunny in tone, with amorous strollers in the fanciful garden behind, the painting exudes a confidence in marriage based on love that strikes a modern note. Such sentiment is not uncommon in seventeenth-century texts either, despite ubiquitous calls for socially and financially balanced marriages. As Isaac Massa and Beatrix van der Laen fulfilled those requirements, they could freely commission a pictorial celebration of their bliss – however actual or imagined.

Less common than marriage portraits were family portraits, perhaps because of their greater expense, as portrait prices were partly calculated per head. Their surviving number is considerable, though, and their variety somewhat greater than that of marriage

portraits. In two very different paintings, for example, Jan Miense Molenaer juxtaposed parents and decently raised children with a classroom of rascals, and portrayed several generations of a family joined in musical harmony (see FIG. 4). This painting is explicit about its function to preserve memory, as it includes portraits of family members already deceased.

The same purpose is evident in a large portrait of the De Bray family, in which all members participate in the legendary banquet of Antony and Cleopatra (see FIG. 99, page 131). It was painted in 1669 by Jan de Bray (c. 1627-97), probably represented in profile at left, the son and brother of several Haarlem painters. His parents impersonate the Roman general and the Egyptian queen, at a feast she organized in a bet that she could spend the largest fortune on one meal. Although the fare was simple, Cleopatra defeated Antony by dissolving one outsized pearl earring in acid and swallowing the drink. Since Jacob Cats and others commented on the humorous but reprehensible vanity of the story, De Bray's decision to make his family perform it may seem bizarre. In most family portraits, poses, gestures, costumes, and attributes speak of harmony, good education, and modesty; the wife and mother in particular would display exemplary virtue. The decadent Cleopatra seems the antithesis of a modest, reticent, and maternal woman. Although her banquet is indeed an unparalleled theme in portraiture, the genre of the portrait in historical guise to which it belongs makes explicit the theatricality of all portraiture, in which sitters pose before painters and viewers in carefully selected guises and settings. The historical portrait genre presupposes a beholder steeped in the traditions of painting, and De Bray's painter family would have been an ideal audience for such experiments.

Jan de Bray painted an earlier version of the composition in the 1650s, when all his family were alive. That painting was later sold to Charles II, King of England, and De Bray must have made the painting reproduced here to preserve the memory of the picture and of his parents and siblings who had died by then. The King apparently enjoyed the composition as a history painting, for it is unlikely that he would have desired a portrait of a Haarlem family. As a connoisseur, however, he may have appreciated De Bray's clever blend of portrait and history conventions.

Pastoral costumes were among the favorite historical guises. From the early 1620s, nobles in particular chose to be represented as the protagonists of Italian and Dutch pastoral plays. A ravishing portrait of Anna du Pire by Bartholomeus van der Helst (1613-70) indicates the special resources of pastoral portraiture (FIG.

103. BARTHOLOMEUS VAN DER HELST
Anna du Pire as Granida, 1660. Oil on canvas, 27$\frac{1}{2}$ x 23" (70 x 58.5 cm). Private collection.

Anna du Pire is placed on the leading left side, originally opposite the portrait of her husband, the painter. This reversal of the standard marriage pendant arrangement may be due to her status in the story as princess, of higher rank than the shepherd Van der Helst impersonated.

103). In contrast to Verspronck's decently buttoned sitters in black-and-white, Du Pire is wrapped in swaths of red, blue, and white silk, bedecked with pearls and a red feather headdress. Her décolleté leaves little to the imagination. A respectable woman could be represented in this way only for sound narrative reasons, and they are suggested by the bow and arrows and the shell filled with water. Viewers familiar with the famous play *Granida* (1615) by

Pieter Cornelisz Hooft would have recognized these elements as references to its title heroine, a princess lost during the hunt who receives water from an adoring shepherd. The portrait indeed has a shepherd pendant of her husband, the painter himself, and the pair form a romantic marriage set. Although Du Pire's identification with Granida justifies her attire, even for a pastoral portrait this painting teeters on the edge of proper representations of actual people. Because she was Van der Helst's wife, probably only he and his intimates, acquainted with his innovative portraiture, had access to her portrait.

Until the 1640s, elegant, bright portraits, pastoral or otherwise, had largely been the preserve of members of the Stadhouder's court and other nobles. By contrast, successful urban citizens had themselves portrayed in expensive but understated fashions, thus claiming a nobility based on interiorized virtue. After the temporary demise of the court with the death of Willem II in 1650, non-aristocratic elites for the first time assumed complete leadership of the Republic, which had just gained definitive independence. It has been argued that, as regents absorbed the court's political power, they began to favor the lavish portraits formerly associated with titled nobility. Many burghers took up the courtlier modes of portraiture developed by Anthony van Dyck (1599-1641) and his followers in Flanders and England. Besides representing an increasingly luxurious society of rentiers and land investors, these portraits elegantly mark the full transfer of power and its supporting ideology to the urban regents.

Other genres of painting also bespeak the secure prosperity and noble aspirations of regent families in the second half of the century. Paintings were larger on average, to fit vast spaces in the houses built or extended on the main canals in Amsterdam and Leiden and in the newly constructed country retreats. More tellingly, new themes suggest a widening interest in noble pursuits, especially the hunt. This carefully regulated pastime was reserved for the nobility and high regents through a system of permits. There was a sufficient market for hunting imagery, especially in Amsterdam and Haarlem, for painters to specialize in it.

Willem van Aelst (1626/27-after 1683), who had been court painter to the Medici in Florence, supplied Amsterdam citizens with fine still lifes of game. In several (FIG. 104), Van Aelst displayed the finely worked equipment of the huntsman on a marble ledge: a velvet hunting bag with chamois strap, trimmed with gold embroidery and fringes, and a tasseled horn. Above it he suspended the exquisite catch of a fat partridge and three small game birds. But the picture offers food for thought as well. The marble slab

105. PHILIPS WOUWERMANS. *Stag Hunt in a River*, 1650s. Oil on canvas, 4'5" x 6'5" (1.3 x 1.9 m). North Carolina Museum of Art, Raleigh.

is supported by a classicizing relief that represents the bath of Diana, the classical goddess of the hunt, and her nymphs. The huntsman Actaeon happened upon them and feasted his eyes on their flesh. In punishment, the chaste Diana changed him into a deer, as the antlers next to the nymph at left remind the viewer. His own dogs then devoured him. The message seems mixed, for the hunter and the collector, both of whom depend on the acute, loving sight that proved Actaeon's downfall. The story may urge viewers not to place too much value on the physical pleasures of the hunt and painting, yet such a warning is at best ironic when issued by such a seductive painting. Van Aelst underscored the lifelikeness of the scene, however implausible the arrangement, with the fly poised to feast on the dead partridge – a motif that could also be read as a reminder of the bird's imminent putrefaction and of art's capacity to postpone such rot indefinitely.

The least familiar object in Van Aelst's painting is the red and tan falcon's hood. Falconry (hunting with carefully trained birds of prey) was the most exclusive noble privilege. Philips Wouwermans (1619-68) repeatedly represented ladies holding falcons or hawks in hunting scenes. His *Stag Hunt in a river* (FIG. 105) also represents a prerogative of aristocrats; even they were permitted to hunt deer only one day per year. The Italianate, rose-colored

landscape seems a leisure ground, a never-never land rather than a productive hunting field, even if the run-down cottage hints at the transience of such pleasures. Especially in the eighteenth century, such paintings fetched high prices from Dutch, French, and British aristocratic and upper-middle-class collectors. Wouwermans must have done well with them in his lifetime, too, for he died as wealthy as some of his patrons. The viewing and display of hunting landscapes and gamepieces must have contributed as much to personal and social identity as portraits could. At least some of the people who owned such paintings may not have had access to the actual hunts.

Professional and Civic Identity

Numerous people were portrayed not only in familial roles but also as professionals. Thomas de Keyser (1596/97-1667), Amsterdam's leading portrait painter before Rembrandt arrived, portrayed

106. REMBRANDT
The Preacher Cornelis Claesz Anslo and Aeltje Gerritsdr Schouten, 1641. Oil on canvas, 5′6″ x 6′9″ (1.7 x 2.1 m). Gemäldegalerie, Berlin-Dahlem.

The identification of the woman as Anslo's wife has occasionally been doubted, but it was recorded early on by members of his family, with whom it remained for a century and a half. Anslo preached to the Mennonites, a pious, non-hierarchical Calvinist congregation that had no ordained preachers.

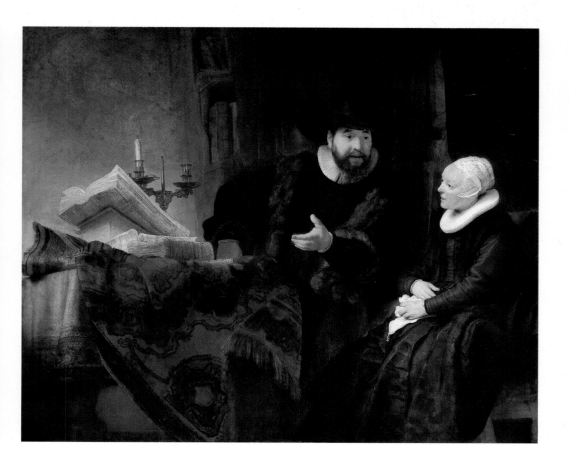

Constantijn Huygens as a man of letters and diplomacy, receiving a message from his personal clerk in his study filled with fine objects of trade and learning (see FIG. 7). Huygens himself wrote several epigrams (witty short poems) on portraits, in which he noted that, although painters could never match nature, they almost managed to represent persons as if speaking. Such qualified praise for portrait painters resounds throughout seventeenth-century poetry on portraits. It appears especially in laudatory descriptions of male subjects, as their professions and private identities frequently depended on the capacity for articulate speech. In women, eloquence was considered less desirable, often equated with gossipy loquaciousness. Portraits usually represent women with mouth closed and without the rhetorical gestures of male sitters.

Of all painters to portray men in their speaking identities, Frans Hals and Rembrandt were the most successful. Rembrandt's portrait of the Protestant preacher Cornelis Anslo (1592-1646) speaking to his wife Aeltje Schouten (1598-1657) virtually embodies the formula (FIG. 106). More than any vocation, the preacher's depended on the persuasiveness of speech, and Anslo, who was famous for his eloquence, looks equal to the task. Almost half of the painting is occupied by the Bible and exegetical texts that support his faith and speech. But he does not need them as he preaches, leaning away from his desk to speak to his wife and his imaginary audience. He holds out his open left hand, in a rhetorical gesture of address. Reaching a universal congregation, he does not regard his wife or anyone in particular, letting the word issued from his opened mouth deliver his message. His wife stands model for the Christian audience. With her ear, rather than her eyes, turned towards him, she is absorbed in his words.

Rembrandt's near life-size painting of 1641 must have made an impressive display of Anslo's oratory. In the same year, Rembrandt published an etching of Anslo alone at his desk, with closed mouth. Three years later, Joost van den Vondel, who was related to Anslo by marriage, published four lines apparently about the print:

> Aye Rembrandt, paint Cornelis's voice.
> His visible part is the least choice:
> The invisible is known only through the ear.
> Whoever wants to see Anslo, must hear.

This poem may seem uncomplimentary to Rembrandt but it fits the seventeenth-century mold of poems about portraits: it praises a preacher whose identity exists in his oratory, and it acknowledges

107. GERBRAND VAN DEN EECKHOUT
Four Members of the Amsterdam Coopers Guild, 1657. Oil on canvas,
5'3" x 6'2" (1.6 x 1.9 m). National Gallery, London.

One of the officers represented is the painter's brother, Jan van den
Eeckhout, who belonged to the guild. The introduction served Gerbrand
van den Eeckhout well, for the guild commissioned another group
portrait from him in 1673, four years after his brother's death.

the difficulty of representing such a man in a soundless medium. It has been suggested that Rembrandt knew the quatrain when he was finishing the painting and that he tried to answer Vondel's challenge in it, by opening Anslo's mouth and adding his wife. Whatever the relationship between poem and painting, it is clear from Rembrandt's sizable production of speaking likenesses that Dutch sitters appreciated his visualizations of public identity.

Professionals seldom worked in isolation, and many took pride in their roles within governing bodies of their organizations. Numerous groups of directors, or governors of guilds, hospitals, orphanages, and quality control boards, had themselves portrayed on large canvases, for display in their board rooms. The number and variety of these Dutch portraits was unparalleled in Europe, and in one sense this production is a secular modification of the former guild practice of commissioning altarpieces for chapels.

In 1657, Gerbrand van den Eeckhout (1621-74), a successful pupil of Rembrandt, painted four directors of the guild of coopers and wine rackers (FIG. 107). Closely framed by the picture's edges, the men fill the room with their bulk and calm, talking over their account books with restrained gesture. Two of the men regard the viewer directly, as does the dog, traditional symbol of fidelity. Behind them is a painting of the guild's patron saint, Matthias, with an axe, tool of their trade and the alleged instrument of his martyrdom. Other cooperage implements adorn the picture's frame, but these allusions do not overburden the portrait. The lifelikeness of these flesh-and-blood burghers suffices to inspire confidence. They momentarily interrupt their business to attend to the beholder, one man marking his place in the ledger. Their differentiated facial features guarantee their individuality, commemorated also in a document on the table that bears their names. Ironically, their names can no longer be matched to their faces, and it is their corporate identity, established by the sameness of their weighty presences, that is most memorable. These men seem to be of a species of responsible leader.

The most frequently produced professional group portraits represent officers of civil militia companies. With origins in the fifteenth century, these organizations of male citizens, commanded by members of the urban elite, helped patrol and defend their cities. To this end, each company had the right to carry firearms. All men who could afford the dues served in these civic guards. In the seventeenth century, companies were still mobilized in times of peril but they rarely performed actual military services. They continued to fulfill significant social functions in their neighborhoods, where they met in company halls, most of them deco-

rated with portraits and insignia related to the militia's history and privileges. When dignitaries visited a town, guards marched to add lustre to the festivities and display the city's strength. Banquets, shooting drills, and other activities reinforced the group's cohesion, and the halls and exercise grounds also served as places for the exchange of information. The portraits of these companies, or rather of their officers, are different from the professional guild portraits, as militia members could have any type of respectable job. Although akin to professional group portraits in their presentation of the company as reliable and unified by its traditions, militia portraits could be more celebratory, even swaggering, in keeping with the guards' military and festive roles.

In Haarlem, Frans Hals was sufficiently well off to serve in the St. George civic guard. His membership probably secured him his first commission to paint the company's officers, an honor and financial plum that the city's companies would bestow on him four more times. It is easy to understand why. Although such paintings had been produced for a century or so, Hals's first effort in the genre imbued it with novel liveliness. In the *Banquet of the Officers of the St. George Militia* of 1616 (FIG. 108), the officers are crowded around a banquet table that evokes the traditional farewell meal for the officers, who had just finished their three-year term in 1615. These banquets were more lavish than the choice but small selection of roast meat, olives, bread, and wine suggests. This hint of a communal banquet, kept small to give prominence to the officers, serves to symbolize the harmony fostered and enacted by that social ritual. Several of the officers perform tasks associated with the celebration. At the head of the table, second from the left, the colonel raises his glass to make a toast. A captain in the center of the painting lifts the roast with his left hand as he prepares to carve it ceremoniously. The three flag-bearers are standing as if they have just entered to surrender their colors, as was the custom. Most of these ritual motifs are present in earlier militia pieces. Hals's new achievement is their pictorial integration into a seemingly natural event, unified by the dynamic, varied repetition of sashes and banners in the company's orange and white.

Rembrandt's largest painting, *The Nightwatch* of 1642, represents an Amsterdam company in another ceremonial role, gathering for a procession (FIG. 109). It was one of six group portraits painted between 1639 and 1645 of militia companies that shared a prestigious, recently expanded assembly hall (see FIG. 15). The decoration of this social space, opposite the street from the shooting range, constituted the most significant public commission in Amsterdam before the new town hall. The central man

108. FRANS HALS
*Banquet of the Officers
of the St. George Militia,*
1616. Oil on canvas,
5'6" x 10'5" (1.7 x 3.2 m).
Frans Halsmuseum,
Haarlem.

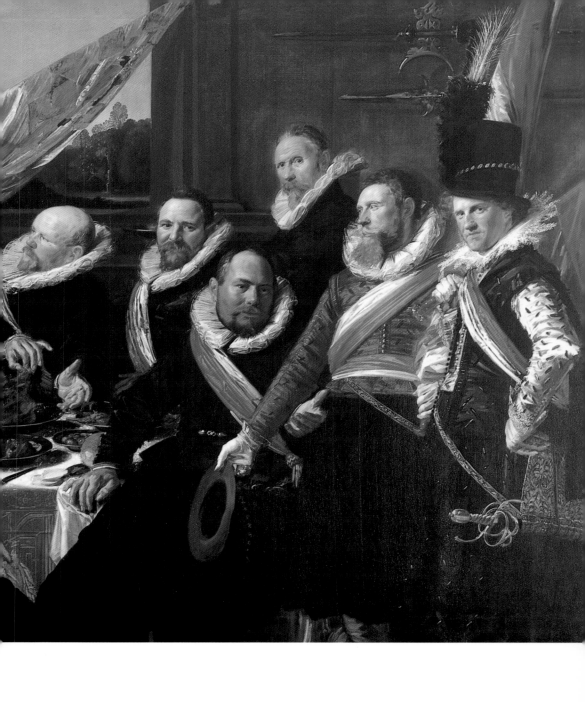

in *The Nightwatch* is Captain Frans Banning Cocq (1605-55). His family album records the painting's theme: the captain "summons his lieutenant...to order his company of citizens to march." Banning Cocq indeed has his mouth open and hand extended in a speaking gesture. The shadow of his hand significantly falls onto the golden costume of his lieutenant. Both men stride ahead, and the company is starting to follow. Strikingly, the caption in Banning Cocq's album focuses on the painting's momentary action, rather than its portrait status. The remarkable hierarchy of portrayal, with its emphasis on the captain and the lieutenant, led later observers to believe that the other 14 sitters had been dissatisfied, but Rembrandt was paid full price, each sitter paying a share depending on his prominence in the painting. The myth does indicate Rembrandt's departure from the militia portrait norm, in which the highest officers stand out but never condemn the others to oblivion. Rembrandt subordinated the likenesses to a cen-

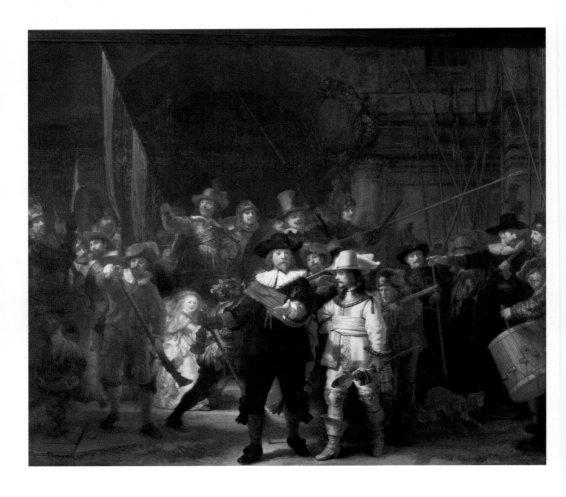

tral action that expresses the ceremonial function of the civic guard. The nuanced pattern of light and dark unifies the company, in a pictorial metaphor for its harmony.

Two small, spotlit girls and a helmeted youth stride to the right, against the company's flow, and their divergent path marks their allusive significance. The most prominent maiden has a fowl suspended from her belt, a curious ornament to her brocaded dress. Its noticeable claws refer to the company's traditional emblem of a claw. The helmeted character fires a musket, to the surprise of the guardsman between the captain and the lieutenant. That officer's restraining gesture evokes the company's rules governing the exercise of its muskets: unlike the rogue figure, the company officers know when to wield their arms. Rembrandt visualized the company's command of musketry by letting two officers handle weapons: at left, one primes his musket, and at right, another blows the pan after firing. Together with the central firing, these actions demonstrate the firearm's use. Arms drill was a highly developed practice, elucidated in a manual first published in 1607 and illustrated by Jacques de Gheyn II. Rembrandt may have referred to its prints as he painted the figures wielding muskets, for their poses conform strikingly to those in the illustrations (FIGS 110 and 111).

110. JACQUES DE GHEYN II
Ramming the [gun] powder,
woodcut from *The Exercise of Armes,* 1619, 7 x 5″
(17.8 x 12.7 cm). Private collection.

By structuring *The Nightwatch* as one action in the company's history and by articulating its traditions and rights, Rembrandt blended the conventions of portraiture and history painting. *The Nightwatch* seems an almost deliberate synthesis of the two genres that formed the backbone of his career. Perhaps for this reason Samuel van Hoogstraten described the painting as too unified after Rembrandt's own choice and insufficiently concerned with portraiture, even though he admired its apparently effortless composition. Like portraits in historical guise, Rembrandt's experiment has a theatrical look. The drummer at right, in sixteenth-century costume, even recalls traditional processions of rhetoricians, but it is unnecessary to postulate a specific performance or procession. The theatricality of *The Nightwatch* proclaims the representational function of the civic guard and simultaneously acknowledges the role play of all portraits.

111. JACQUES DE GHEYN II
Priming the pan, woodcut
from *The Exercise of Armes,*
1619, 7 x 5″ (17.8 x 12.7
cm). Private collection.

Militia portraits embody community in the grandest manner. As the discussion of Dutch pictorial myths has suggested, however, less assuming works could foster and express shared civic or class identity as well. Paintings of traditional village festivals, no longer real events for most urban owners of such works, nostalgically project harmonious community, in a period in which social celebration increasingly retreated into the home. A *May Queen Festival* by Richard Brakenburg (1650-1702), painted in 1700,

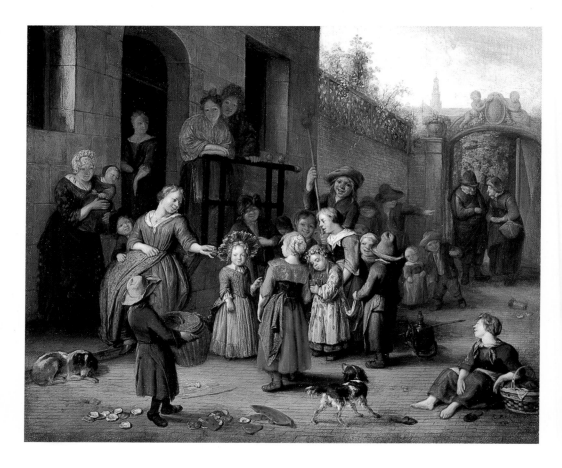

112. RICHARD BRAKENBURG
May Queen Festival, 1700.
Oil on canvas, 16 x 19" (41
x 48 cm). Szépmüvészeti
Múzeum, Budapest.

imagines a lovely procession of country bumpkins, all as innocent as the girl who leads the quest for spring treats (FIG. 112). This innocuous interpretation of country festival seems at odds with Calvinist rhetoric and occasional government edicts against "Popish," and potentially inflammatory, public celebrations. More gently than such arguments, Brakenburg's painting takes the sting out of lower-class pleasure, allowing well-off viewers to enjoy it as communal harmony.

Identities Preserved: Ironies of Portraiture

Portraiture was a primary means by which Dutch society constituted the individual; its production was more voluminous than that of written biographies, for example. The ideal self varied with such factors as social status, gender, marital situation, professional interest, and religious denomination. Preferred qualities in portraiture of the citizen elite included moral strength,

moderation, learning, eloquence, social grace, and fidelity to spouse, profession, and city. Such ideal personhood was not accessible to all in equal measure. Women partook of it somewhat less than men. The identities of servants, peasants, and urban workers, as articulated in genre pictures, were even more restricted and very much attributed from outside and above. Albert Eckhout's images of Brazilian people, although individualized ethnographically, are not likenesses of specific persons either: although using portrait conventions, each stands for a type rather than one self (see FIG. 87). The rules governing who could be portrayed, and how, thus mirrored and structured hierarchies in the social fabric.

Yet despite portraiture's claim to immortalize worthy individuals, most sitters have lost identity with time. Most of the portraits in this book seem more recognizable as works by a known artist than as likenesses of specific persons. Only prominent historical characters, such as Jan Six, or those represented especially memorably, such as Frans Banning Cocq, evade this predicament. Many sitters cannot be named. In 1690, Haarlem's civic guards were already so concerned about this issue that they conducted research to put names to Hals's militia officers. But they had not forgotten who painted them.

Strong marks of personal style – the painterly dash of Hals, the characteristic light and dark of Rembrandt – ensure that later generations know portraits primarily by their makers. Hals's insistent style can even call the status of his portraits into question. *The Laughing Cavalier* claims to be a portrait through the subject's pose and background, his direct look at the viewer, and the traditional inscription of age (see FIG. 56), yet the upturned mustache, the gleam in his eye, and the flamboyant costume all flout modest portrait conventions, as indicated by the name the sitter received later. The painting crosses the rules of individual likeness with those of the militia banquet and the genre figure. Like *The Nightwatch*, *The Laughing Cavalier* bespeaks the artist's identity as eloquently as that of the portrayed.

Architecture of Community

Any discussion of artistic contributions to civic identity must consider architectural statements of community. Just as the restrained classical buildings of private citizens acknowledged the prestige and discernment of their owners, so guild and town halls allowed corporations and cities to project a vision of their communalities. In this sense, municipal buildings portray their cities, as the different cases of Delft and Amsterdam may demonstrate.

In 1618, a fire raged through the Delft town hall, destroying all but the fifteenth-century tower. The burgomasters immediately began to rebuild their government center, which had been a source of civic pride. Within two months they approved Hendrick de Keyser's design for a new building in the old location (FIG. 113). Although the symmetrical plan and facade of De Keyser's building transformed the old irregular pile of foundations and additions, the new town hall maintained connections with its impressive past. De Keyser reused parts of the old walls and incorporated the tower with its famous carillon. By placing the main entrance in the facade on the open market square, he gave the community a frontal view of the tower. There, it communicates directly with Delft's greatest religious tower across the square, that of the New Church. The facade has a three-storey central bay, or "frontispiece," flanked by two-storey side bays. The covered balcony above the entrance gave access to temporary scaffolds, built in front of the town hall to allow the population to witness executions. (Besides serving obvious exemplary functions, such displays of capital punishment assured the community of the just

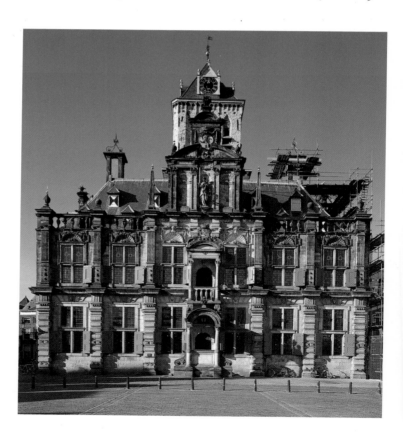

113. HENDRICK DE KEYSER
Delft Town Hall, Market
Square, 1620.

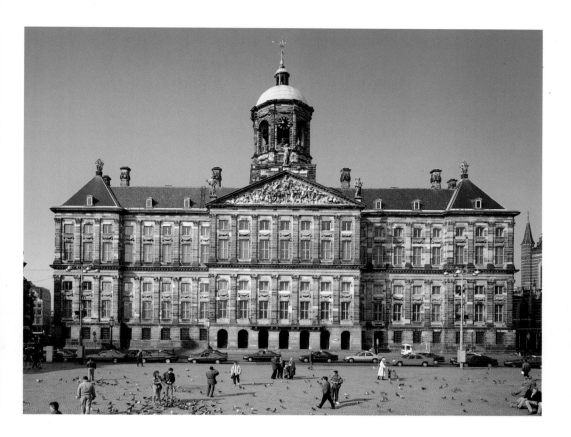

enforcement of its laws.) De Keyser designed the facade according to classical principles, placing Doric pilasters on the ground floor, Ionic ones on the second, and Corinthian in the top level of the frontispiece, and relating the individual parts according to classical proportions. Although this usage followed prescriptions from Italian Renaissance treatises, the facade looks distinctly local. The strongly vertical frontispiece, reinforced by the tower behind, stands in a Netherlandish tradition first perfected in Antwerp, as does the richly colored ornamental idiom, classical in origin but recombined by local grammar. The Delft town hall gained renown as Holland's finest, a status it enjoyed until mid-century, when Amsterdam constructed a veritable government palace.

By the 1630s, Amsterdam's old town hall had become derelict. The decision to replace it was hastened by its overcrowding, occasioned by the rapid growth of the city's population (from 60,000 in 1600 to 135,000 by 1640), economy, and civil service. In 1648, the four burgomasters selected Jacob van Campen's scheme for the largest building ever built in the Republic, rivaling the palaces of ancient and modern Rome and the sixteenth-century town hall

114. JACOB VAN CAMPEN The former Amsterdam Town Hall, now Royal Palace, Dam Square, 1647-55.

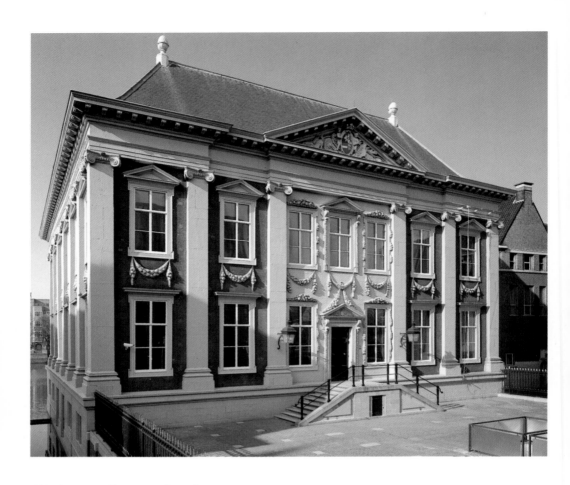

115. JACOB VAN CAMPEN AND PIETER POST
South facade of the Mauritshuis, The Hague, 1633-44.

In the Amsterdam town hall, the grandest architectural statement of regent government in the Republic, Van Campen developed a more severe version of the elegant classicist mode he had created in the Mauritshuis for the noble military leader Johan Maurits.

of Antwerp. Van Campen's command of classical principles is evident in the symmetrical plan and facades, with their low pediments and insistent rows of elegant Corinthian and Composite pilasters (FIG. 114). The sparingly ornamented exterior is more rigorously classical than the Delft town hall or even the Mauritshuis, the residence Van Campen had built for the Brazilian governor Johan Maurits (FIG. 115). Instead of a tall tower for the city clock and bell, Van Campen designed a cupola along recent Italian lines. The building's two main floors deliver the exterior promise of lucid organization. The regularity of the plan, its lofty rooms efficiently connected by corridors and staircases, maps an ideal of rationalized government. The massive stone walls and vaults embody the reliable and unwavering government necessary for Amsterdam's economic and civic stability.

The building was festively inaugurated in 1655, with sermons likening it to the Temple of Jerusalem and with a procession of militia companies. A panegyric by the poet Joost van den Vondel announced Amsterdam's arrival in the international league of public architecture led by classical Rome and Renaissance Venice. He described the building as a sanctuary for a republican government, impervious to corruption and watchful to preserve peace and foster economic and civic life. The building's sculptural and painted program coherently visualized this statement of purpose. In the east and west pediments, sculpted personifications of the oceans and continents bring homage and the fruits of commercial enterprise to Amsterdam's maiden. Her global reach is laid down also in maps of the hemispheres and the northern sky in the marble pavement of the citizen's hall, a public room two storeys tall that divides the building's north and south halves. In the chambers of burgomasters and justices, paintings and sculptures detail the responsibilities of the regents for justice, peace, and virtue, through such historical exemplars as Marcus Curius Dentatus (see FIG. 70) by Govert Flinck. Marveling at the building's comprehensive articulation of the city's ambitions and self-image, Amsterdam's citizens and visitors praised it as the eighth wonder of the world.

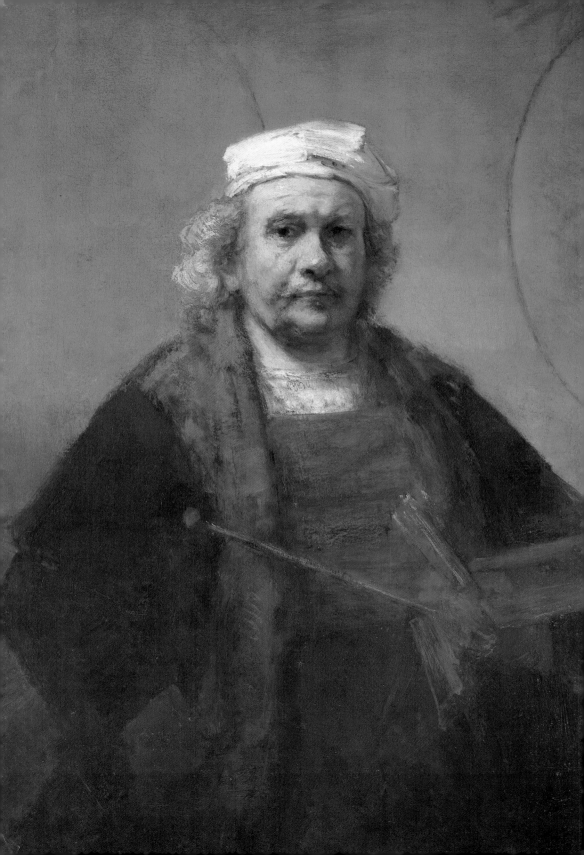

SIX

Artistic Authority

D utch pictorial culture produced meaning in interactions between artists, customers, and other viewers of images. In the pictorial results of those negotiations artists called attention to their handiwork by signatures or self-portraits, and more obliquely through distinctive motifs or marks of their artistry. They also made explicit statements, both verbal and visual, about the aims and means of pictorial representation.

Representing Selves

According to Italian Renaissance art theory, all painters depict themselves in their work. This proverb, well known in the Netherlands, originally meant that painters unwittingly represent other people with their own features. Soon, however, writers on art applied the rule to the overall character of an artist's production. Many painters seem to have adopted the notion, with self-portraits and with particularly insistent pictorial manners.

No painters before Rembrandt – and few after – portrayed themselves more frequently and in more varied guises than he. From his apprentice days, he sketched, etched, and painted his own face and body, leaving almost two self-portraits per year of his career. The function of these works has been the subject of heated debate. No self-portraits were recorded in the inventory of his possessions drawn up in 1656 and a few were owned by international collectors: apparently, however personal they may look and however important they may have been to Rembrandt's sense of self, they were meant for public viewing as well.

A large self-portrait of the 1660s acknowledges this dual condition of self-portraiture, as it seems both confrontational and deeply introspective (FIG. 116). Rembrandt stands frontally before the viewer, in a pose apt for kings, as Hans Holbein's unforgettable

116. REMBRANDT
Self-Portrait in Painter's Costume, c. 1660-62. Oil on canvas, 45 x 37½" (114.3 x 95.2 cm). Iveagh Bequest, Kenwood House, London.

formula for King Henry VIII of England (1491-1547) attests. But Rembrandt acts as lord of a painterly realm. He wears the long smock, plain white cap, and simple collar of the painter. His left hand, a heavily reworked area of the painting, is virtually constituted by painter's tools. Rembrandt's emphasis on the manual, labor-intensive basis of the painter's art, proclaimed by the obvious materiality of the paint surface, reverses conventions of self-portraiture, according to which painters pose as gentlemen or intellectuals. Behind Rembrandt, presumably on the wall, are two roughly painted circles. They may represent a map of the Earth in which each circle represents one hemisphere or perhaps a juxtaposition of a smaller terrestrial globe with a larger celestial one. Either cartographic motif might make present the visible world that was thought to be the domain of all artists, an apt reference for Rembrandt, who worked universally, in almost all pictorial genres.

By representing himself as artisanal master of his pictorial world, Rembrandt advocated his own style of painting, which shows such clear evidence of his hand. This "rough" manner, it is evident from the majority of contemporary works, lost some of its favor with collectors after mid-century, when the "neat" manner was preferred more widely. In the years in which Rembrandt painted this self-portrait, the Amsterdam government rejected his *Conspiracy of Claudius Civilis*, painted for the town hall, probably in part for its rough, shadowed looks (see FIG. 71). Rembrandt's furrowed brow and shaded eyes do not announce his distress at his critical misfortunes, however. They are the traditional marks of the melancholy artist, a painter tormented, according to ancient medical lore, by an excess of the body fluid black bile. Since the Renaissance, such melancholy had been considered a condition of intellectual and artistic genius, as Cesare Ripa pointed out in his manual of personifications. The Dutch edition states that Melancholy is represented as old and as having drawn geometrical figures. This prescription offers additional clarification for the circles behind the aging Rembrandt. By assuming the exalted stigma of melancholy, Rembrandt may have made his proclamation of the manual basis of his art even more defiant.

Although Rembrandt usually represented himself seriously, he sometimes chose comic, even debauched roles. Jan Steen, a predominantly comic painter, frequently portrayed himself in such guises in dissolute households and tavern scenes and thus constructed a comic identity in paint. In his account of a birth celebration, the prankster making the sign of the cuckold sports Steen's features (see FIG. 91). Although the extent of Steen's compromising self-

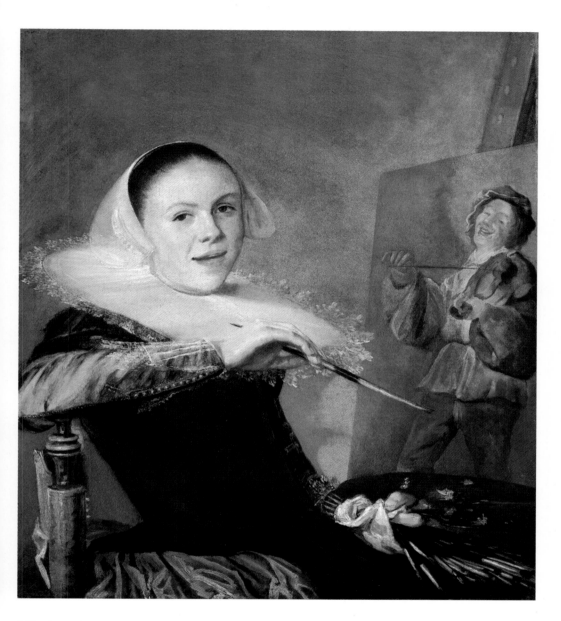

117. Judith Leyster
Self-Portrait, c. 1630. Oil on
canvas, 29¼ x 25½" (74.3 x
65 cm). National Gallery of
Art, Washington, D.C.

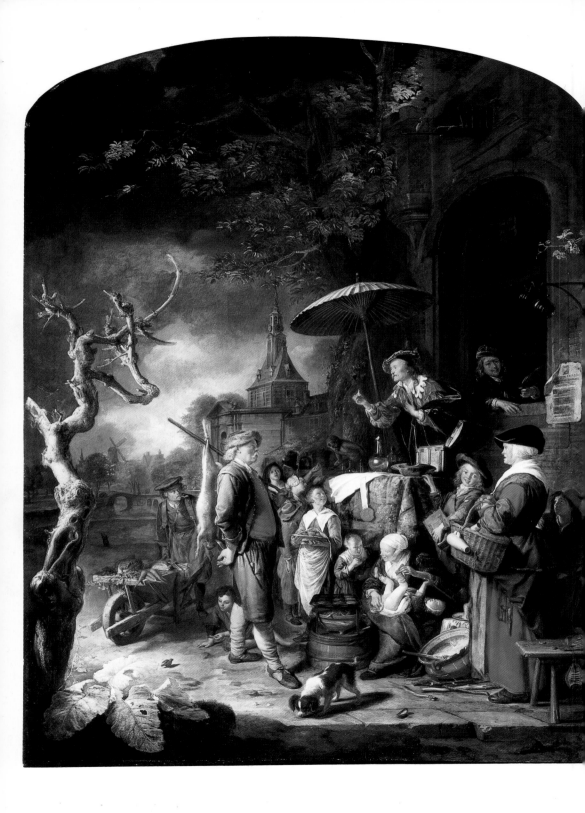

portraiture is unparalleled, many of his colleagues represented themselves in similar vein on occasion. Judith Leyster (1609–60), a genre specialist, created a cross between proper and jolly self-representations. In her self-portrait of 1630 (FIG. 117), she is seated at her easel in elegant dress, rather than the smock she would have worn at work, but she advertises her chosen specialty, for she has just painted a comic figure and, like Steen in his self-presentations, she smiles at the viewer. Laughter and smiling were uncommon in sober portraiture, although Leyster's teacher, Frans Hals, and her husband, Jan Miense Molenaer, used it to enliven their likenesses. In her self-portrait, Leyster presented herself as a lady artist, genre painter, and master in Haarlem's recent tradition. The synthesis is as remarkable and distinctive as much of her small output, which is unlike that of most contemporary genre painters.

At the opposite end of the spectrum from Rembrandt's three-dimensional paint layers stand the smooth surfaces of his first pupil, Gerard Dou (FIG. 118). As already suggested, the seeming absence of Dou's involvement in pictures such as the *Quack* paradoxically emphasizes his miraculous handicraft. Dou and his Leiden followers seem to have developed this manner deliberately, perhaps from an initial stimulus in Rembrandt's early, consciously realist works. In the *Quack*, Dou mused on his artistic identity. At first sight, the painting merely represents a traditional comic theme, in which gullible people listen to a quack doctor hawking his spurious wares, authenticated by numerous fake patent letters. The familiar motif of the woman cleaning a baby and the dead tree in the foreground signal the futility of his medicine and of all human endeavor to escape death. But these standard references do not exhaust the painting's metaphoric means. Dou represented himself in the window behind the quack, visually rhyming his own professional identity with that of the charlatan. Comic and serious texts alike called painting deceptive, for its ability to convince the viewer of the materiality of its two-dimensional representation. In its lying appeal to the sense of sight, painting, and especially Dou's brand of it, might resemble quackery. By stating this comparison in a large eye-fooling painting, Dou forged a pictorial identity from deceptiveness. Where Rembrandt's late self-portrait claimed an almost outmoded roughness as trademark and thus invited viewers to see him as defiantly isolated, as nineteenth-century viewers did too enthusiastically, so Dou's painted self encouraged legends about him as excessively neat and secretive.

Many still-life painters played with the image of painting as faithful mirror, by including reflecting surfaces and by mirroring their studios and themselves in them. In what seems a standard

118. GERARD DOU
Quack, 1652. Oil on panel, 44 x 32½" (112 x 83 cm). Museum Boymans-van Beuningen, Rotterdam.

119. Pieter Claesz
Vanitas Still Life, 1630s. Oil on panel,
14 x 23¹/₂″ (36 x 59 cm). Germanisches
Nationalmuseum, Nuremberg.

vanitas arrangement (FIG. 119), Pieter Claesz included not only the requisite skull, overturned glass, and timepiece but also a glass ball that reflects the objects on the table and the painter himself at the easel, presumably in the act of painting this very still life. Like so many of his contemporaries, Claesz destabilized the vanitas theme by including his portrait, the genre of painting most obviously intended to immortalize people in paint. The watch may signal life's passing but it also evokes art's life-extending power. Although neatly attired rather than in workshop smock, Claesz by his self-reflection among handmade objects acknowledged the craftliness of his art, perhaps in defense of still life against the low theoretical classification that it owed to its concern with plain things.

Self-portraits within genre scenes or still lifes also function as signatures. As already noted, signatures were by their nature self-conscious, in Pieter Saenredam's church interiors acting as a realist guarantee and as a mark of his authorship and initial ownership of the work. Many painters made visual puns on their names. Judith Leyster, whose surname translates as "Lodestar," frequently signed her name L★. Steen, meaning "Stone," represented his name as if carved on a stone lintel or sharpening stone.

Rembrandt is known by his first name because of his deliberate decision about 1633, once his career had taken off, to sign only with that distinctive name. Three illustrious Italian artists provided precedents for this practice: Michelangelo, Raphael, and Titian were known primarily by single names. Through prints after their compositions and through the Italian paintings present in the Netherlands, Rembrandt was familiar with their works. The example of Titian seems to have been especially formative for his pictorial identity. The warm reds and browns of his mature style were associated with Titian, as was the Venetian's distinctive, robust brushwork (see FIG. 28). In his Titianesque self-portrait (see FIG. 116), Rembrandt holds a rectangular palette, unusual in the Netherlands and often called a Venetian palette. Italian accounts of Titian's painterly style, encouraging viewers to see it from a distance, were known in the Netherlands through Karel van Mander's publication of his biography. In 1720, Arnold Houbraken similarly recorded that Rembrandt told customers to stand back from his paintings, as the paint's smell might irritate them. Even if it never occurred, Houbraken's anecdote acknowledges Rembrandt's admiration for the Venetian tradition, in which paintings cohere almost miraculously when seen from afar.

Although self-portraits and signatures are the most obvious signs of authorship, distinctive themes, locations, and styles constitute similar claims. Gabriel Metsu apparently painted an

Amsterdam vegetable market that took place just outside his home (see FIG. 79). Similarly, Dou lived near the city gate depicted at the center of his *Quack*. In different ways, Frans Hals's quick brush strokes are equally self-referential – however much followers might be instructed or tempted to copy them. Such pictorial trademarks also had a practical function, as they allowed artists to stake territories within the competitive picture market.

Figuring Art

The small number of Dutch theoretical treatises on art contrasts with the huge quantity of pictures produced in the seventeenth century. Many painters made up for the lack by speaking of art through their works. They explored, more or less consciously, the possibilities of a pictorial discourse on art. The contributions of Dutch art writers, however, provide a context for those statements in paint.

Karel van Mander, Philips Angel, and Samuel van Hoogstraten are sometimes considered derivative writers who copied Italian Renaissance treatises on art, from the dissertation on painting by Leonbattista Alberti (1404-72) to the artists' biographies by Giorgio Vasari (1511-74). Van Mander was well aware of Italian predecessors, but his synthesis of their works, his omissions and additions, his novel biographies of Northern artists, and his exegesis of Ovid made his work an original product of Haarlem's artistic society around 1600. Owned by numerous painters and collectors, it was of enormous significance for the creation of a Netherlandish artistic identity. Van Mander paid more attention than Italian theorists to realist craft, describing Jan van Eyck's invention of oil paint as foundation for the uncanny verisimilitude of Netherlandish painting and praising later artists for their accuracy. He also wrote sensitively about the acknowledged Netherlandish specialty of landscape art and suggested how it should be seen.

Angel's speech of 1641, intended to justify a separate guild of Leiden painters, should not be held to the standards of a well-wrought intellectual treatise. In its many departures from Van Mander, it reveals the author's practical experience and sense of Leiden's artistic identity. Angel advocated the innovative, well-rewarded specialty of deceptive painting practiced most famously by Dou.

Van Hoogstraten's treatise of 1678, less extensive than Van Mander's, is occasionally considered a stifling plea for classicist painting, at odds with the lively variety of contemporary Dutch

pictures. His notorious ranking of painting, from history paint-
ing at the top to still life at the bottom, is not as restrictive as it
seems, however. Van Hoogstraten's own illusionistic still lifes
brought him imperial recognition. In his book as well as his
pictorial inscriptions, he boasted of the honor and rewards such
works reaped at the highest courts. Although he ranked the
genres, he believed that painters could attain the highest quality
and rewards of art within each level. Van Hoogstraten's treatise
is also significant for its marked emphasis on the most accurate
representation of "the visible world," which is its subtitle. Van
Hoogstraten's perspective box pictures his views on art in Dutch
terms (see FIG. 60). In small scenes on three of its sides, he rep-
resented the reasons for painting articulated in his treatise. Painters,
the vignettes state, paint for financial gain, for honor, and for
the love of it. This programmatic statement of art's rationale
houses the Dutchest of scenes: a spotless middle-class interior with
anonymous figures, rather than a specimen of the exalted his-
torical genre.

Seventeenth-century Dutch treatises may thus have fostered
an awareness of Netherlandish, and even Dutch, pictorial tradi-
tion. Arnold Houbraken certainly interpreted Van Mander's book
in this manner. His biographies of Netherlandish artists published
between 1718 and 1721 deliberately continued Van Mander's
lives of Netherlandish artists where they leave off. His three
volumes have been accused of classicist bias and untruthful gos-
sip but his anecdotes also make the artists come alive in words and
evoke the character of their works. Besides offering the historian
factual leads, Houbraken thereby gave invaluable insight into
the early reception of Dutch paintings.

Dutch treatises did not merely reflect on art that had already
been produced but also impelled artists to enact theoretical notions
and to emulate the feats of famous painters of antiquity. Many
Dutch painters took up these challenges more or less consciously.
Legends about the Greek painter Zeuxis, who deceived animals
with painted fruits, may account in part for the favored Dutch
motif of insects poised on painted flowers and dead birds (see FIG.
104). In a double deceit, Adriaen van de Venne painted a blue-
bottle as if sitting on the surface of his *Fishing for Souls*, thus
suggesting that the fly is trying to enter his pictorial world and
also challenging viewers to determine whether the fly requires
shooing away (FIG. 120). The self-conscious motif suits the prob-
able purpose of the painting, made in the first year of his career,
as a demonstration piece for potential patrons. The confident self-
portrait in the left foreground underscores this function. Tempest

120. ADRIAEN VAN DE VENNE
Fishing for Souls, 1614
(detail of FIG. 8, page 18).
Oil on panel, 38½" x 6'2½"
(98 cm x 189 cm).
Rijksmuseum, Amsterdam.

paintings answer Van Mander's exhortation to match the Greek painter Apelles, who allegedly could paint ephemeral events such as lightning with fewer pigments than were available to modern artists (see FIG. 83). Apelles's colleague Pausias apparently painted a hugely admired ox looking directly at the viewer, with his whole body visible in foreshortening. Although Paulus Potter did not foreshorten his *Bull* that strongly, he may have painted his behemoth in imaginative emulation of the lost Greek model (FIG. 121).

121. PAULUS POTTER *The Bull*, 1647 (detail of FIG. 77, page 108). Oil on canvas, 7'5" x 11' (2.3 x 3.4 m). Mauritshuis, The Hague.

One of the foremost issues in Italian art theory, mentioned by Van Mander and elaborated by Angel, was the presumably age-old rivalry between sculpture and painting. As might be expected given the primacy of painting in the Republic, Angel decided the comparison, usually known as the *paragone*, in favor of painting. As primary argument he adduced the viscous, multicolored substance of paint, which allowed painters to achieve a more complete imitation of nature. This reasoning turns into a virtue the traditional charge against painting that it is "appearance without being." Its deceptiveness is the guarantee of its supreme artificiality. Painters could even forge the sculptor's own materials and products, as many did in deliberate inclusions of painted sculpture.

Angel also claimed greater nobility for painting: not only was it presumably older than sculpture but it could be performed at leisure, seated at an easel. This aspect of the *paragone* gives ideological charge to the practice of representing oneself seated at the easel in fine dress (see FIG. 117), and it makes Rembrandt's self-portrait standing in work clothes more deliberately unconventional. Angel noted that, unlike sculptors, painters could accomplish their best works late in life. Several painters proudly marked their old age beside their signatures; not accidentally, Jan van der Heyden did so in one of his most meticulous pictures, completed at the age of 75, in the year of his death (see FIG. 39).

With its combination of artificial objects and rare natural ones – the armadillo carcass and the tortoiseshell and ivory in the cabinet – Van der Heyden's arrangement is an ideal miniature collection. As such, it also makes explicit another central rivalry of Renaissance art theory: that between art and nature. People engaged in science, theology, and art alike marveled at the creative diversity of nature, her ability to form colored shapes beyond the flights of human fancy. Richly veined stones, intricately limbed insects,

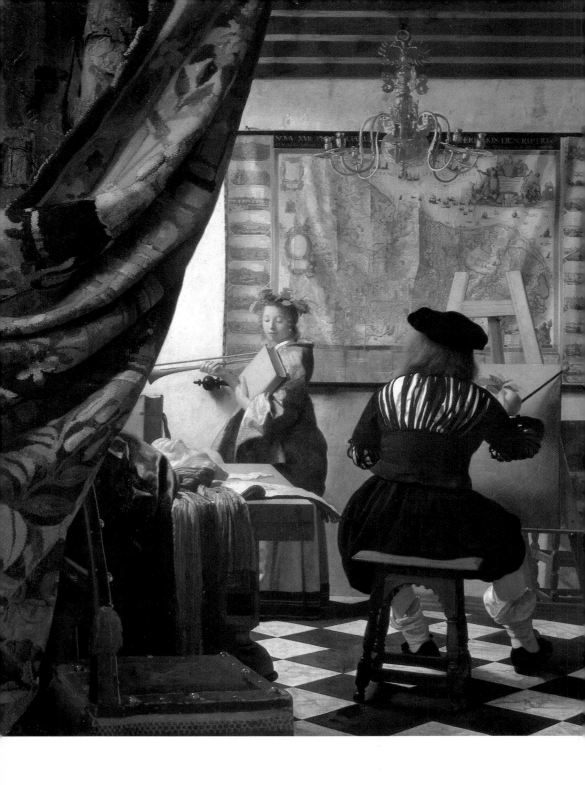

clashingly striped tulips, and tortuously spiraled shells not only induced awe before the Creator but also incited artists to match his creative acts in representations that may look as miraculous. The rich collection of marble ledges, exotic shells, and newly bred flowers in Dutch pictorial culture attests to the productive stimulus of nature's challenge.

That art was not all about imitating nature is clear. Several painters made eloquent statements about the enabling conditions of art in paintings of artists at work. Ostensibly a lifelike situation, Vermeer's studio painting was already called *The Art of Painting* by his widow (FIG. 122). Vermeer positioned the beholder peeking at a painter and his model from just behind a colorful tapestry. It marks the border between the viewer's universe and a more coolly tinted, harmonious pictorial world. This is no self-portrait: a view of the sitter from behind would have been unacceptable even for the most innovative portraiture. Moreover, contemporaries would have seen the painter's fanciful garb, of imprecise historical location, as belonging to the past. He is caught just painting a woman crowned with a laurel wreath, holding a trumpet and a book. Cesare Ripa prescribed these accessoriess for Clio, Greek muse of history: the wreath signals the honor she brings, the trumpet the fame she confers. Honor and fame were among the finest motivators and rewards of painting, accorded especially for its deceptiveness, signalled by the mask on the table. The painting of "history" was art's highest challenge, of course, but Vermeer's literal interpretation of this tradition – representing a personification of History – in his own specialty of genre painting seems ironic. History here also means Netherlandish history, in the first place political, as implied by the prominent map of the 17 provinces united before the Dutch secession. But the painting itself, a meticulously crafted interior in a long Netherlandish tradition, also embodies a Netherlandish art history. Besides proclaiming the commemorative function of this and all paintings, however, Clio serves her proper role as muse. The inspiration of the artist by a muse, then as now often represented as rapturous passion between the sexes, here occasioned a stilled meditation on the nature of visual representation, one that admirably accomplished art's brief of memorability.

Vermeer's muse in one sense embodies the seduction of the eye that painting was said to perpetrate. This metaphor, which equates deception and seduction, was thematized in numerous eye-fooling paintings of young women by Dou, Frans van Mieris, Jan Steen, and their followers. These seductresses address men, either protagonists within paintings or male viewers posited

122. JOHANNES VERMEER
The Art of Painting, c. 1662-65. Oil on canvas, 4'3" x 3'7" (1.3 x 1 m). Kunsthistorisches Museum, Vienna.

Vermeer kept this work at home, perhaps because it was his fullest account of his art, to be held for his own viewing or for display of his ability to potential buyers. One year after Vermeer's death, his widow deeded this painting to her mother, to keep it in the family rather than sell it to settle the painter's remaining debts.

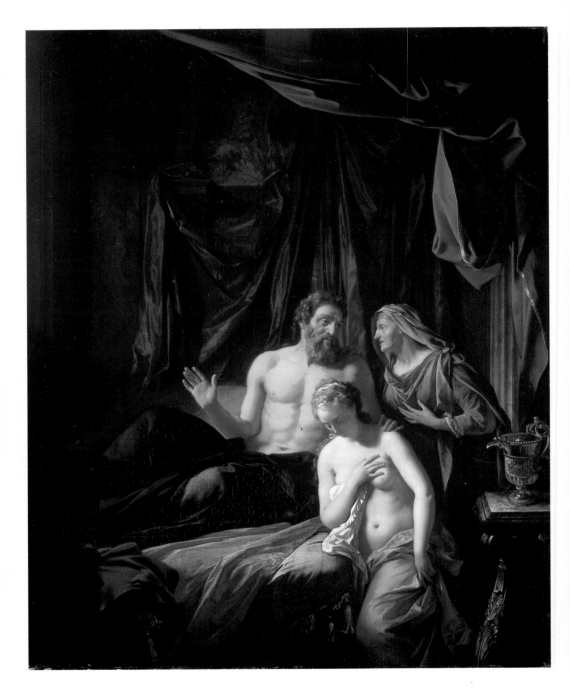

123. ADRIAEN VAN DER WERFF
Sarah Presenting Hagar to Abraham, 1699. Oil on canvas, 30 x 24″ (76.3 x 61 cm). Bayerische Staatsgemäldesammlungen, Staatsgalerie, Schleissheim.

Debating the moral wisdom of fathering a child with Hagar, Abraham averts his eyes from her tempting flesh.

170 *Artistic Authority*

outside. Adriaen van der Werff, a successful fine painter of Rotterdam, made the seductiveness of painted flesh explicit, in his *Sarah Presenting Hagar to Abraham* (FIG. 123). In the biblical story Sarah, still childless in maturity, gave her Egyptian slave to her husband Abraham, so he could produce an heir with her. Hagar's smooth nudity announces her success in arousing the aging man—a feat that later caused his wrenching dilemma, when Sarah gave birth to Isaac and asked Abraham to dismiss Hagar and her son. The air of illicit titillation suffusing such paintings of seduction, roundly condemned by Calvinist preachers, surely enhanced their appeal, even or possibly because the represented women are ultimately two-dimensional and cold. They offer allowable pleasure, vicarious thrills that can be experienced without moral danger, neutralized by the intellectual workings of metaphor. Like Dou's *Quack*, seductresses play their tricks for a sophisticated audience that knows itself distinct from the stereotyped customers represented or implied – the gullible boors, the lecherous lovers.

Van der Werff's painting is polished to such a sheen as to become unrealistic and very obviously art, precious art. Price was never far below the surface of seventeenth-century painting; indeed, it was constituted in it. The timepieces in still-life and genre paintings speak not only of transience and art's ability to halt it for ever or, in Angel's words, "several hundred years, which is enough." They may also claim the time required to make the painting, time translated into cost. In their motifs and their labor-intensive execution, many Dutch paintings acknowledge their status as choice and expensive commodities. Still lifes often represent fine metals and coins, and flower arrangements showcase the latest tulips. The more explicit seductresses and prostitutes have obvious services for sale, as do quacks. The seventeenth-century pictorial preoccupation with financial value registers canny awareness of the newly expansive art market. Many painters, including Vermeer and Jan van Goyen, dealt in pictures on the side. Painting for profit on the open market was an inevitable but base motivation according to Renaissance theorists; in the Republic it became an honorable course, not least because it implied the artist's freedom to paint according to choice. It was also rapidly becoming the Dutch way, in a society sustained by refined manufacturing and trade. On the outside of Samuel van Hoogstraten's perspective box, profit as the artist's motivation is the virtual equal of fame and love. In 1621, Ambrosius Bosschaert, dealer and painter of sophisticated flower pieces, was not ashamed to present a masterpiece to the Stadhouder's butler – and ask an astronomical 1000 guilders for it.

Reproducible Individuality: Prints

Intended for multiple reproduction, prints seem to deny artists the possibility of construing pictorial identity in an individual work. Indeed, an important traditional function of prints was the reproduction of other works in self-effacing styles. Yet paradoxically, some of the most distinctive Dutch artists were best known through their prints. Before the age of photography, which enabled the development of the illustrated art book, artists were most widely recognized through their engravings and etchings.

During his lifetime, Rembrandt built his considerable reputation outside the Republic primarily on etchings. He did so by discarding the more anonymous line of engraving for quirkier lines, developed in experiments with the media of etching and drypoint. These two techniques offered rather different opportunities from engravings and woodcuts.

To make an etching, the artist covers a copper plate with soft resin, then draws a design with a needle, scraping the resin away down to the plate but not into it. The plate is then bathed in acid that does not affect the remaining resin but eats away the copper along the exposed lines. When the acid has bitten the design into the plate, the remaining resin is scraped off and an impression can be made by inking the plate and rolling it through a press. The resin is not as resistant to the etcher's needle as the plate is to the engraver's burin, so etchings are more freely drawn, and hence can seem more "personal." This effect is even stronger with drypoint, in which the artist uses a needle to scratch directly into the plate, leaving a small amount of crumply metal residue, or "burr," along each line. The inked burr lends a soft, atmospheric quality to the quirky, scratchy design, but as it wears away rapidly each time it is rolled through the press, a print that shows it will be quite rare. Moreover, the registration of the burr in each impression varies much more than that of the engraved line. Rembrandt individualized his prints still further by combining different techniques within one print, or by altering the paper for various impressions. He also would rework his plates after taking one or more impressions

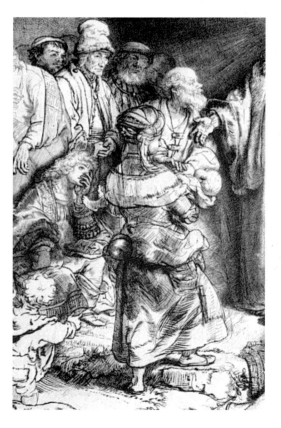

124. REMBRANDT
The Hundred Guilder Print, c. 1642-49 (detail of FIG. 32, page 51). Etching, drypoint, and engraving, 10½ x 15″ (27 x 38 cm). British Museum, London.

from it, thus creating several versions, or "states," of one print. Already in the seventeenth century, but especially in the eighteenth, collectors took pains to collect different states or different impressions of Rembrandt's plates.

Through prints, Rembrandt familiarized a wide public with his rich, manually exacting techniques as well as his unconventional approach to themes. His *Hundred Guilder Print* is an inventive recombination of biblical motifs, executed in the full range of line from light and clean to deeply shaded (FIG. 124). Undoubtedly its virtuosity and tender religious theme appealed to most connoisseurs of art. The *Seated Female Nude* would have been more problematic (see FIG. 65). Rembrandt articulated, even exaggerated, every wrinkle and roll of aging flesh. By representing the

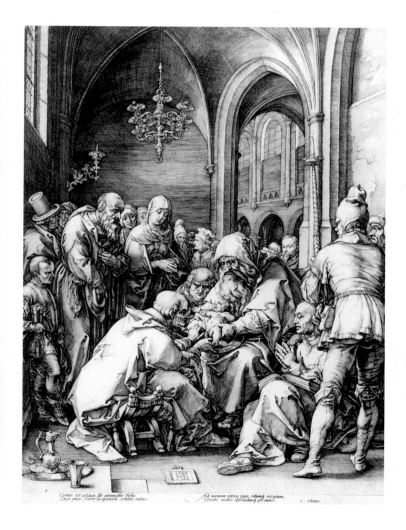

125. HENDRICK GOLTZIUS *Circumcision in the Church of St. Bavo at Haarlem*, 1594. Engraving, 18½ x 14" (47 x 35.5 cm). British Museum, London.

woman's garter marks he showed her as an undressed woman rather than an idealized nude, acknowledging her status as studio model or wife. The etching seems programmatic about Rembrandt's approach to representation: the imitation of nature, not art, should come first. Although critics through the centuries have taken Rembrandt to task for his deliberate anti-idealization, other viewers, and especially modern ones, have seen it as a sign of strong creative genius.

Whatever Rembrandt's "true character," his works, and especially his prints, surely encourage such readings of his persona. His etched lines, however carefully orchestrated, look like the spontaneous jottings of a draftsman, not the laborious efforts of the engraver. During the Renaissance, theoreticians and collectors had begun to value drawings for their presumably direct transcription of the artist's initial, most personal ideas. Rembrandt's draftsmanly prints capitalized on and furthered this new estimation of drawing.

Well before Rembrandt and in an almost opposite manner, Hendrick Goltzius (1558-1617) had explored individuality in draftsmanship and prints. From the 1580s, Goltzius worked as inventive and reproductive engraver in Haarlem, Holland's most self-conscious artistic community. In 1593 and 1594, he executed a remarkable series of imitations of the styles of renowned printmakers and painters. The series is devoted to the *Life of the Virgin*, the theme of a famous series of prints by Albrecht Dürer (1471-1528), the first artist to have made a career out of virtuoso printmaking. One of the finest engravings in Goltzius's series, the *Circumcision*, emulates Dürer's silvery brilliance (FIG. 125). Van Mander mentioned that Goltzius made one impression look old, to fool collectors into believing Dürer was its author. The self-consciousness of the exercise is clarified by Goltzius's self-portrait as witness, in the right background, and the event's setting in Haarlem's church of St. Bavo. Goltzius seems to lay claim to Dürer's Northern heritage by bringing it home to Haarlem. His chameleonic assumption of stylistic guises is mirrored in stories recorded by Van Mander that he liked to fake other identities; his lived as well as his pictorial personae seem to have relished deceptive imitation.

In 1600 Goltzius abjured all printmaking for the challenges of painting. One of the first products of this decision was a dazzling emulation of his own print style, with its sinuous lines and hatched and cross-hatched shadows, in a pen drawing – but a pen drawing made on a canvas primed with oil paint, and finished with highlights in oil (FIG. 126). Van Mander reported that a painter first owned this work, but that it was soon bought by the Holy Roman Emperor Rudolf II, who called in connoisseurs to

126. HENDRICK GOLTZIUS *Without Ceres and Bacchus, Venus is Chilled*, c. 1600-02. Pen and black ink and highlights in oil on canvas, 41 x 31″ (104 x 79 cm). Philadelphia Museum of Art.

The title is a classical proverb, claiming that the goddess of love is warmed by the goddess of agriculture and the god of wine, a refined way of saying that wine and food fuel love. Although Goltzius did not include Ceres and Bacchus directly, he visualized the saying by having a youth bring fruits and a satyr offer grapes and by warming Venus literally with reflections from Cupid's torch.

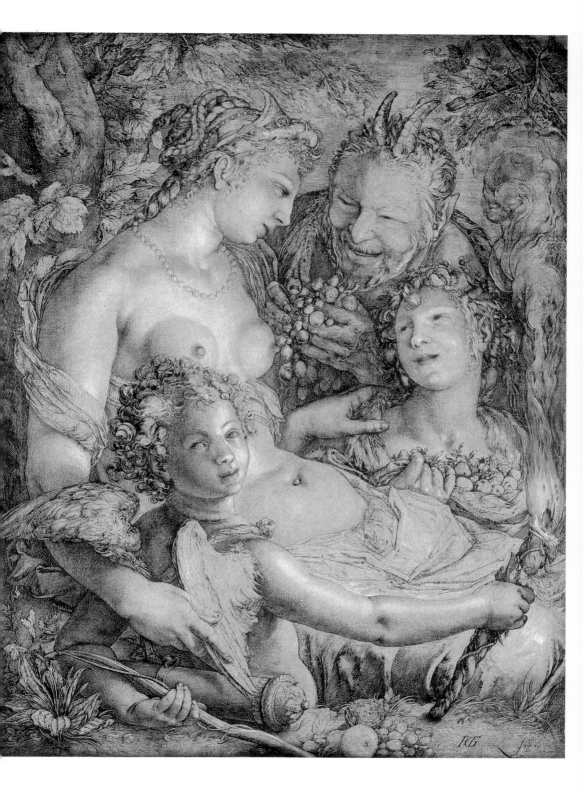

marvel at the artifice. His account suggests that even such an artificial hybrid could seduce the eye, not by its realism but by its belief-defying technical prowess. The work actually thematizes seduction, as a satyr, the classic lecher, presents grapes to the nude Venus. She has her arms around her son, Cupid, who displays his bow and arrow case behind his back. Contemporary poems frequently compared the effect of a lovely woman on male viewers to the stinging darts sent off by Cupid to incite love. Cupid's burning torch allowed Goltzius to display his mastery of theoretical challenges to represent fire, smoke, and light reflections.

This deliberately artificial picture thus represents the love which should fuel an artist's creative ardor, the love that is one of art's three motivations, according to Van Mander and Van Hoogstraten. Goltzius proclaimed his awareness of the other two components of this triad in his personal motto, "honor above gold," a pun on his name. However much he may have valued his art for the love and honor of it, he did not spurn its financial rewards. According to Van Mander, Goltzius rushed to get his *Life of the Virgin* series finished in time to send it to the Frankfurt fair, a crucial biannual exchange that enabled printmakers to sell their work and spread their reputations. Goltzius earned income as entrepreneurial publisher as well, and, in his fascination with metamorphosis and gold, towards the end of his life was duped by an alchemist.

Drawing on recent socio-historical investigations of Dutch pictorial culture, this book has tried to suggest how works of art participated in debates within the Republic about pressing, often contradictory concerns, from political primacy and religious doctrine to household management and personal identity. The articulation of such positions or ideals may frequently seem relatively independent of the intentions of artists. Yet artists cast ideas and arguments in visual form, and many of them appear to have been self-conscious about this task. A full account of seventeenth-century art thus cannot ignore artistic intentionality, however unconscious. Studying the ways in which artists constructed authorial identity, and thereby authority over the readings their works allow, can also clarify the development of notions of self in the seventeenth-century. The self-references of artists registered ideas about what it meant to be an individual artist in a given geographic location and they helped define and expand the professional identity of artists.

Between the end of the sixteenth century and the beginning of the eighteenth, the United Provinces overcame unprecedented

political insecurity to establish a new Republic and a merchant economy that was the envy of Europe. Although the political revolt had been led primarily by noblemen, its success depended on the religious zeal of the leaders of the Reformed Church and the vigorous support of the towns, in which a broad burgher class was led by a citizen elite with strong mercantile interests. As the frequent conflicts between State and Church, noble Stadhouders and urban regent class indicate, political authority in the Republic, in the absence of a traditional central ruler such as the Spanish King, was not self-evident. In the course of the seventeenth century, however, the regent elite assumed ever broader powers, particularly after the peace of 1648 removed the urgency of a federal Stadhouder's office. Within the towns, regent families controlled political offices without significant resistance from the citizenry at large, and in the provincial assemblies and States-General they far outweighed rural aristocrats. As if proclaiming their political takeover, regents from the first decades of the seventeenth century occasionally assumed new titles and bought country manors, but this process of aristocratization did not permeate the citizen elite until after 1650, when the suspension of the Stadhouder's office finally concentrated power in the regents. From that moment, regents no longer needed to define themselves as a class different from noblemen, with their own nobility of interior virtue, but they did have a stake in differentiating themselves from the lower rungs of the urban citizenry. Since Willem III's election as Stadhouder in 1672 was brokered by regent factions, the return of the office did not encroach on the power of their class.

The varied genres and modes of art produced in the Republic play out, if always obliquely, the frequently contradictory interests of different socio-economic, political, and religious constituencies. In the last two decades of the sixteenth century, some two hundred artists moved from the Southern Netherlands to the Republic, for economic and especially religious reasons. They introduced and transformed categories of pictures previously developed in Antwerp, including peasant and high-life genre painting (see FIG. 45), a decorous, meticulously finished type of landscape, noble portraiture (see FIG. 10), and especially refined mythological pictures in the elegant Mannerist style (FIG. 127). These categories of painting

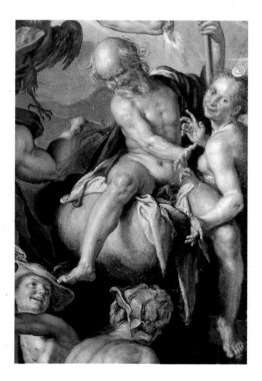

127. JOACHIM WTEWAEL
Mars and Venus Discovered by the Gods, c. 1603-04 (detail of FIG. 67, page 95). Oil on copper, 8 x 6⅛" (20.2 x15.5 cm). The J. Paul Getty Museum of Art, Malibu.

were patronized by the most famous noble collectors of Europe, including the Holy Roman Emperor Rudolf II in Prague. In the Northern Netherlands, urban institutions, wealthy merchants, and high officials eagerly collected these novel genres, perhaps valued especially for their associations with aristocratic discernment.

Yet as the Republic gained a surer footing with the Twelve-Year Truce, the conflicts of interest between the urban merchant elite, the middle-class Reformed leaders, and the Orange Stadhouders, bent on dynastic rule, became more evident. These developments are registered indirectly in the novel modes of art produced in the 1610s and 1620s in Amsterdam, Haarlem, and Leiden, the most prominent merchant towns of Holland. Besides offering cheerful decoration or contemplation of God's creation, the seemingly unassuming landscapes of Claes Jansz Visscher, Esaias van de Velde (FIG. 128), and Jan van Goyen, executed in newly sketchy, less labor-intensive techniques, helped constitute a sense of the local landscape as plain but productive, as the rightful preserve of a population dedicated to such burgher values as hard work and a frugal, God-fearing life. The merry companies of Willem Buytewech and others (see FIG. 89), also painted more fluidly than previous genre paintings, offered opportunities for gawking at courtly fashions or passing moral judgment on nonproductive feasting, but in doing so they might simultaneously ridicule the legendary pleasures of aristocrats. Regent portraits of the first three decades of the seventeenth century became quite distinct from noble formulas. The plainly colored clothes and

simple pictorial order proclaim modest burgher values such as marital love and financial responsibility. They also imply accessible, rather than regally remote, presence (see FIGS 100 and 101).

The pictorial innovations associated with these genres allowed faster and cheaper production, thus helping supply keep up with demand as broader sections of a newly prosperous middle class were able to afford paintings. At the same time the efforts of regents, increasingly remote from actual mercantile enterprise, to distinguish themselves more clearly from the lower citizenry are articulated in the development from the 1640s of new types of painting that were more expensive or had aristocratic associations. The citizen elite began to collect pastoral paintings more avidly, and their portraitists began to emulate international aristocratic formulas (see FIG. 103). Amsterdam collectors in particular favored more monumental, and more finely executed, landscape paintings (see FIGS 52, 73, and 75), as well as meticulous hunting scenes (FIG. 129). In Leiden, regents who had always been less active commercially than their counterparts elsewhere patronized the finest

129. WILLEM VAN AELST
Hunting Still Life, mid-1660s
(detail of FIG. 104, page 139).
Oil on canvas, 25³/₄ x 20³/₄"
(65.5 x 52.7 cm). Johnny
Van Haeften Ltd, London.

of fine painters. This delicate style was later favored especially by international noble patrons, who courted artists such as Adriaen van der Werff (see FIGS. 97 and 123). The seamless domestic interiors of Vermeer and De Hooch, produced in Delft, were affordable only to upper-middle-class collectors, many of them investors rather than merchants.

However eagerly regent patrons assumed aspects of aristocratic identity, they never forgot their power base in the towns, where they continued to serve as officers in the prestigious militia companies (FIG. 130). The Amsterdam town hall (see FIG. 114), splendid symbol of urban potency, was built in the classicist style first introduced in aristocratic architecture (see FIG. 115), but it outdid such buildings in rigorous grandeur. The newly monumental or finely painted city views celebrated the towns as harmonious and enduring polities.

The efficacious articulation in pictures of the new political situation and growing prosperity of the Republic as the proper, natural condition of the United Provinces was in large part responsible for eighteenth-century views of the seventeenth century as the Dutch Golden Age. By the time Houbraken's biographies of artists were published, writers had begun to perceive the once harmonious, thriving Republic as in decline. Although the definition and timing of such a decline are still debated, the eighteenth-century Republic did experience falling international market shares, debilitating political rifts, and a weakening of artistic patronage. Where seventeenth-century collectors had on the whole favored contemporary works over paintings produced in the past, in the eighteenth century owners preferred Golden-Age pictures that reflected and represented the Republic in its more prosperous, presumably natural state.

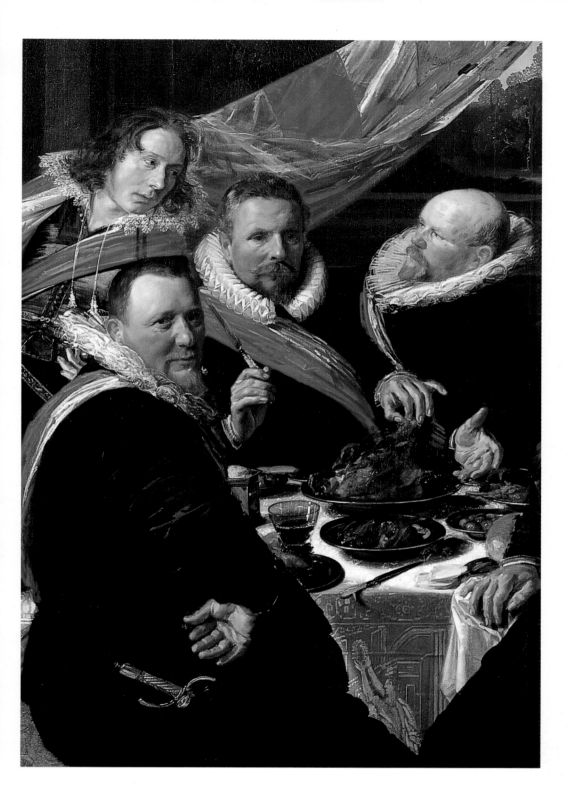

Political and Economic Events	Prints and Books

1585-1608
From Spanish recapture of Antwerp to eve of the Twelve Years Truce

1585 Antwerp recaptured for the Spanish Netherlands Exodus of Protestants to the North Dutch blockade of the River Scheldt **1588** Maurits of Orange appointed Stadhouder **1588** Defeat of the Spanish Armada by Anglo-Dutch fleet **1602** East Indies Company chartered **1607** Dutch defeat of Spanish fleet off Gibraltar **1608** New Exchange founded at Amsterdam	**1594** Hendrick Goltzius's *Life of the Virgin* engra⋯ **1600** Hendrick Vroom's *Landing at Philippine* engraving, ordered by States-General **1603** *Sailing Cars* woodcut by Jacques de Gheyn and others **1604** Karel van Mander's *Schilder-Boeck*, manual history of painting **1605** Jan van de Velde's *Spieghel der Schrijfkonst* manual of writing

1609-48
From Twelve Years Truce to Peace of Münster

1609 Declaration of Twelve Years Truce between the Dutch Republic and the Spanish Netherlands **1618-19** Calvinist Synod of Dordrecht, favoring the stricter faction in the Church **1619** Beheading of State Pensionary Johan van Olden- barnevelt Foundation of Dutch settlement in Batavia **1621** End of the Twelve Years Truce West Indies Company chartered **1625** Death of Maurits of Orange; his half-brother Frederik Hendrik Stadhouder **1629** Frederik Hendrik takes 's-Hertogenbosch, Catholic frontier city **1630-54** Northeastern Brazil under Dutch government **1637-44** Johan Maurits of Nassau-Siegen Governor General of Brazil **1647** Death of Frederik Hendrik; his son Willem II Stadhouder **1648** Peace of Münster: legal recognition of Dutch Republic	**1609-21** Claes Jansz Visscher's *Leo Belgicus* map **1611** Claes Jansz Visscher's etchings of *Pleasant N* **1615** Pieter Cornelisz Hooft's *Granida* **1624** Johan de Brune's *Emblemata* with engraving Adriaen van de Venne **1625** Jacob Cats's *Houwelick*, marriage treatise w engravings by Adriaen van de Venne **1635** Adriaen van de Venne's *Tafereel van de Belacchende Werelt* **1637** Publication of the "States Bible," commissic by the States-General **1641** Philips Angel's speech "Praise of Painting" a Leiden, published 1642 **1642** Pieter Cornelisz Hooft's *Nederlandsche His* **1644** Dutch edition of Cesare Ripa's *Iconologia* **1648** *Historia Naturalis Brasiliae* published by Joh Maurits of Nassau-Siegen **1640s** Rembrandt's *Hundred Guilder Print*

1649-72
From Peace of Münster to end of the Stadhouderless period

1649-50 Willem II in conflict with States-General and Amsterdam **1650** Death of Willem II; birth of future Willem III **1651** Abolition of the Stadhouder position in five provinces **1652** Colony founded at Cape of Good Hope, Africa **1652-54** First Anglo-Dutch War, mostly English success **1653** Johan de Witt Advocate of Holland, leader of the Republic **1665-67** Second Anglo-Dutch War, largely Dutch success **1672** French invasion of the Republic Assassination of Johan and Cornelis de Witt Willem III Stadhouder after Orangist and popular pressure	**1651** Constantijn Huygens's *Hofwyck*, lyric poem his country house **1659** Joost van den Vondel's dedicatory poem to Amsterdam Town Hall

1673-1718
From end of the Stadhouderless period to first volume of Arnold Houbraken's biographies of Netherlandish painters

1672-73 Defeat of the French army **1672-74** Third Anglo-Dutch War **1677** Willem III marries Mary, daughter of James II **1689** Willem (William III) and Mary II assume English crown **1702** Death of Willem III; beginning of second Stadhouderless period	**1678** Samuel van Hoogstraten's *Inleyding tot de Hooge Schoole der Schilderkonst* treatise **1684** *'t Amsterdams Hoerdom*, brothel guide **1705** Maria Sibylla Merian's *Metamorphosis Insectorum Surinamensium* **1718** First volume of Arnold Houbraken's *Groote Schouburg*, biographies of Netherlandish a⋯

Painting and Sculpture	Architectural and Engineering Projects
c. 1600-02 Hendrick Goltzius's *Without Ceres and Bacchus, Venus Is Chilled* **1593** Cornelis van Haarlem's *Wedding of Peleus and Thetis* **c. 1603-04** Joachim Wtewael's *Mars and Venus Discovered* **1604** Jacques de Gheyn II's parchment nature album for Rudolf II **1601-10** Several *Peasant Fairs* by David Vinckboons	**1585, 1593** Residential expansion projects in Amsterdam **1593** Carolus Clusius head of the new Leiden botanical garden **1607-12** Draining of the Beemster lake near Amsterdam
1610-13 Sculpted roodloft for the Cathedral of St. John, 's-Hertogenbosch **1614** Adriaen van de Venne's *Fishing for Souls* **1614** Hendrick de Keyser begins the tomb of Willem I, Delft **1624** Frans Hals's *Laughing Cavalier* **1625** Hendrick Ter Brugghen's *St. Sebastian* **1635** Four pastoral paintings by Abraham Bloemaert, Dirck van der Lisse, and others for the Stadhouder's court **c. 1637-44** Frans Post and Albert Eckhout in Brazil to paint landscapes, flora, and people **1642** Rembrandt's *The Nightwatch* **1645** Rembrandt's *Jan Six* **1647** Paulus Potter's *Bull*	**1609-72** Planned expansion of Amsterdam through system of concentric canals **1611** Hendrick de Keyser's building for the Amsterdam Exchange founded in 1608 **1612-40** Large-scale land reclamation projects in the province of Holland **1613** Lieven de Key's spire for the New Church in Haarlem **1620** Hendrick de Keyser's Delft Town Hall **1620-31** Hendrick de Keyser's Westerkerk in Amsterdam **1633-44** Mauritshuis, The Hague, by Jacob van Campen and Pieter Post
1648-50 Decoration of the Oranjezaal in memory of Frederik Hendrik, Huis ten Bosch, The Hague **1650** Gerard Houckgeest's *New Church at Delft with the Tomb of Willem I* **1652** Gerard Dou's *Quack* **1655-97** Sculptural and painted decorations of the Amsterdam Town Hall **c. 1661** Johannes Vermeer's *View of Delft* **1662** Samuel van Hoogstraten's *View into a Corridor* **c. 1662-65** Johannes Vermeer's *Art of Painting* **1663** Jan Steen's *In Luxury, Look Out* **c. 1670** Jacob van Ruisdael's *Windmill at Wijk bij Duurstede*	**1647-55** Jacob van Campen's Amsterdam Town Hall **1663** Amsterdam Catholic Church of Our Lord in the Attic **c. 1667** Rapenburg 6, Leiden
1686 Willem van de Velde II's *"Gouden Leeuw" before Amsterdam* **1687** Adriaen van der Werff's *Children before a Hercules Group* **1690s** Ludolf Backhuysen's *Ships Running Aground in a Storm* **1700** Richard Brakenburg's *May Queen Festival* **1712** Jan van der Heyden's *Room Corner with Curiosities*	**1670s-90s** Petronella Oortmans' dolls' house **1682** Founding of Amsterdam botanical garden **1686-92** Building and landscaping of country palace Het Loo for Willem III and Mary II

Bibliography

INTRODUCTION AN INVITATION TO LOOK

The most comprehensive and most lavishly illustrated survey of Dutch art in the seventeenth century is HAAK, BOB, *The Golden Age: Dutch Painters of the Seventeenth Century* (New York: Abrams, 1984). For the early period, KLOEK, WOUTER TH., *et al.*, *Dawn of the Golden Age: Northern Netherlandish Art 1580-1620* (exh. cat.; Amsterdam: Rijksmuseum, 1993). Historiographic issues and excellent illustrations in BROOS, BEN, *et al.*, *Great Dutch Paintings from America* (exh. cat.; The Hague: Mauritshuis, and San Francisco: Fine Arts Museums, 1990). Bibliographic essays on specific issues can be found in MULLER, SHEILA D. (ed.), *Dutch Art from c. 1475 to 1990: An Encyclopedia* (New York: Garland, 1996). On Jan Steen, see CHAPMAN, H. PERRY *et al.*, *Jan Steen: Painter and Storyteller* (exh. cat.; Washington, D.C.: National Gallery of Art and Amsterdam: Rijksmuseum, 1996). For De Hooch, SUTTON, PETER C., *Pieter de Hooch* (Oxford: Phaidon, 1980).

ONE MAKING AND MARKETING PICTURES IN THE DUTCH REPUBLIC

For the political history of the Republic, see GEYL, PIETER, *The Netherlands in the Seventeenth Century 1609-1648* (London: Ernest Benn, 1961); ISRAEL, JONATHAN I., *The Dutch Republic: Its Rise, Greatness, and Fall, 1477-1806* (Oxford: Oxford University Press, 1995); PARKER, GEOFFREY, *The Dutch Revolt* (revised edition, London: Penguin, 1985); ROWEN, HERBERT, H., *The Princes of Orange: The Stadholders in the Dutch Republic* (Cambridge: Cambridge University Press, 1988). Dutch economic history has been charted expertly by BOXER, C. R., *The Dutch Seaborne Empire 1600-1800* (London: Penguin, 1965) and ISRAEL, JONATHAN I, *Dutch Primacy in World Trade 1585-1740* (Oxford: Oxford University Press, 1989).

The social and cultural history of the Dutch Republic have been analyzed by ZUMTHOR, PAUL, *Daily Life in Rembrandt's Holland* (London: Weidenfeld and Nicolson, 1962); VAN DEURSEN, A. TH., *Plain Lives in a Golden Age: Popular Culture, Religion and Society in Seventeenth-Century Holland* (Cambridge: Cambridge University Press, 1991), and SCHAMA, SIMON, *The Embarrassment of Riches: An Interpretation of Dutch Culture in the Golden Age* (New York: Knopf, 1987).

Still unsurpassed as an introduction to the production and sale of paintings is a series of articles by MARTIN, W., "The Life of a Dutch Artist in the Seventeenth Century," *Burlington Magazine*, 7 (April to September 1905), pp. 125-31 and 416-25; 8 (October 1905 to March 1906), pp. 13-24; 10 (October 1906 to March 1907), pp. 144-54; 10 (October 1906 to March 1907), pp. 363-70; and 11 (April to September 1907), pp. 357-69. A detailed case study for one town has been offered by MONTIAS, JOHN MICHAEL, *Artists and Artisans in Delft: A Socio-Economic Study of the Seventeenth Century* (Princeton: Princeton University Press, 1982). Montias has also written excellent articles on the sale and collecting of paintings in the Dutch Republic: "Cost and Value in Seventeenth-Century Dutch Art," *Art History*, 10 (1987), pp. 455-66; "Art Dealers in the Seventeenth-Century Netherlands," *Simiolus*, 19 (1989), pp. 244-56; and "Works of Art in Seventeenth-Century Amsterdam: An Analysis of Subjects and Attributions," in FREEDBERG, DAVID, and DE VRIES, JAN (eds.), *Art in History/History in Art: Studies in Seventeenth-Century Dutch Culture* (Santa Monica: Getty Center, 1991), pp. 331-72. In this last collection of essays, see also VAN DER WOUDE, AD, "The Volume and Value of Paintings in Holland at the Time of the Dutch Republic," pp. 284-329. For a market study focused on landscape painting, CHONG, ALAN, "The Market for Landscape Painting in Seventeenth-Century Holland," in SUTTON, PETER C., *Masters of Seventeenth-Century Dutch Landscape Painting* (exh. cat.; Amsterdam: Rijksmuseum; Boston: Museum of Fine Arts; and Philadelphia: Museum of Art, 1987), pp. 104-20. Collecting and display in Dordrecht have been analyzed by LOUGHMAN, JOHN, "Aert Teggers, a Seventeenth-Century Dordrecht Collector," *Burlington Magazine*, 133 (1991), pp. 532-37. For a Dutch collection of ancient and Italian works, LOGAN, ANNE-MARIE S., *The "Cabinet" of the Brothers Gerard and Jan Reynst* (Amsterdam and New York: North-Holland, 1979). An interesting but sweeping attempt at a synthesis of market conditions in DE MARCHI, NEIL, and VAN MIEGROET, HANS J., "Art, Value, and Market Practices in the Netherlands in the Seventeenth Century," *Art Bulletin*, 76 (1994), pp. 451-64.

For a meticulous biography of Rembrandt, DUDOK VAN HEEL, S. A. C., "Rembrandt van Rijn (1606-1669): A Changing Portrait of the Artist," in BROWN, CHRISTOPHER, *et al.*, *Rembrandt, The Master and His Workshop: Paintings* (exh. cat.; Berlin: Altes Museum; Amsterdam: Rijksmuseum; and London: National Gallery, 1991), pp. 50-67. Much information on Rembrandt's studio organization can be found in that catalogue and in the introductory essays to the multi-volume catalogue of his paintings still being prepared by a Dutch committee of scholars: BRUYN, JOSUA, *et al.*, *A Corpus of Rembrandt Paintings*, 3 vols (The Hague and Boston; Nijhoff, 1982-89). For a stimulating but hard-pressed interpretation of the implications of this evidence, ALPERS, SVETLANA, *Rembrandt's Enterprise: The Studio and the Market* (Chicago: University of Chicago Press, 1988). Rembrandt's patrons are discussed in lively fashion by SCHWARTZ, GARY, *Rembrandt: His Life, His Paintings* (Harmondsworth: Viking, 1985); Schwartz offers unpersuasive interpretations of Rembrandt's paintings. More sensitive and reliable as an introduction to Rembrandt's work is WHITE, CHRISTOPHER, *Rembrandt* (London: Thames and Hudson, 1984).

Informative about women working in the Republic is KLOEK, ELS, *et al.* (eds), *Women of the Golden Age: An International Debate on Women in Seventeenth-Century Holland, England and Italy* (Hilversum: Verloren, 1994).

For the audience for pastoral art, KETTERING, ALISON McNEIL, *The Dutch Arcadia: Pastoral Art and Its Audience in the Golden Age* (Montclair: Allanheld and Schram, 1983).

Van der Hem's atlas is surveyed in *Een Wereldreiziger op Papier: De Atlas van Laurens van der Hem (1621-1678)* (exh. cat.; Amsterdam: Royal Palace, 1992). For seventeenth-century collecting of artificial and natural objects, see *De Wereld binnen Handbereik: Nederlandse Kunst- en Rariteitenverzamelingen, 1585-1735* (exh. cat. and volume of essays; Amsterdam: Historisch Museum, 1992); a separate summary in English is available.

TWO *TEXTS AND IMAGES*
On the image debate between Catholics and Protestants, see FREEDBERG, DAVID, "The Hidden God: Image and Interdiction in the Netherlands in the Sixteenth Century," *Art History*, 5 (1982), pp. 133-53, and "Art and Iconoclasm, 1525-1580," in FILEDT KOK, J. P., *et al.*, *Kunst voor de Beeldenstorm: Noordnederlandse Kunst 1525-1580* (exh. cat.; Amsterdam: Rijksmuseum, 1986). On the choir screen of 's-Hertogenbosch, WESTERMANN, MARIËT, "A Monument for Roma Belgica: Functions of the *Oxaal* at 's-Hertogenbosch," *Nederlands Kunst-historisch Jaarboek*, 45 (1994), pp. 382-446. For a detailed account of Saenredam and his images of Protestant as well as Catholic churches, SCHWARTZ, GARY, and BOK, MARTEN JAN, *Pieter Saenredam: The Painter and His Time* (London: Thames and Hudson, 1990).

A comprehensive survey of reading and writing and their relationship to painting is provided in SCHULTZE, SABINE (ed.), *Leselust: Niederländische Malerei von Rembrandt bis Vermeer* (exh. cat.; Frankfurt-am-Main: Kunsthalle, 1993). For an excellent overview of the production and reading of Dutch literature in the seventeenth century, SCHENKEVELD, MARIA A., *Dutch Literature in the Age of Rembrandt: Themes and Ideas* (Amsterdam and Philadelphia: John Benjamins, 1991).

On Adriaen van de Venne, see ROYALTON-KISCH, MARTIN, *Adriaen van de Venne's Album in the Department of Prints and Drawings of the British Museum* (London: British Museum, 1988).

An exemplary study of the relationship between texts and images for one genre is GOEDDE, LAWRENCE OTTO, *Tempest and Shipwreck in Dutch and Flemish Art: Convention, Rhetoric, and Interpretation* (University Park and London: Pennsylvania State University Press, 1989).

On the conflation of handwriting and picture-making, MELION, WALTER, "Memory and the Kinship of Writing and Picturing in the Early Seventeenth-Century Netherlands," *Word and Image*, 8 (1992), pp. 48-70. For Western self-consciousness about writing as a skill lacking in New World cultures, GREENBLATT, STEPHEN J., *Marvelous Possessions: The Wonder of the New World* (Oxford and Chicago: Oxford University Press and University of Chicago Press, 1991). A partial but stimulating account of Van Mander is MELION, WALTER S., *Shaping the Netherlandish Canon: Karel van Mander's Schilder-Boeck* (Chicago and London: University of Chicago Press, 1991). On the tradition of rhetoricians,

WESTERMANN, MARIËT, entry on the topic in *Dutch Art: An Encyclopedia* (*op. cit.*, Introduction).

The prestige and many subgenres of history painting are examined by BLANKERT, ALBERT, *et al.*, *Gods, Saints and Heroes: Dutch Painting in the Age of Rembrandt* (exh. cat.; Washington, D.C.: National Gallery of Art; Detroit: Institute of Arts; and Amsterdam: Rijksmuseum, 1980). For a compelling analysis of Dutch Ovidian painting and the importance of Van Mander's explication of the *Metamorphoses*, SLUIJTER, ERIC JAN, *De "Heydensche Fabulen" in de Noordnederlandse Schilderkunst circa 1590-1670* (Leiden: private printing of Ph.D. thesis, 1986), with English summary.

THREE *VIRTUAL REALITIES*
The term "reality effect," or "effect of the real," was coined in reference to nineteenth-century French novels by BARTHES, ROLAND, "The Reality Effect," in *The Rustle of Language*, trans. HOWARD, RICHARD (New York: Farrar, Strauss and Giroux, 1986), pp. 141-48. For the conventionality of "realism," see the rigorous philosophy of GOODMAN, NELSON, *Languages of Art: An Approach to a Theory of Symbols* (second edition; Indianapolis: Hackett, 1976). A stimulating analysis of the reality effect in Western painting has been offered by BRYSON, NORMAN, *Vision and Painting: The Logic of the Gaze* (New Haven: Yale University Press, 1983). The classic on realism in Western painting, with which these authors take issue, is GOMBRICH, ERNST, *Art and Illusion: A Study in the Psychology of Pictorial Representation* (Princeton: Princeton University Press, 1960).

On Dutch artists drawing after life, see the articles by Martin (*op. cit.*, Chapter One). A good introduction to Dutch drawings after the model in SCHATBORN, PETER, *Dutch Figure Drawings from the Seventeenth Century* (exh. cat.; Amsterdam: Rijksprentenkabinet, and Washington, D.C.: National Gallery of Art, 1981).

The manifold functions of music and musical instruments in Dutch culture and pictures are surveyed by BUIJSEN, EDWIN, and GRIJP, LOUIS PETER, *Music and Painting in the Golden Age* (exh. cat.; The Hague: Hoogsteder and Hoogsteder Gallery, 1994).

Many writers have commented on the relationship between optics and seventeenth-century painting in Delft; see especially WHEELOCK, JR., ARTHUR K., *Perspective, Optics and Delft Artists around 1650* (New York and London: Garland, 1977); LIEDTKE, WALTER A., *Architectural Painting in Delft: Gerard Houckgeest, Hendrik van Vliet, Emanuel de Witte* (Doornspijk: Davaco, 1982); BROWN, CHRISTOPHER, *Carel Fabritius: Complete Edition with a Catalogue Raisonné* (Oxford: Phaidon, 1981); and WHEELOCK, JR., ARTHUR K., *Vermeer and the Art of Painting* (New Haven: Yale University Press, 1995). The writings and paintings of Samuel van Hoogstraten have been analyzed by BRUSATI, CELESTE, *Artifice and Illusion: The Art and Writing of Samuel van Hoogstraten* (Chicago: University of Chicago Press, 1995). On Jacques de Gheyn II, see the chronological study of VAN REGTEREN

ALTENA, I.Q., *Jacques de Gheyn: Three Generations*, 3 vols (The Hague, Boston, and London: Nijhoff, 1983).

The theory that Dutch realism is "apparent" since it "hides" deeper significance has been argued most consistently by EDDY DE JONGH, in exhibition catalogues and articles on genre painting, portraiture, and still life, such as "Grape Symbolism in Painting of the 16th and 17th Century," *Simiolus*, 7 (1974), pp. 166-91; *Still-Life in the Age of Rembrandt* (exh. cat.; Auckland: City Art Gallery, 1982); and "Some Notes on Interpretation," in *Art in History/History in Art* (op. cit., Chapter One), pp. 118-36. For similar arguments from a more theoretical point of view, and for drawing from life and from the mind, MIEDEMA, HESSEL, "Over het Realisme in de Nederlandse Schilderkunst van de Zeventiende Eeuw," *Oud Holland*, 89 (1975), pp. 2-18, with English summary.

Insightful but ultimately reductive arguments for all Dutch picturemaking as a mode of knowledge construction that breaks down modern borders between science, art, craft, writing, and mapping have been presented by ALPERS, SVETLANA, *The Art of Describing: Dutch Art in the Seventeenth Century* (Chicago: University of Chicago Press, 1983). For a more nuanced investigation of the intersection between Dutch natural history, art, and exotic trade, FREEDBERG, DAVID, "Science, Commerce, and Art: Neglected Topics at the Junction of History and Art History," in *Art in History/History in Art* (op. cit., Chapter One), pp. 376-428.

For seminal studies of the intellectual and sensual delight collectors, art theorists, and artists took in the reality effect and in a limited number of themes, SLUIJTER, ERIC J., "Didactic and Disguised Meanings?" in *Art in History/History in Art* (op. cit., Chapter One), pp. 175-207. See also his *Leidse Fijnschilders van Gerrit Dou tot Frans van Mieris de Jonge 1630-1760* (exh. cat.; Leiden: Stedelijk Museum de Lakenhal, 1988), with English summary.

A simpler argument that Dutch painters painted as realistically as possible just because collectors liked it and because it paid well, has been made by HECHT, PETER, *De Hollandse Fijnschilders: Van Gerard Dou tot Adriaen van der Werff* (exh. cat.; Amsterdam: 1989); for an English summary of his position, see HECHT, PETER, "The Debate on Symbol and Meaning in Dutch Seventeenth-Century Art: An Appeal to Common Sense," *Simiolus*, 16 (1986), pp. 173-87.

On the requirement of lifelike representation in comic theory and practice, ALPERS, SVETLANA, "Realism as a Comic Mode: Lowlife Painting Seen through Bredero's Eyes," *Simiolus*, 8 (1975-76), pp. 115-43, and WESTERMANN, MARIËT, "How Was Jan Steen Funny? Strategies and Functions of Comic Painting in the Seventeenth Century," in BREMMER, JAN P., and ROODENBURG, HERMAN, *A Cultural History of Humour from Antiquity to the Present* (Cambridge: Polity, 1996).

For the many types of still-life painting and seventeenth-century appreciation of them, see *Still-Life in the Age of Rembrandt* (op. cit., above), with emphasis on vanitas readings. An excellent analysis of flower still life is TAYLOR, PAUL, *Dutch Flower Painting, 1600-1720* (New Haven: Yale University Press, 1995); more briefly the essays and fine plates in *Bouquets from the Golden Age* (exh. cat.; The Hague: Mauritshuis, 1992). A stimulating reading of possible seventeenth-century responses to still life in GOEDDE, LAWRENCE O., "A Little World Made Cunningly: Dutch Still Life and *Ekphrasis*," in WHEELOCK, JR., ARTHUR K., *et al.*, *Still Lifes of the Golden Age: Northern European Paintings from the Heinz Family Collection* (exh. cat.; Washington, D.C.: National Gallery of Art, 1989), pp. 35-44.

FOUR *DUTCH IDEOLOGIES AND NASCENT NATIONAL IDENTITY*

For the workings of ideology through seemingly 'natural' representation BARTHES, ROLAND, *Mythologies* (New York: Jonathan Cape, 1972, first published in 1957) and WARNER, MARINA, *Managing Monsters: Six Myths of Our Time* (London: Vintage, 1994). SCHAMA's book (op. cit., Chapter One) interprets Dutch culture as a rich verbal and pictorial fabric of myth.

The fundamental analysis of Dutch representations of history is the magisterial account of VAN DE WAAL, H., *Drie Eeuwen Vaderlandsche Geschied-Uitbeelding 1500-1800: Een Iconologische Studie*, 2 vols (The Hague: Nijhoff, 1952), with an extensive English summary.

A wide-ranging introduction to Dutch landscape painting in *Masters of Seventeenth-Century Dutch Landscape Painting*, (op. cit., Chapter One). For an account of early seventeenth-century definitions of the Dutch scene in prints, LEVESQUE, CATHERINE, *Journey through Landscape in Seventeenth-Century Holland: The Haarlem Print Series and Dutch Identity* (University Park: Pennsylvania State University Press, 1994).

On cow paintings, CHONG, ALAN, *Aelbert Cuyp* (forthcoming, 1996). For vegetable market paintings, and especially Metsu's, STONE-FERRIER, LINDA, "Market Scenes as Viewed by an Art Historian," in *Art in History/History in Art* (op. cit., Chapter One), pp. 28-57.

For a survey of pictures documenting the Dutch conquest of the sea, KEYES, GEORGE S. *et al.*, *Mirror of Empire: Dutch Marine Art of the Seventeenth Century* (exh. cat.; Minneapolis: Institute of Arts; Toledo: Museum of Art; and Los Angeles: County Museum of Art, 1990). For tempest scenes, GOEDDE (op. cit., Chapter Two). The scientific project in Brazil has been detailed by WHITEHEAD, P. J. P., and BOESEMAN, M., *A Portrait of Dutch 17th Century Brazil: Animals, Plants, and People by the Artists of Johan Maurits of Nassau* (Amsterdam, Oxford, and New York: North-Holland, 1989).

For fine objects in still life, examples in SEGAL, SAM, *A Prosperous Past: The Sumptuous Still Life in the Netherlands 1600-1700* (exh. cat.; Delft: Het Prinsenhof; Cambridge, Mass.: Fogg Art Museum; Fort Worth: Kimbell Art Museum 1988). Critical interpretive issues have been raised by BRYSON, NORMAN, *Looking at the Overlooked: Four Essays on Still Life Painting* (London: Reaktion, 1990). For a challenging interpretation of the making and viewing of Dutch still-life painting as fetishistic practices, FOSTER, HAL,

"The Art of Fetishism," in *Fetish*, issue of *Princeton Architectural Journal*, 4 (1992), pp. 6-19. An admirable survey of Dutch genre painting is SUTTON, PETER C., *et al.*, *Masters of Seventeenth-Century Dutch Genre Painting* (exh. cat.; Philadelphia: Museum of Art; Berlin-Dahlem: Gemäldegalerie; and London: Royal Academy, 1984). For an inspiring study of Dutch domestic paintings, FRANITS, WAYNE, *Paragons of Virtue: Women and Domesticity in Seventeenth-Century Dutch Art* (Cambridge: Cambridge University Press, 1993).

FIVE PORTRAITURE AND THE IDENTITY OF SELF AND COMMUNITY

A Japanese exhibition catalogue, fully translated in an English supplement, surveys most subgenres of Dutch portraiture: DE JONGH, E., *et al.*, *Faces of the Golden Age: Seventeenth-Century Dutch Portraits* (Yamaguchi: Prefectural Museum of Art, etc., 1994). Interesting interpretive issues are raised in *Nederlandse Portretten*, volume 8 of the *Leids Kunsthistorisch Jaarboek* (1989, published in 1990), with articles and summaries in English. For a full overview of marriage and family portraiture, see De JONGH, E., *Portretten van Echt en Trouw* (exh. cat.; Haarlem: Frans Halsmuseum, 1986). Marital portraits have been interpreted as social and theatrical encounters by SMITH, DAVID, *Masks of Wedlock: Seventeenth Century Dutch Marriage Portraiture* (Ann Arbor: University of Michigan Press, 1982). On pastoral portraiture, KETTERING (*op. cit.*, Chapter One).

For insightful readings of the political and private significance of burgher portraiture, WOODALL, JOANNA, "Status Symbols: Seventeenth-Century Netherlandish Portraiture," *Dutch Crossing*, 42 (autumn 1990), pp. 34-68. Hunting scenes are discussed by SULLIVAN, SCOTT A., *The Dutch Gamepiece* (Totowa and Montclair, N.J.: Allanheld and Schram, 1984). For Frans Hals, SLIVE, SEYMOUR, *et al.*, *Frans Hals* (exh. cat.; Washington, D.C.: National Gallery of Art; London: Royal Academy; and Haarlem: Frans Halsmuseum, 1989). His militia portraits have been catalogued by KÖHLER, NEELTJE, and LEVY-VAN HALM, KOOS, *Frans Hals: Militia Pieces* (Maarssen and The Hague: Gary Schwartz/SDU, 1990). Militia portraits in general and the *Nightwatch* in particular are situated expertly by HAVERKAMP-BEGEMANN, EGBERT, *Rembrandt: The Nightwatch* (Princeton: Princeton University Press, 1982). Insightful about Dutch personhood in painting is a short essay by BARTHES, ROLAND, "The World as Object," in his *Critical Essays* (Evanston: Northwestern University Press, 1972).

Dutch seventeenth-century architecture has been analyzed by KUYPER, W., *Dutch Classicist Architecture: A Survey of Dutch Architecture, Gardens and Anglo-Dutch Architectural Relations from 1625 to 1700* (Delft: Delft University Press, 1980). For the Amsterdam town hall and its program of sculpture and painting, FREMANTLE, KATHERINE, *The Baroque Town Hall of Amsterdam* (Utrecht: Haentjens, Dekker and Gumbert, 1959).

SIX ARTISTIC AUTHORITY

The by now classic critiques of authorship are BARTHES, ROLAND, "The Death of the Author," in his *Image-Music-Text* (New York: Fontana, 1977), pp. 142-48, and FOUCAULT, MICHEL , "What is an Author," in his *Language, Counter-Memory, Practice: Selected Essays and Interviews* ed. and trans. D. F. BOUCHARD (Ithaca: Cornell University Press, 1977), pp. 113-38. For notions of artistic authorship, MOXEY, KEITH, *The Practice of Theory: Poststructuralism, Cultural Politics, and Art History* (Ithaca and London: Cornell University Press, 1994).

An innovative study of Rembrandt's identity through self-portraiture is CHAPMAN, H. PERRY, *Rembrandt's Self-Portraits: A Study in Seventeenth-Century Identity* (Princeton: Princeton University Press, 1990). The first chapter of ALPERS, SVETLANA, *Rembrandt's Enterprise* (*op. cit.*, Chapter One), analyzes Rembrandt's painterly identity. Instructive, though ahistorical, about Rembrandt's suggestion of interior qualities through a "Rembrandt effect" is BAL, MIEKE, *Reading Rembrandt: Beyond the Word-Image Opposition* (Cambridge: Cambridge University Press, 1991). For Rembrandt's interest in Titian, VAN DE WETERING, ERNST, "Rembrandt's Manner: Technique in the Service of Illusion," in *Rembrandt, The Master and His Workshop: Paintings* (*op. cit.*, Chapter One), pp. 12-39. For Steen's comic persona and works, see *Jan Steen* (*op. cit.*, Introduction). Leyster's work is situated historically in *Judith Leyster: A Dutch Master and Her World* (exh. cat.; Haarlem: Frans Hals Museum, and Worcester, Mass.: Worcester Art Museum, 1993). For a most thoughtful account of painterly identity as constituted in still life, BRUSATI, CELESTE, "Stilled Lives: Self-Portraiture and Self-Reflection in Seventeenth-Century Netherlandish Still-Life Painting," *Simiolus*, 20 (1990-91), pp. 168-82. A high-keyed argument for Van Mander's interest in defining a Netherlandish art history has been made by MELION (*op. cit.*, Chapter Two).

My interest in the structuring of artistic identity in reproducible media is informed by BENJAMIN, WALTER, "The Work of Art in the Age of Mechanical Reproduction," in his *Illuminations: Essays and Reflections* (New York: Schocken, 1969). For Rembrandt's involved printmaking techniques, WHITE, CHRISTOPHER, *Rembrandt as an Etcher: A Study of the Artist at Work*, 2 vols (University Park: Pennsylvania State University Press, 1969). On Goltzius, NICHOLS, LAWRENCE, The *"Pen Works"* of Hendrick Goltzius, exh. issue of *Philadelphia Museum of Art Bulletin* (Winter 1992), and MELION, WALTER, "Love and Artisanship in Hendrick Goltzius's Venus, Bacchus and Ceres of 1606," *Art History*, 16 (1993), pp. 60-94.

Picture Credits

Collections are given in the captions alongside the illustrations. Sources for illustrations not supplied by museums or collections, additional information, and copyright credits are given below. Numbers to the left refer to figure numbers unless otherwise indicated.

Index